four honest outlaws

yale university press: new haven and london

MICHAEL FRIED

four honest outlaws:

SALA

RAY

MARIONI

GORDON

Designed by Gillian Malpass

Printed in Singapore

Library of Congress Cataloging-in-Publication Data
Fried, Michael.
 Four honest outlaws : Sala, Ray, Marioni, Gordon / Michael Fried.
 p. cm.
 Includes bibliographical references and index.
 ISBN 978-0-300-17053-5
1. Art, Modern--20th century. 2. Art, Modern--21st century.
3. Sala, Anri, 1974---Criticism and interpretation. 4. Ray, Charles,
1953---Criticism and interpretation. 5. Marioni, Joseph, 1943---Criticism
and interpretation. 6. Gordon, Douglas, 1966---Criticism and
interpretation. I. Title.
 N6490.4.F75 2011
 709.2'2--dc22
 2011001769
A catalogue record for this book is available from The British Library

To Allen Grossman

Magnificent poet,

towering intellect,

beloved friend

Tolstoy: the meaning (importance) of something lies in its being something everyone can understand. That is both true & false. What makes the object hard to understand – if it's significant, important – is not that you have to be instructed in abstruse matters in order to understand it, but the antithesis between understanding the object & what most people *want* to see. Because of this precisely what is most obvious may be what is most difficult to understand. It is not a difficulty for the intellect but one for the will that has to be overcome.

Ludwig Wittgenstein*

* Ludwig Wittgenstein, *Culture and Value*, ed. G. H. von Wright in collaboration with Heikki Nyman, rev. ed. of the text by Alois Pichler, trans. Peter Winch (Oxford and Malden, Mass., 1998), p. 25e.

contents

POSTSCRIPTS

preface and acknowledgments

The essays in this book were originally drafted as four Alexander Lectures, which I delivered at University College, University of Toronto, on successive days in March 2008. My warmest thanks to Dr. Sylvia Bashevkin, Principal of the College, for hosting my visit, and to Prof. Suzanne Akbari of the Departments of English and Medieval Studies for doing everything in her power to make the occasion a success. The initial writing took place under the ideal working conditions provided by the Wissenschaftskolleg zu Berlin, where my wife, daughter, and I spent the academic year 2007–8. Special thanks are due Benjamin Drieschner, then a member of the technical staff, who helped me prepare the Powerpoint presentations on which the lectures depended.

Among those – besides the artists – with whom I have discussed the content of these essays are Jennifer Ashton, James Conant, Ruth Leys, Reinhart Meyer-Kalkus, Walter Benn Michaels, Robert B. Pippin, Ralph Ubl, and Bryan Wolf,

all of whom have my heartfelt thanks. On the occasion of my visit to Toronto in March 2008, David Mirvish generously opened his unequaled collection of Color Field painting to Joseph Marioni and me, for which I am deeply grateful. Bert Ross, Douglas Gordon's chief technical assistant, kindly provided DVDs of Gordon's works whenever I asked for them; my thanks to him as well. Others who assisted me in similar ways are Lewin Quehl (for Sala), Aiko Hachisuka (for Ray), and Charles Abdoo (for Marioni). My thanks to Hans Ulrich Obrist for providing me with the texts of more than a few unpublished conversations with Anri Sala. I have also given versions of the Sala lecture at the University of Chicago, the Institute of Modern the Art in Valencia, the Photographers' Gallery in London, the Art Center College of Design, Princeton University, the Contemporary Arts Center in Cincinnati, the University of Georgia, Duke University, and the University of Athens; and of the Gordon lecture at Witte de Witt in Rotterdam, the Wissenschaftskolleg zu Berlin, the Institute of Contemporary Art in London, the New York Studio School, and the University of Texas at Dallas. It would require a long list of names to thank all those who invited me to do so and who hosted me on those occasions.

My year at the Wissenschaftskolleg was made possible by a Distinguished Achievement Award from the Andrew W. Mellon Foundation. Once again I am grateful to Gillian Malpass, my editor at Yale University Press, for her intellectual passion and nonpareil design skills; working with her is always a privilege. I should add that I have done my best to keep the footnoting in this book as light as possible; these are critical essays, not works of scholarship, and in the present age of web-based information I have not felt compelled to provide detailed bibliographies of the four artists. All artist's statements that are not attributed to particular sources were said to me in conversation. Finally, I want to thank Anri Sala and Douglas Gordon for agreeing to make their work available on the DVD accompanying this book.

introduction
(optional)

This book comprises four essays on contemporary artists: Anri Sala, Charles Ray, Joseph Marioni, and Douglas Gordon. In effect it goes on from a much longer book published in 2008, *Why Photography Matters as Art as Never Before* – but I am already getting ahead of myself. Let me begin, then, by providing a framework, at once critical, historical, and personal, for the essays that follow. I realize, naturally, that for many readers – including some likely to be sympathetic to my arguments – I will be covering familiar material; they are encouraged to skip this introduction and go directly to the essay on Sala. Other readers, though, perhaps including younger artists of different nationalities (that is my hope), will be coming to this book without any background in my previous writing, and I see

no alternative to running through some basic points yet again. So without further apology: I started out in the early 1960s writing about contemporary painting and sculpture in magazines such as *Arts*, *Art International*, and (especially) *Artforum*. My beginning orientation was "formalist," a term that I believe has no relevance to my writing starting as early as the fall of 1966. Along with others in my generation, I was for a time part of the circle that gathered around the influential New York-based art critic Clement Greenberg; the artists I admired, besides the major painters of the Abstract Expressionist generation and the sculptor David Smith, included Morris Louis, Helen Frankenthaler, Kenneth Noland, Jules Olitski, Frank Stella (a contemporary of mine at Princeton; we met when I was 16 and he was 19, a huge stroke of luck for me), and the British sculptor Anthony Caro. (I am illustrating Louis's superb Unfurled, *Alpha-Pi* [1960], and Caro's *Midday* [1960], the first of his great abstract welded steel sculptures. *Midday* stood in the courtyard of Caro's house in Hampstead, London, when I visited him for the first time in the fall of 1961; seeing it there and then ranks among the transformative events of my life.) In the spring of 1965, while a graduate student in

1
2

1 Morris Louis, *Alpha Pi*, 1960. Acrylic on canvas, 260 × 449.7 cm. The Metropolitan Museum of Art, New York. Arthur Hoppock Hearn Fund, 1967 (67.232).

art history at Harvard, I organized for the Fogg Art Museum an exhibition called "Three American Painters" that comprised recent work by Noland, Olitski, and Stella. All the next year, 1965–6, was given over to scholarly studies in art history but in 1966–7 I wrote a series of articles and catalogue introductions, for the most part published in *Artforum*, in which I tried to do three things: first, deal intensively with work by Louis, Noland, Olitski, Stella, and Caro (among others); second, critique and formulate an alternative to Greenberg's theory of modernism; and third, put forward a sweeping critique of Minimalism, a "movement" that had recently come to the fore and that was in tension, to say the least, with the high modernist work that I most admired. The culminating essay in that ambitious effort, "Art and Objecthood," was published in the summer 1967 issue of *Artforum*; after all this time, it remains probably the single piece of writing for which I am best known.

My basic charge was that Minimalist or, as I preferred to call it, Literalist work was essentially a kind of theater – that it was theatrical – meaning by this that it sought to bring about – indeed, that by and large it actually did bring about –

2 Anthony Caro, *Midday*, 1960. Steel painted yellow, 240 × 96 × 366 cm. The Museum of Modern Art, New York. Mr. and Mrs. Arthur Weisenberger Fund, 1974.

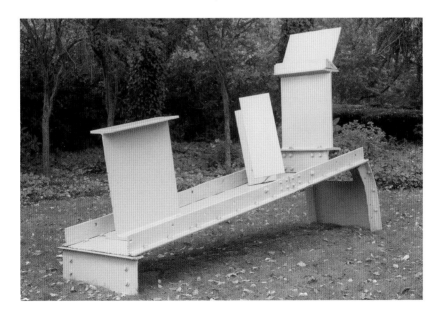

what I considered to be the wrong sort of relationship between the work and the beholder, the viewer, the audience. Simply put, whereas the whole point of a characteristic high modernist painting like *Alpha-Pi* or a high modernist sculpture like *Midday* was to foreground relationships among elements *within* the work itself (the rivulets of intense color and the rectangular blank canvas in the Louis, the steel girder segments in the Caro), a Minimalist or Literalist work deliberately minimized (no pun intended) such relationships in favor of placing as much emphasis as possible on the relationship *between* the work and the viewer, which in practice meant between the work, the gallery space in which it was encountered (soon to be characterized by Brian O'Doherty as the "white cube"), and the embodied and mobile – that is, ambulatory – human subject, whose "experience" of that relationship (one cannot quite say "of the work") consisted simply in the ongoing, present-tense registration of the shifting parameters of those three factors or elements. In Robert Morris's words, none of this "indicates a lack of interest in the object itself. But the concerns now are for more control of . . . the entire

3 Tony Smith, *Die*, 1962. Steel, oiled finish, 183.85 × 183.85 × 183.85 cm. National Gallery of Art, Washington, D.C.

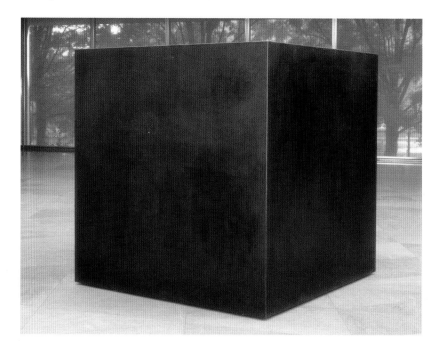

situation. Control is necessary if the variables of object, light, space, body, are to function. The object has not become less important. It has merely become less self-important."[1] Becoming less self-important meant becoming simple, single, holistic objects; thus Morris advocated "the use of strong gestalt or unitary-type forms to avoid divisiveness" (p. 150). Tony Smith's *Die* (1962), a six-foot black [3] steel cube, remains the exemplary instance of this, along with various works by Donald Judd, Morris's L-shaped wooden pieces of the mid-1960s, and Carl [4, 5] Andre's floor pieces of metallic squares arranged in a grid. Further, as my brief [6] reference to the viewer's "experience" already suggests, there was in the Minimalist/Literalist esthetic an inbuilt indeterminacy with respect to subjective response: since what mattered was the embodied subject's ongoing perception of his or her negotiation of the total situation (that is, the gallery space including the lighting plus the object plus the embodied subject himself or herself), there could be no sense given to any claim as to the "rightness" of any particular understanding of a given work, for each subject's "experience" was unique and in a sense incom-

4 Donald Judd, *Untitled*, 1966. Blue lacquer on aluminum and galvanized iron, 101.6 × 482.6 × 101.6 cm. Norton Simon Museum of Art, Pasadena, California, Gift of Mr and Mrs Robert A. Rowan.

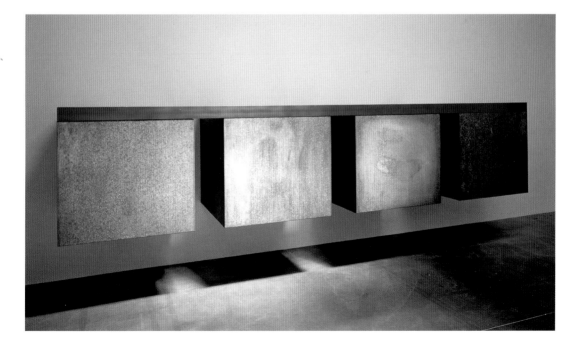

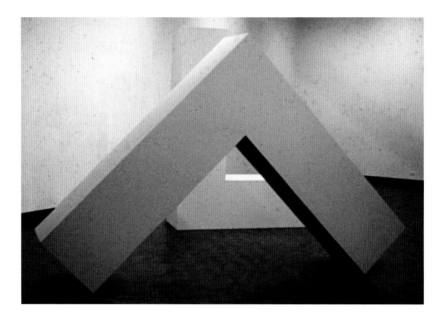

5 Robert Morris, *Untitled (Three L-Beams)*, 1969. Refabrication of a 1965 original, painted plywood, three units, each 243.8 × 243.8 × 61 cm.

mensurable with every other subject's. (Each subject's "experience" *was* the work, in a manner of speaking.) In contrast, the precise relationships that a Louis or a Caro comprises were intended by the artist to be precisely what and as they are; in an encounter with their work the viewer's "experience" matters in the sense of providing a channel of insight into the overall structure of intentions that made the work what it is; but – this is the crucial point – the viewer's merely subjective response cannot stand in for the work itself, which is what the Minimalist/Literalist esthetic would have it do. As "Art and Objecthood" puts it: "the rightness or relevance of one's conviction about specific modernist works, a conviction that begins and ends in one's experience of the work itself, is always open to question" (pp. 158–9). I also wrote of Caro's sculptures: "It is as though Caro's sculptures essentialize meaningfulness *as such* – as though the possibility of

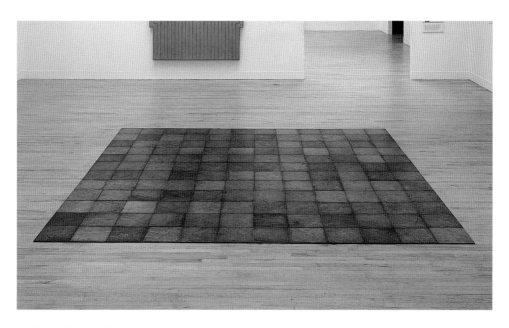

6 Carl Andre, *144 Magnesium Squares*, 1969. 1 × 365.8 × 365.8 cm. Tate Modern, London.

meaning what we say and do *alone* makes his sculpture possible" (p. 162). (The issue of intention has been formulated with exemplary clarity by Walter Benn Michaels in *The Shape of the Signifier* and by Jennifer Ashton in *From Modernism to Postmodernism*.[2])

Another, closely related aspect of the Minimalist/Literalist project concerned what I called objecthood, and it is here that my critique of that project also involved a rejection of Greenberg's theory of modernism. According to Greenberg in his major theoretical essay "Modernist Painting" (1960), soon supplemented by "After Abstract Expressionism" (1962), the project of modernism in each art consisted in the continual testing of the current conventions of that art so as to determine which ones were now revealed to be inessential, dispensable. By the early 1960s, Greenberg maintained, such testing had come to reveal that

the essence of the art of painting consisted in just two constitutive norms or conventions, flatness and the delimitation of flatness. Thus (he wrote in "After Abstract Expressionism"), a tacked-up blank canvas already exists as a picture "though not necessarily as a successful one."[3] Now flatness and the limitation of flatness were, as he also said, literal properties of the support, and the strong implication of his thought was that precisely that fact, that literalness, is what made them essential for painting in this way. As it seemed to me, the Minimalists or Literalists had in effect accepted Greenberg's theorization of the modernist "reduction" (as he called it), but thereupon had come to feel that the very logic of such a "reduction" called in the end for much more powerful and pointed thematizations of literalness than could be provided by Greenberg's tacked-up canvas (it is not hard to sympathize with that feeling, given their premises). What this led to in practice was the "projection" of objecthood via strong three-dimensional gestalts such as one finds in Smith's *Die* and numerous works by Judd and Morris in particular. A related feature of the Minimalist/Literalist strategy was the use of unitary shapes and the simplest principles for ordering individual units, as in Andre's floor pieces based on assemblages of metal squares. Let me acknowledge that my own polemical and theoretical project in "Art and Objecthood" led me to slight significant differences between the work of individual Minimalists, most notably between Morris and Judd. In Judd's angry words some years later, "Fried cross-referenced Bob Morris, Tony Smith, and myself and argued against the mess."[4] There is justice in his charge – but I saw no other way to make the argument against Minimalism/Literalism that I then felt, and indeed continue to feel, needed to be made.

Against Greenberg's view of modernism I argued, first, that his notion of the timeless literal essence of painting led to a cul-de-sac artistically and theoretically: for example, once it has been revealed that flatness and the delimitation of flatness are what really matter, what are ambitious modernist painters to do except restate the obvious? (Greenberg tried to answer this question in "After Abstract Expressionism" but without success.) Rather, I maintained, the correct way to think about "essence" in the arts was historically, or say dialectically: the mod-

ernist project, in my view, was not a matter of doing away with norms and conventions that had been revealed to be inessential – as if in pursuit of a timeless and unchanging core – but rather of discovering precisely which conventions, at a given moment, turned out to be crucial to the enterprise of painting (for example) at its most serious and exalted, which is to say at its most committed to providing instances of painting capable of standing comparison with the painting of the past whose quality is not in doubt (a formulation that goes back to the time of Manet). I was prepared to agree with Greenberg that those conventions often involved a relation to issues of literalness, but the relation was not one of isolation and hypostatization, as his texts implied, but rather of what I called *acknowledgment*, a way of thinking that immediately and to my mind productively raised the further question of what at a given moment counts as such acknowledgment. From that point of view, the Minimalist/Literalist projection of abstract or generic objecthood was itself based on a misunderstanding of the historical problematic of modernism in the arts. (As I made clear at the time, notions of convention and acknowledgment so understood link my art criticism with the early philosophical writings of Stanley Cavell, a close friend at Harvard during those years, as well as of Cavell's source thinkers J. L. Austin and, especially, Ludwig Wittgenstein.[5])

Finally, "Art and Objecthood" put forward the claim that "theater and theatricality are at war today, not simply with modernist painting and sculpture but with art as such – indeed with modernist sensibility as such" (p. 163; not quite a direct quotation). (Please note: they are at war "*today*," in 1966–7, not throughout history. The claim may be mistaken but its historical specificity ought at least to be recognized.) This led in turn to three propositions or theses: 1) "The success, even the survival, of the arts has come increasingly to depend on their ability to defeat theater." 2) "Art degenerates as it approaches the condition of theater." 3) "The concepts of quality and value – and to the extent that these are central to art, the concept of art itself – are meaningful, or wholly meaningful, only within the individual arts. What lies *between* the arts is theater" (pp. 163–5). The third point in particular, with its insistence on the importance of medium-specificity,

continues to provoke controversy; I will only say that I wish I had put "between" in scare quotes instead of in italics. The basic idea, of course, is that for a putative work of art to compel conviction with respect to the issue of quality or value, it had to establish itself as a compelling instance of a particular art – it had to be a good painting or sculpture, not a good work of art *tout court*, a notion I considered meaningless. The Minimalist/Literalist alternative, with its emphasis on "experience" and indeterminacy, and its substitution of "interest" for "value" or "conviction," as in Judd's statement that "a work needs only to be interesting," amounted, it seemed to me, to giving up on the idea of quality and settling for theatrical effect. Another feature of my argument worth noting, because it will be directly relevant to my account of videos by Anri Sala, is the distinction "Art and Objecthood" draws between the notion of Minimalist/Literalist presence, understood as a kind of theatrical stage presence and associated with duration (of the "experience" that in effect stands in for the work itself), and what I call presentness, a sort of virtual or metaphorical (not literal) instantaneousness, which I gloss, not wholly perspicuously, by saying of, for example, a painting by Noland or Olitski or a sculpture by David Smith or Caro that "at every moment the work itself is wholly manifest" (p. 167).

Any reader who is encountering these ideas for the first time can hardly be expected to be convinced of their rightness after so brief a summary both of the ideas themselves and of the opposing position. The important point, in any case, is that my arguments did not prevail in the world of contemporary art; on the contrary, the overwhelming impetus of new art during the 1970s and indeed the 1980s (and after, but starting around 1980 the story gets complicated in interesting ways) was nothing but theatrical in my pejorative sense of the term, to the extent that it has sometimes seemed to me that I might inadvertently have contributed to that development by providing so clear a program for an antimodernist – or as it came to be called, postmodernist – gamut of artistic practices. (Douglas Crimp's early essay "Pictures" comes close to saying as much.[6]) In any case, by the end of the 1960s I essentially stopped writing art criticism; I remained in personal contact with the artists I was closest to – for example, spending time

with Caro in his studio whenever the opportunity arose – but I turned my intellectual and writing efforts in the direction of the history of art (and the writing of poetry, but that is another story). Withdrawing from the contemporary art arena seemed the only rational course of action to take. On the one hand, there was little point in writing still another article or catalogue introduction praising the artists I had been backing since the early 1960s – doing so would have been counterproductive both for them and for me. On the other, having written "Art and Objecthood," which from the start – for reasons I understood perfectly – was the focus of boiling hostility in the art world, I did not see any point in going on about why the theatricalization of contemporary art seemed to me a thoroughly depressing development. Equally, I soon came to feel that there was an extremely important job to be done of a strictly art-historical sort, if I could bring it off – namely, to provide an account of the evolution of painting in France between the middle of the eighteenth century, the time and place when and where it had come to seem to me that modern, but not yet modernist painting first got under way, and the early 1860s, the moment of the arrival on the scene of Manet and his generation, a moment I equated (following Greenberg but on different grounds) with the emergence of modernist painting, the key works being of course Manet's *Olympia* (1863, exhibited 1865) and its even more astonishing immediate predecessor, the *Déjeuner sur l'herbe* (1862–3).

My art-historical work began with my dissertation on Manet's use of "sources" in previous painting, but I soon realized that in order to provide the sort of account of the pre-history of modernist painting that I was beginning to see was needed, I would have to retreat to Harvard's Widener Library and whenever possible the Bibliothèque Nationale and in effect make myself a *dix-huitièmiste*, an eighteenth-century specialist, a task that took several years (there was no one at Harvard who could teach me what I needed to know) but that also contained within it the glorious reward of becoming familiar with – indeed of saturating myself in – the writings of the great *philosophe* and pioneer art critic and theorist Denis Diderot, one of the most brilliant and attractive thinkers in the entire history of European culture. The result of that effort of self-education and also

of many hours spent looking at and mulling over paintings and engravings in Paris and elsewhere was my book *Absorption and Theatricality: Painting and Beholder in the Age of Diderot*, which appeared in 1980. As that title suggests, what I found when I immersed myself in the period between the mid-1750s and the early 1780s in France – roughly, between Chardin and Greuze and the advent of David, with Diderot as my principal guide to the pictorial issues at stake in their work – was the origin, the initial phase, of the antitheatrical problematic one of whose climactic episodes I myself had both analyzed and exemplified in "Art and Objecthood" and other essays of 1966–7 (I shall have more to say about one of these, "Shape as Form: Frank Stella's Irregular Polygons," further on in this book). Put slightly differently, for Diderot the contemporary renewal of painting (also of drama) as a major art depended absolutely on the ability of painters (and playwrights, actors, directors, and scene designers) to devise various means of negating or neutralizing what I came to call the primordial convention that paintings and stage plays are made to be beheld; only if that could be done would the actual beholder be stopped, held, and transfixed by the work. By the same token, the least sense on the beholder's part that the representation in question had him or her in view, that in effect it wanted something from an audience by way of response, was, Diderot maintained, fatal to its existence as a work of art. (Among his basic precepts: "Treat the beholder as if he did not exist." "Act as if the curtain never rose." "If you lose the sense of a person who is alone and one who presents himself in company, throw your brushes into the fire.") For Diderot and his contemporaries, probably the most crucial aspect of this distinction concerned the depiction of persons ostensibly *absorbed* in what they were doing, feeling, and thinking. That is, what mattered was whether or not such a figure or group of figures struck the beholder as so deeply engaged in (for example) working on a drawing, as in Chardin's *Young Student Drawing* (around 1733–8), or swearing to fight to the death for Rome, as in David's *Oath of the Horatii* (1784–5), or swooning with anticipatory grief – the women at the right of the *Oath* – that they appeared oblivious to everything else, including specifically the beholder's presence before the painting, or whether on the contrary they gave the impression of

7

8

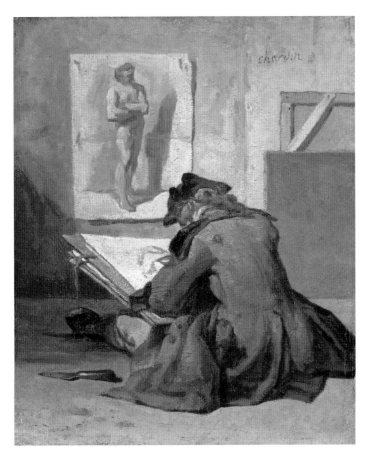

7 Jean-Baptiste-Siméon Chardin, *Young Student Drawing*, ca. 1733–8. Oil on panel,
21 × 17 cm. Kimbell Art Museum, Fort Worth, Texas.

seeking only to *appear* so engaged in order to make a particular impression on
their audience. Art of this second kind was held to be theatrical, not genuine –
for Diderot and likeminded critics an unforgivable fault. In other words, in the
course of researching and writing *Absorption and Theatricality*, I discovered that
in "Art and Objecthood" and related essays I had been a Diderotian art critic of

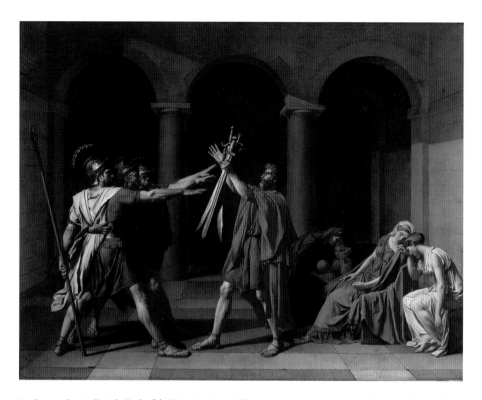

8 Jacques-Louris David, *Oath of the Horatii*, 1784–5. Oil on canvas, 329.8 × 424.8 cm. Musée du Louvre, Paris.

a particularly uncompromising stamp (no more uncompromising than Diderot, however). Before leaving Chardin and David, let me call attention to the way in which viewing Chardin's seated draftsman from the rear – his face is wholly turned away from us – in no way impedes our sense of his absorption in his task (if anything, the reverse is true). Let me underscore as well the dramatic intensification of absorption in David's *Oath*, a crucial development for the genesis of modern painting in France but one which barely more than ten years later led David himself to think that the *Oath* might have erred in the direction of exaggeration, hence of theatricality. The result of that change of perspective was his

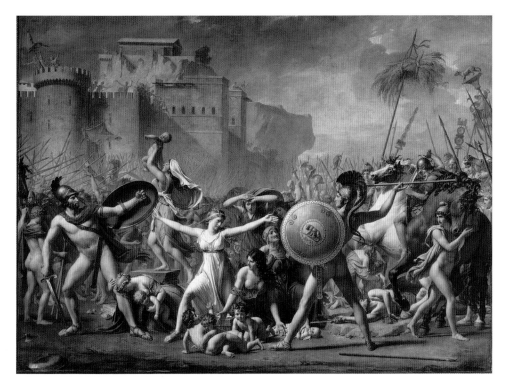

9 Jacques-Louis David, *Intervention of the Sabine Women*, 1796–9. Oil on canvas, 385 × 522 cm. Musée du Louvre, Paris.

Intervention of the Sabine Women (1796–9), a work that itself soon became almost a watchword for theatricality to later generations because it came to appear insufficiently intense, too much a matter of figures seemingly holding poses instead of being one with their ostensible actions. In short I am not talking about stable qualities here. (To be precise: what proved unstable was the effect of the works in question, not simply on the exhibition-going public but also in the eyes of David himself. The intention behind both the *Horatii* and the *Sabines*, which is also to say the intrinsic meaning of both canvases, was and has remained antitheatrical.)

I went on to write two more books, *Courbet's Realism* (1990) and *Manet's Modernism or, the Face of Painting in the 1860s* (1996), which brought my narrative of the prehistory of modernist painting to the point of crisis at which the very basis of the Diderotian project, the denial or negation of the beholder, was no longer tenable even as a theoretical proposition and at which therefore the existence of the beholder, or rather what I referred to a moment ago as the primordial convention that paintings are made to be beheld, had to be acknowledged with a new force and explicitness. This, I argued, is what takes place in Manet's revolutionary masterpieces of the first half of the 1860s such as the 10, 11 *Déjeuner sur l'herbe* and *Olympia,* in each of which a single figure, a mostly naked woman – in both cases based on Manet's favorite model, Victorine Meurent – gazes directly out of the canvas as if addressing the beholder. Yet something in the very blankness of that gaze and indeed in what I have called the radical

10 Edouard Manet, *Déjeuner sur l'herbe*, 1862–3. Oil on canvas, 208 × 264 cm. Musée d'Orsay, Paris.

facingness (also the *strikingness*) of the painting as a whole seems intended to make the beholder register, subliminally or otherwise, his or her own structurally secondary or supererogatory character relative to the contents of the image. As if "being beheld" is built into the painting from the start, in a way that places the actual beholder in an unprecedented position, ontologically speaking. This in turn means that the *Déjeuner* and *Olympia*, while wholly non-absorptive, are anything but simply theatrical in the Diderotian sense of the term.

As mentioned above, *Manet's Modernism*, the third volume in my trilogy, appeared in 1996 and it was shortly before then that I first met the photographer Jeff Wall. Before turning to photography, I need to stress that throughout the more than twenty-five years during which I researched and wrote my trilogy (also a fourth book on Thomas Eakins and Stephen Crane), I never imagined for a moment that what I was doing might bear any direct relevance to contemporary

11 Edouard Manet, *Olympia*, 1863. Oil on canvas, 130.5 × 190 cm. Musée d'Orsay, Paris.

artistic practices. Now consider this brief excerpt from a 1993 conversation between Wall and the critic Martin Schwander. The work under discussion between them, a lightbox photograph, is *Adrian Walker, Artist, Drawing From a Specimen in the Dept. of Anatomy at the University of British Columbia, Vancouver* (1992). Schwander first: "With *Adrian Walker* you made a portrait of a young man who is concentrating so intensely on his work that he seems to be removed to another sphere of life." Then Wall:

> But I don't think it is necessarily clear that *Adrian Walker* is a portrait. I think there is a fusion of a couple of possible ways of looking at the picture generically. One is that it is a picture of someone engaged in his occupation and not paying any attention to, or responding to the fact that he is being observed by, the spectator. In Michael Fried's interesting book about absorption and theatricality in late eighteenth-century painting, he talks about different relationships between figures in pictures and their spectators. He identified an "absorptive mode," exemplified by painters like Chardin, in which figures are immersed in their own world and activities and display no awareness of the construct of the picture and the necessary presence of the viewer. Obviously, the "theatrical mode" was just the opposite. In absorptive pictures, we are looking at figures who appear not to be "acting out" their world, only "being in" it. Both, of course, are modes of performance. I think *Adrian Walker* is "absorptive."[7]

As a matter of fact I had become aware of some of Wall's work, including *Adrian Walker*, by the mid-1990s and had actually wondered whether just possibly he had been reading me, but did my best to fight down that idea as improbable. Then in 1995 we met by chance at the Boymans Museum in Rotterdam and it emerged that our interests had indeed converged in this extraordinary way. From that moment on I began paying attention to what was taking place in contemporary art photography (more and more as time went by), until finally I realized – it took several years for the realization fully to sink in – first, that a considerable number of the leading figures in that domain (Wall, Bernd and Hilla

12 Jeff Wall, *Adrian Walker, artist, drawing from a specimen in the Department of Anatomy at the University of British Columbia, Vancouver*, 1992. Transparency in lightbox, 119 × 164 cm.

Becher, Thomas Ruff, Thomas Struth, Andreas Gursky, Jean-Marc Bustamante, Hiroshi Sugimoto, Luc Delahaye, Thomas Demand, Candida Höfer, Beat Streuli, Philip-Lorca diCorcia, Rineke Dijkstra, Patrick Faigenbaum, Roland Fischer, and James Welling) could be seen as pursuing a many-faceted collective enterprise best understood as constituting a new and unexpected phase of the antitheatrical (or Diderotian) tradition; and second, that precisely for that reason my art-historical trilogy on French eighteenth- and nineteenth-century painting and art criticism,

and not only that, my art criticism as well, specifically the articles I wrote in 1966–7 culminating in "Art and Objecthood," turned out to bear a surprisingly close relation to the work of the photographers I have just named. In the book on recent art photography I went on to write, *Why Photography Matters as Art as Never Before* (2008), I attempt to establish the force of these claims through intensive analyses of particular works and groups of works. What this means varies sharply from one photographer to the next (absorptive motifs are only part of the story, a fact regularly ignored by critics of that book). So for example my pages on Struth's classic museum pictures argue that the strongest and most compelling of them make visible a separation between two "worlds," that of the museum-goers and that of the paintings on the museum walls, of a sort that cannot be discerned as such in ordinary unphotographed actuality; Struth's family portrait photographs and Dijkstra's full-length portraits of adolescents in bathing suits on various beaches in the United States and Europe are described in terms of their simultaneous assertion of a forthright address to the viewer (or at least to the camera) and the consequent revelation of a host of behavioral traits that are plainly not under conscious control (and therefore are not being "exhibited" by the subjects of the portraits); my account of Gursky's work suggests that his photographs characteristically offer the viewer images that on the one hand are spectacularly open to visual inspection and on the other rebut the very possibility that they represent a point of view that could be taken up literally or imaginatively by someone standing before the photograph (I speak of this as the "severing" of his photographs from the viewer); Delahaye's large-scale panoramic photojournalistic pictures are understood in dialectical relation to Gursky's work, sharing with the latter a "disappearing" of the photographer but aiming, unlike Gursky's photographs, at a virtual merging of viewer and depicted scene (ideally, of viewer and world), a state of affairs that carries antitheatrical implications of an opposite sort; my commentary on Höfer's rooms and interiors emphasizes the extent to which the viewer is "excluded" from those spaces, a claim I also make about Struth's "Paradise" series and Sugimoto's Seascapes; and Demand's photographs of full-size cardboard reconstructions of real-world places and things are interpreted as allegories of intention, that is, images every detail and feature of which must be

regarded as the product of a specific intention on the part of the sculptor/photographer – a reading which of course places them at the farthest pole from the indeterminacy of Minimalism/Literalism. Finally, the magnificent Typologies of Bernd and Hilla Becher are seen in terms of a project they call "complet[ing] the world of things," which I understand as a making manifest of the conditions of genuine object-specificity, or, as I also call it, "good" objecthood, the distinction between "good" and "bad" modes of objecthood lying beyond the scope of the pre-art-photographic argument of "Art and Objecthood."

Naturally I do not pretend that so brief a summary of some of the readings in *Why Photography Matters* is adequate as it stands, and can only refer the reader who wishes to know more to the book itself. However, one additional point needs to be made: if one looks closely at Wall's *Adrian Walker* one will see that Schwander's claim that the young man "is concentrating so intensely on his work that he seems to be removed to another sphere of life" goes too far. The more attentively one gazes and reflects the clearer it becomes that the draftsman had to have been aware of the presence of Wall's camera, and indeed the more finely one examines his facial expression and bodily attitude the more restrained – that is, the less obviously absorptive – they come to seem. As Wall later explained (in an interview), there was in fact a real Adrian Walker, who was a draftsman and who made the drawing on his drawing board in the laboratory specified in the work's title, but the picture

is also a re-enactment, by the artist in the picture, of his own practice. That is, he and I collaborated to create a composition that, while being strictly accurate in all its details, was nevertheless not a candid picture, but a pictorial construction. I depicted the moment when he has just completed his drawing, and is able to contemplate it in its final form, and, once again, at the same time, to see its subject, the specimen, the point from which it began. [Note Wall's careful wording: the draftsman "is able to contemplate the drawing in its final form"; nothing is said about the draftsman being lost in contemplation, which he clearly is not.] There was such a moment in the creation of his drawing, but the moment depicted in the picture is in fact not that moment, but a re-

enactment of it. Yet it is probably indistinguishable from the actual moment. [Such a picture, Wall elsewhere explains, is an example of what he calls "near documentary."] (p. 41)

My own term for this aspect of Wall's art – its insistent if sometimes extremely subtle acknowledgment of its own constructedness and artifactuality – is "to-be-seenness" (hereafter I will dispense with the quotation marks), and I understand the latter condition as a hallmark of the work of all or almost all the photographers discussed in my book. Put slightly differently, the resort to absorptive themes and motifs in Wall's photographs – and in those of other important photographers such as Struth, Faigenbaum, Delahaye (in *L'Autre*, a book of close-range photographs of passengers on the Paris Métro made with a hidden camera), Streuli, and diCorcia, to mention only figures discussed in *Why Photography Matters*) – goes hand in hand with a heightened though still in a sense implicit (not that the implicit/explicit opposition is very helpful here) address to the viewer, which is to say that the issue of antitheatricality receives a new, less all or nothing inflection than in the absorptive painting I wrote about in *Absorption and Theatricality*, even as absorption as such continues to work its apparently timeless magic (which is why Schwander's remarks are not simply mistaken). Will the magic go on forever? I broach this question in Postscript 2 of the present book.

So much by way of setting the scene for the essays that follow. Now I want to say something about my reasons for writing those essays and for bringing them together in a short book.

The basic idea is that writing *Why Photography Matters*, or perhaps more accurately my engagement with ambitious art photography over the past not quite fifteen years, has had the result of alerting me to a wider range of artistic possibilities than I had previously been able to take fully seriously. That is, there is a sense in which my early commitment to a particular canon of high modernist painting and sculpture, once Minimalism/Literalism and its successor movements had carried the day, left me stranded in a corner, one that I saw no way of escap-

ing short of relinquishing a set of core values and beliefs that remained, for me, inviolable. Not that I wholly failed to grasp the considerable interest of certain other developments in this country and abroad. But given my basic orientation, I saw nothing which, to use a hackneyed but nevertheless indispensable phrase, compelled my conviction as art to the extent that my initial canon by and large continued to do. My involvement with art photography changed all that, not just with respect to photography but also as regards work in other media (in fact in *Why Photography Matters* I discuss Streuli's videos and Douglas Gordon and Philippe Parreno's film *Zidane: A Twenty-First Century Portrait*). For what it is worth, my sense of things is not so much that I have finally found a way out of the corner to which I was so long and so frustratingly confined as that over the past three decades photography and certain other developments have reconfigured the room; in other words, it is perhaps less a matter of my finally having shifted my orientation (though of course I have, as will become clear in the pages that follow) than of the basic circumstances having become transformed along parameters that have brought them into closer alignment with the views that inspired my early art criticism. I admit that throughout the 1970s and '80s and on into the '90s I never imagined that this might happen – I had lost faith in the dialectic, one might say. That turns out to have been a mistake.

Put slightly differently, this is a book about four artists – a video artist (principally), a sculptor, a painter, and whatever it makes sense to call Douglas Gordon (a video artist certainly, but what else? a deconstructor of movies? a Post-Conceptualist *bricoleur*? a Scottish fabulist in the tradition of James Hogg?) – each of whom has found a way or indeed more than one way to engage meaningfully and at times profoundly with at least some of the issues outlined in the preceding pages (plus another issue, embedment, a particular preoccupation of Charles Ray). Their collective achievement, let me be clear, amounts to something other than a simple return to modernism, as if all that took place artistically and otherwise during the intervening decades could be discounted or ignored. Nevertheless, that the videos, sculptures, and paintings I am about to consider imply a repudiation of the facile rejection of modernism that has marked much of the most fashionable art and theory of that period is also beyond doubt.

I would like to say: Sala, Ray, Marioni, and Gordon seek in different ways to pursue the ultimate stakes of serious art – to attach us to reality. Modernism from Manet onward aimed at nothing less, under conditions it knew to be unpromising. Presentness, antitheatricality, and – as will emerge – embedment concern nothing else. (Stanley Cavell in *The World Viewed*: "Then the recent major painting which Fried describes as objects of *presentness* would be painting's latest effort to maintain its conviction in its own power to establish connection with reality – by permitting us presentness to ourselves, apart from which there is no hope for a world."[8]) I had already drafted these sentences, and chosen the citation from Cavell, when I came across the following from Sala in conversation with Lynne Cooke:

> I started to get interested in something bigger than the image, something that prints the image rather than something that is printed in the image – something that answers to a necessity, an urgency, a drive that enables you to set up the world again through an image, even if for only one minute. Such precise moments make you feel right; they make you feel connected.[9]

Do we take him seriously or not? If not, why not? Because it is inconceivable that a mere video – a mere work of art – could accomplish as much ("set up the world again, even if for only one minute")? Then why pretend to care about art at all if it is merely a matter of playing trivial games among the ruins? Or for that matter anxiously but in the end futilely tending to its so-called criticality? Or – the list could go on and on. Here it may be helpful to explain how I came to be interested in the four artists I am about to discuss.*

*Before moving on, though, I want to illustrate a work I greatly admire by an artist already mentioned several times which I see as answering to Sala's remarks, Luc Delahaye's *A Mass Grave Near Snagoro, Bosnia* (2006), a large color photograph of four workers from the International Center for Missing People systematically digging up the grave and recording its contents. Eighty bodies were found there, all victims from Srebrenica. As certain of Sala's videos also make clear (e.g. *Time after Time* [2003], to be discussed briefly toward the end of this book), feeling "right" and "connected" in his sense of those notions is not always (is never essentially) a matter of feeling "good."

13 Luc Delahaye, *A Mass Grave Near Snagoro, Bosnia*, 2006. Digital chromogenic print, 300 × 180 cm. © Luc Delahaye / Galerie Nathalie Obadia.

Anri Sala first: as I shall spell out shortly, I encountered his 2005 video *Long Sorrow* in the Marian Goodman Gallery in New York in the spring of 2007. I found it gripping, then spellbinding, then food for intense thought, and when several months later I moved temporarily to Berlin, I made contact with Sala, who had been living there for some time. This led to an ever greater familiarity with his work (also with his thinking, naturally), a familiarity further advanced by my attendance at subsequent exhibitions at Hauser and Wirth in London, the North Miami Museum of Contemporary Art, the Contemporary Arts Center in Cincinnati, and Marian Goodman in New York. Quite early on I became interested in writing about his art, and indeed contributed a short text on his 2007 video, *After Three Minutes*, to the Miami/Cincinnati catalogue (that text is in

effect subsumed in the first chapter here). I already know that I shall have more to say in print about Sala's work in the future.

It was Charles Ray's idea that he and I should meet; as will emerge in chapter two, Ray has always been deeply interested in the work of Anthony Caro, and it was my decades-long closeness to Caro that led him to think of exploring the possibility that he and I might have something worthwhile to say to one another. We met for the first time in Los Angeles in the spring of 2003, and quickly discovered that talking sculpture together came easily. We decided to stay in touch, and several years later I agreed to conduct a series of long conversations with him in order to produce a written text of excerpts from the latter to appear in a catalogue published by his New York gallery, Matthew Marks.[10] During these years too I made myself familiar in a first-hand way with much, though unfortunately less than all, of his oeuvre, in part through trips to Los Angeles to see work in progress in his studio and on view in Regen Projects (his gallery there), in part by visiting museums and collections in the United States and abroad where pieces by him were on display, and became convinced, at first with a certain surprise, that Ray is an artist of tremendous originality, one in whose seemingly unconstrained imagination the future of the art of sculpture is being reconceived.

My initial exposure to Joseph Marioni's painting I owe to an old friend, Carl Belz. In 1998 Belz, then the director of the Rose Art Museum at Brandeis University, gave Marioni a large survey exhibition of his work since 1970; this was Belz's valedictory show, and a stunning farewell it was.[11] Belz believed strongly in Marioni's art and wanted me to see it. He also suspected that simply urging me to fly to Logan Airport and take a cab to Waltham, Massachusetts, might not succeed in rousing me from my desk, so he cleverly invited me to read my poetry in the museum (he described this as making me an offer I could not refuse). I accepted, came, read my poems, went through the exhibition, and was immediately convinced by what seemed to me, as it earlier had to Belz, the extraordinary quality of Marioni's color-oriented art. I was also, I wrote soon after, somewhat confounded by the fact that I had responded powerfully to what were, no getting around it, monochromes, a genre of abstract art that had never previously

attracted me. On that occasion, too, I met Marioni; quickly we became friends, and during the more than a dozen years that have gone by since that first encounter we have spent countless hours looking at art together both in New York, where he has a studio, and elsewhere. As for his own painting, there is no body of contemporary work I have looked at more closely or with greater pleasure during that time.

Finally, Douglas Gordon. The key event was simple. One day in March 2003 I was going around the art galleries in New York's Chelsea and found myself in front of Gagosian on East 24th Street. Now if someone had come up to me at that moment, some friend, say, who knew my tastes and biases, and had said, "You're about to see a video projection in which an elephant starts out on the ground and then gets up and then lies down again and then gets up, and you're going to find yourself totally enthralled by it to the extent that from this day forth you will do everything within your power to see other works by the artist who made it," I would have been prepared to bet the contents of my wallet (nothing very impressive, I admit) that that was out of the question. A video of an elephant? Lying down and getting up? Well, yes. Shortly after that I visited a retrospective exhibition of his work curated by Russell Ferguson at the Hirshhorn Museum, and was even more impressed; this led, thanks to Ferguson who brokered an introduction, to getting to know Gordon personally, first in New York on the occasion of a subsequent retrospective at the Museum of Modern Art (2006), then in Edinburgh at an even larger one (2007), and finally during my year in Berlin, where Gordon now makes his home. My impression is that there exists a consensus among contemporary followers of advanced art that Gordon is some sort of genius, but when I press them to say what this might mean – in exactly what his alleged genius consists – they tend to look somewhat blank and then change the subject. I would like to think that chapter four bears on that question.

one: presentness

ANRI SALA

Anri Sala was born in Tirana, Albania, in 1974. He attended art school in Tirana and then, from 1996 to 1998, the Ecole Nationale Supérieure des Arts Décoratifs in Paris where he studied film and video. Between 1996 and 2005 he lived in Paris (French critics tend to think of him as their own) but in 2005 he moved to Berlin, where he lives today. In 1998, while still a student, he made a dazzling and deeply thoughtful short film, *Intervista* (*Interview*), which went on, deservedly, to win various prizes. A brief summary might go like this: *Intervista* begins with Sala coming across a reel of old 16-mm film, which turns out to be news footage from 1977 in which his beautiful mother Valdet, at that time 32 (she looks younger), first appears at a meeting of the Albanian Youth Congress by the side of the Com-

14

munist dictator Enver Hoxha and then gives an interview to the press. However, the film lacks a sound track and Sala shows astonishing resourcefulness, first seeking out the man who originally recorded the sound (which remains lost) and then bringing the film to a school for the deaf and dumb where a student assisted by a teacher provide the missing words. The rest of *Intervista* consists in Sala's showing the film with added subtitles to his mother, who at first is confounded – literally incredulous – that she ever uttered the political banalities that she is revealed to have spoken. (This hardly does justice to the full, moving, beautifully filmed exchange between mother and son.)

The point of the foregoing, however, is not so much to justify my praise of *Intervista* as to call attention to one of the chief concerns of Sala's work, the relation of image to sound, which in many of his videos are treated as essentially autonomous elements that nevertheless – or rather, by virtue of that autonomy – are made to articulate each other in fascinating and productive ways. So for example in *Mixed Behavior* (2003), shot in Tirana on a New Year's Eve, a lone disc jockey stooping under a plastic sheet on a rooftop under steady rain plays records to an invisible audience as fireworks explode and fall (and, unexpectedly, reverse themselves) in the night sky; while in *Air Cushioned Ride* (2006), shot from Sala's car at a roadside rest area in Nevada as he continuously circles a number of huge parked trucks (others come and go in the course of the work), a station on his car radio playing Baroque music and another station devoted to country and Western regularly (and finally predictably) interrupt one another

14a– d Anri Sala, stills from *Intervista*, 1999. Video projection. Color, stereo sound, screen dimensions variable, 26 min.

owing to the blocking wall formed by the trucks, a natural phenomenon known both as cross-modulation and as spurious emission. Indeed a subsequent video, *A Spurious Emission* (2007), shows a group of professional musicians and a singer performing the sound track of *Air Cushioned Ride*, which Sala had had scored by a composer, in a studio, effectively relocating the source of the music within the image instead of, as in the original video, *hors cadre*, in the "surround." Finally, a recent work, *Answer Me* (2008), filmed in the geodesic dome of a listening station in Berlin from the Cold War, features two characters, a woman who urges a man to answer her (their relationship appears to be at a crisis) but his reponse is simply to play aggressively on a set of drums, the sound of which reverberates deafeningly throughout the high, curvilinear space which one senses more than actually sees. The origin of the sound is thus both within and outside the image at the same time. It goes without saying that Sala is not the first video artist to conceive of the relations between image and sound in these or similar terms. But he is particularly ingenious in his treatment of that relation, nowhere more so than in the first of the three works I want to discuss in this essay, *Long Sorrow* (2005). The title comes from the nickname (in German *langer Jammer*) given to an extremely large and famously drab apartment block in Märkisches Viertel, an area in Berlin near where the Wall used to be.

15-27

I shall not say anything more by way of anticipation except that the duration of the video is thirteen minutes. Thanks to Sala, it has been possible to provide a version of the video on the DVD included with this book. I would now like the reader to play it from start to finish.

I don't believe this!

It was real Anri,
because we were building.

I deliberately did not mention in the lead-up to the video that it features the noted "free" or improvisatory saxophonist, Jemeel Moondoc, because I did not want to predetermine the reader/viewer's experience of the opening few minutes, during which a movie camera located in a bare room in an apartment advances slowly toward a window at the bottom of which, seemingly between the sill and the partly open horizontally pivoting main window unit, indeed seemingly just outside the window (but as if tucked back within it, almost as if left behind on the sill), there rests or hovers something rounded, dark, and shiny that cannot quite be identified (at first we think: some sort of abandoned fruit?), something, as the camera gets closer, we see is entwined with leaves and one or more white flowers, something that finally is observed to move, and not only that, to move in apparently motivated relation to the sounds of somewhat disjointed (and at

15–27 (*this and following pages*) Anri Sala, stills from *Long Sorrow*, 2005. Super 16 mm transferred to video projection. Color, stereo sound, screen dimensions variable, 12 min., 57 sec.

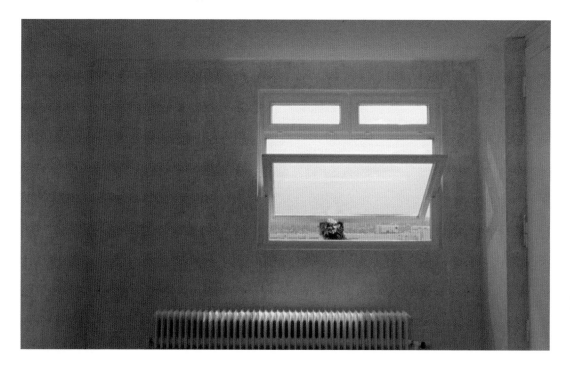

first notably cool) saxophone playing that we have been hearing from the outset . . . until we realize – this takes about two and a half minutes but feels longer – that the object must be, that it is, the head, seen from behind, of a musician playing the saxophone, and that the musician has somehow been suspended outside the window (outside the room, apparently high above the ground: all this while we have been looking out at sky, and, lower down, at buildings and trees some distance away). As the music continues the camera keeps coming closer, continually reframing the window (the interior of the room seeming to darken slightly in contrast as it does so) and bringing the outside scene into sharper focus; the saxophonist's head moves more freely (we recognize dreadlocks and conclude that he is black); until just after four minutes into the video, following a brief silence, he breaks into voice improvisation as well (the initial effect of his strange yelps and cries is jolting; from here on he will shift back and forth between saxophone and voice, sometimes as in call and response). By this time the window largely fills the screen, at some point we have become aware of distant traffic noises (also children's voices), and then at almost exactly five and a half minutes

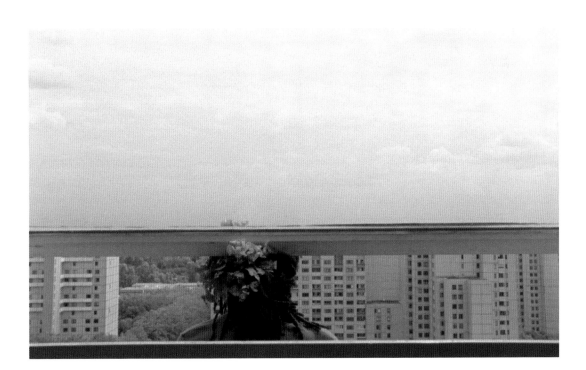

church bells begin to ring (it must be Sunday) and very quickly the saxophonist begins to respond to them on his instrument, at once confirming and filling out our sense of his relation to his situation. This goes on for more than thirty seconds and then, without warning, at about six minutes the scene shifts from interior to exterior, and from a vantage point off to the side the camera shows us two long wooden supports protruding from the building above the top-story window from which powerful lights have been hung to illuminate the action (even though it is broad daylight) and also, toward the bottom right of the screen (it takes a moment to register this), the head of the musician and, for the first time, a glimpse of his saxophone (the top several inches anyway). Then at around six and a half minutes the camera cuts to a close-up of the player in profile, and from then on until toward the very end the camera stays with him, for the most part outside and – except for a stretch of about a minute, during which we are shown him from the front (but even then we are not shown his hands or his body below the chest) – at extremely close range, never giving us the whole of his face but only part of it at any one moment (indeed at moments we are only shown a bit of his forehead

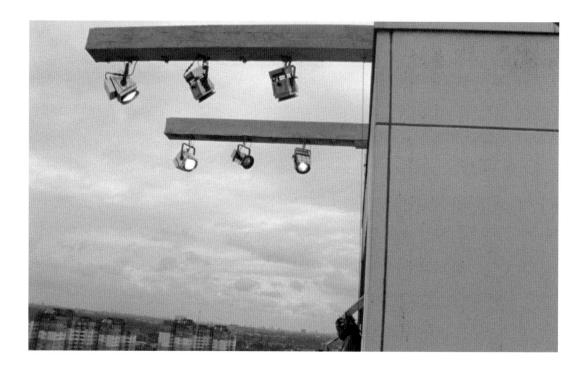

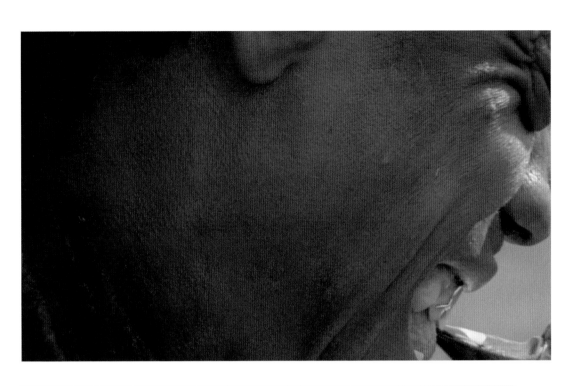

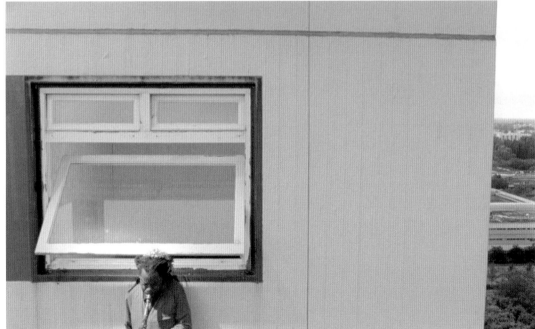

or cheek or hair with its floral decoration) and never disclosing more of his instrument than is necessary for us to understand the effort he is making (basically we are shown only the mouthpiece), until finally at nine minutes we are back in the room and looking down now past his head at the ground and traffic below so that for the first time we are able to appreciate just how high up he must be – eighteen floors, as it turns out. (The play of traffic reflections in the tilted window unit is brilliant, and requires effort to understand. That abrupt shift of perspective prepares us for the end of the video, which is still some time away.) Around nine and a half minutes we are once more outside: the playing becomes increasingly intense, the camera seems to move to within a few inches of the musician's face (in fact this is done entirely optically; the camera never comes nearer to Moondoc than fifteen or twenty feet, but the effect is of the sheerest proximity), we see, we virtually feel, the intensity of his effort, repeatedly we find ourselves looking directly at his eyes, which mostly look down or actually shut but at moments open wide (when they do they often seem to glance or roll upward), also at the space between them, at his frowns and other changes of expression, at

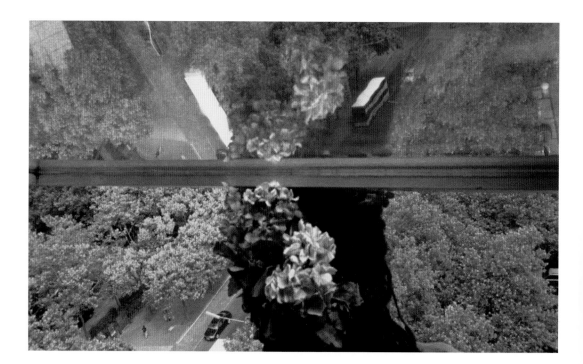

the imperfections in his skin (we are definitely closer than we want to be); again the musician breaks into voice; at not quite eleven and a half minutes we focus (at first blurredly) on his hair and the flowers twined in it, the playing becomes plaintive, then at 11:40 we are back inside and looking down as the player's head starts drifting away to the lower right, then we are outside again and we follow the head as it descends toward the right still playing, sharpest focus being reserved for the trees below with their leaves moving in the wind. The unmistakable impression conveyed by the music is of sadness and regret that something is coming to an end. Or simply of loss. (About the fiftieth time I watched this I thought to myself: Orpheus. And from Simone Weil: "La grâce, c'est la loi du mouvement descendant."[1]) The whole sequence is lyrical, almost dreamlike, until at twelve minutes the music stops. We are given an outside view of the apartment building with the klieg lights still on. We hear another snatch of playing, distant now. Around 12:35 the scene shifts to another view of the building and lights as, in the sky beyond, a passenger plane approaches silently from the left and disappears behind it; one's associations with this are unavoidable and are clearly

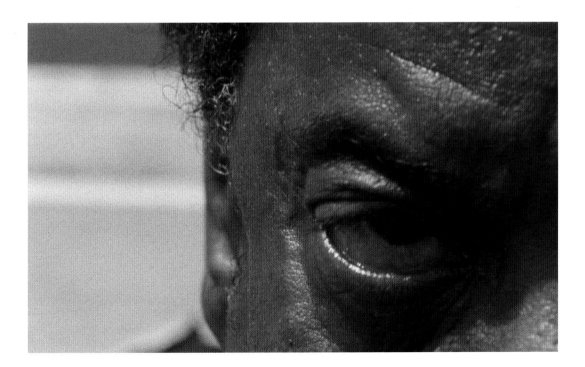

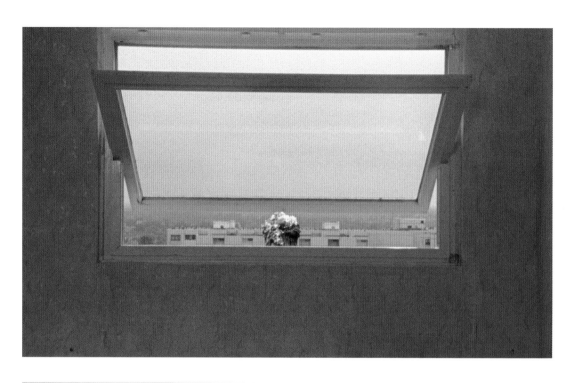

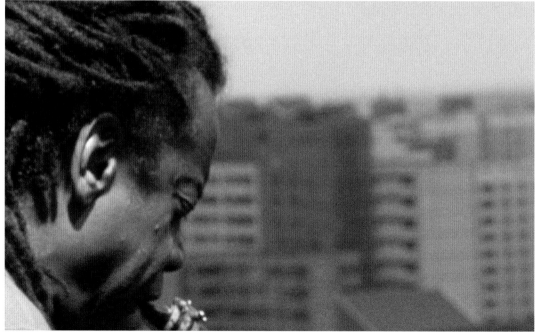

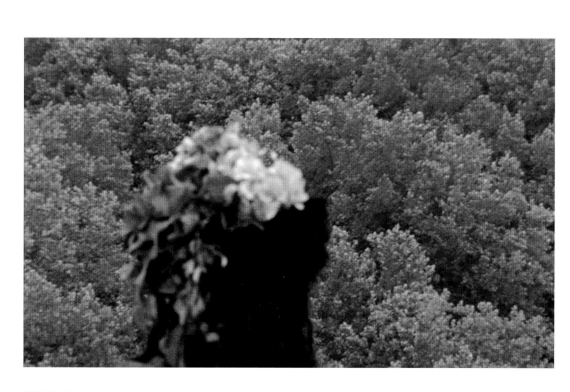

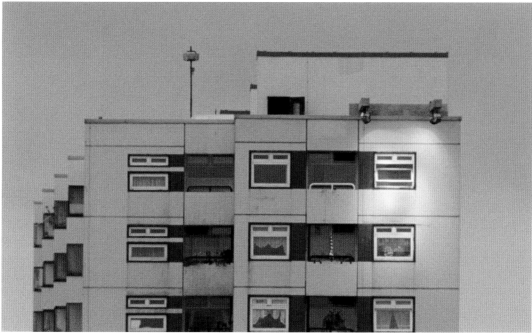

accepted by the artist, who moreover underlines the flight of the plane with a single held note on Moondoc's saxophone. (An extraordinary detail: it is not as if we are invited to imagine that the note is a response to *his* sight of the plane, along the lines of his playing throughout most of the video. How are we to understand it then? I shall come back to this.) Finally there is a distant view of the building complex and the surrounding neighborhood with the klieg lights still on. At thirteen minutes almost exactly the video is over.

The question now is what to make of *Long Sorrow* as I have described it. Let me go for six main points:

(1) The first thing that struck me about *Long Sorrow* when I first encountered it at the Marian Goodman Gallery – I came upon it when it was perhaps two-thirds of the way along – was the saxophonist's seemingly total absorption in his playing. This was the point in the video when the music was at its most intense; it may have been fortunate for me that I walked in on it just then because it made the dual issue of absorption and to-be-seenness immediately palpable. There was, I felt in the moment, no question as to the authenticity of the saxophonist's engagement in what he was doing: it seemed inconceivable that he was merely

mugging for the camera, or that the sounds I was hearing could have issued from any other source than his efforts, though of course that was altogether within the realm of technical possibility. In other words, within a very short time – just a few minutes – I had formed the conviction that I was seeing still another work – not a still photograph but a video – in which a protagonist's absorption was thematized in a way that activated, brought into play, an entire tradition of representation that went back to the middle of the eighteenth century in France if not indeed earlier.

(2) At the same time, the camera (I am still talking about my first few minutes in front of *Long Sorrow*) could scarcely have been more active. In fact I soon realized that I was being allowed only glimpses of the player's mouthpiece, never of the whole instrument or even of his fingers pressing the keys, and only fractional and decentered views of his face from extremely close range (his lips, his teeth, his cheek, his brow, his eyes, his hair, his skin), as if the camera were intent not only on reducing to an absolute minimum the physical and so to speak the psychical distance between itself and its subject but also of asserting its own priority, one might almost say its willfulness, in relation to the viewer. More broadly,

the viewer of *Long Sorrow* is from the first made continually aware of the choices and movements of the camera, starting with its slow traveling shot *en avant* – recalling Michael Snow's classic avant-garde film *Wavelength* (1967) – toward the window and the unidentified object half-upon, half-just beyond the sill (I should also acknowledge the presence of the Minimalist object-like radiator below the window), continuing through its subtle reframing of the window toward the close of that shot, its shift to outside the building, its unpredictable leaps from one viewpoint to another, reaching a peak of activity, seemingly in the saxophonist's face, precisely in the portion of the video I had walked in on. Not surprisingly, I understand Sala's emphasis on the activity of the camera as an assertion of what in connection with Wall's *Adrian Walker* in the Introduction to this book I called to-be-seenness, the difference being that in that photograph what is subtly thematized is the fact that the subject has been posed by the photographer (that the photograph is in essential respects a construction) and that in the video the viewer is made continually aware that he or she is permitted to see only and precisely what the camera – which in the end obviously means the maker of the video – allows to be revealed. The question that now arises is how that emphasis on the camera relates to the viewer's conviction (I am speaking for myself but I hope others will agree) of the saxophonist's – Moondoc's – absorption in his playing. The answer I want to propose is that not only does the viewer's moment-to-moment awareness of the camera's seemingly arbitrary jumps and drifts and deflections not come between him or her and Moondoc and his music, it is rather that one's conviction of Moondoc's total engagement is made the more intense by the fact of its being presented in so fragmentary, willful, at times even frustrating a manner. Put slightly differently, my personal sense is that no calmer, steadier, more seamless and comprehensive mode of presentation could have yielded a comparably persuasive account of Moondoc's performance as a whole. If this is correct, how is it to be understood?

(3) Here one has to consider the larger situation in which Moondoc has been placed: he is standing facing outward on a smallish platform (which we viewers

are never shown; in addition, he was restrained for safety from behind) many stories in the air, and – it turns out – required to improvise on the saxophone in response to his surroundings. In other words, the circumstances are anything but ordinary, and it would be astonishing if Moondoc as we see him throughout the video were not in a state of some anxiety, or at least if any weakening of his own concentration on his playing were not likely to have disorienting consequences. (In fact the video was shot in Super 16-mm movie film and then edited digitally. For the thirteen minutes of *Long Sorrow* Sala shot perhaps five hours of film in ten-minute reels over five days. The sound was recorded separately but in real time.) "From the very beginning," Sala remarks in a published conversation with Hans Ulrich Obrist,

> I had in my mind a weird presence caught in between the sill and the pane of a window, a presence that in the beginning looks like something left behind, but then with time the viewer would realize that this something is alive. What might look like a forgotten plant behind a window of an empty apartment is instead the head of a musician who is improvising free jazz while suspended outside, groundless, in a vertigo situation. I wanted someone to improvise free jazz in the void, somebody for whom music is not only an ongoing concilia- tion with emptiness in life [let that go for the moment] but is also what keeps him together, while being suspended outside the eighteenth floor.[2]

In other words, Sala deliberately placed Moondoc (with the musician's consent, naturally) in a highly stressful situation, one that the viewer is made – not quite to share, that would be to go too far – but at any rate to register in an intensely empathic, almost kinesthetic way. What is truly noteworthy is that this is done without ever revealing the basic, engineering facts about that situation – indeed we do not even get to see the larger context of the building and its setting until the last few seconds of the video, by which time Moondoc is gone and the camera unit as well. (In effect, only the lights remain.) Here it is hard to know whether what makes this empathic response possible are certain technological features of

the medium (if so what exactly are they?) or whether, more simply, but in the end more mysteriously, the decisive factor is the artist's ability to use film, sound, and editing in a way that at every instant leaves no room for doubt in the viewer's mind as to the veracity, the actuality, of the state of affairs which *Long Sorrow* purports to depict. This is how I understand the activity of the camera at its most intense and invasive, the viewer registering it as motivated at once by the double project of violating Moondoc's private space as if in a constantly renewed attempt to break his concentration and thereby of demonstrating that even under so extreme a goad not the least trace of distraction, not even for a split second, is there to be observed. The movement of the camera away from Moondoc's face, notably to his hair and the flowers in his hair, can seem to express that determination in hyperbolic form, as can the extreme close-ups dwelling on the imperfections in his skin – as if the evidence of less than total absorption might somehow leak from his pores. At the same time, one has a sense of the camera coming progressively to share or catch Moondoc's improvisatory fervor, in effect doubling and then redoubling the intensity of his playing in sheerly visual terms. No doubt, too, it matters in ways we cannot gauge that no less than six spatially separated microphones were used to record Moondoc's playing – also certain outside noises – including one inside his saxophone.

More broadly, the video medium in Sala's hands turns out to have a formidable ability to evoke, to make present, what is offscreen, *hors cadre* – what belongs to the encompassing visual and aural environment of the image on the screen – and although that ability is by no means foreign to traditional cinema, on the contrary one might even say narrative cinema depends on such a power of implication, it would be altogether remarkable to find a movie the action of which, as in *Long Sorrow,* continually depends on that for its grippingness. (It helps that the entire video is only thirteen minutes long.) Considered in this light, the camera and the cameraman, or rather the team, including Sala, in their pod at the top of an enormous crane become just another feature of the environment that Moondoc has to overcome – more accurately, that he has to "transcend" –

in and through the act of improvisation. He himself has spoken of the need he felt "to be totally drawn into the music to forget my situation,"[3] which is surely apt, as long as we understand that forgetting his situation was at the same time and by its very nature a matter of converting that situation into music. This is the significance of the extraordinary stretch when church bells suddenly ring out and Moondoc almost at once begins to answer them: it is precisely then that we first fully grasp what is going on, though doubtless "fully" should be in scare quotes: we have still not got outside the room, much less taken in the vertiginousness of the basic *dispositif*. It is what is equally explicitly at stake when the camera zeroes in on Moondoc's eyes, which even when they look up – at which instants they cannot have been literally unseeing of the filmic apparatus – convey not the least hint of diminished concentration on his playing. On the contrary, the music is then at its most intense, as – we are made to feel – under those circumstances it would have to be in order to maintain the level of engagement that we find ourselves witnessing.

(4) I said in connection with Sala's *Intervista* that virtually all his work is marked by an interest in the relation of image to sound (or image track to sound track), and *Long Sorrow* is no exception. In *Long Sorrow*, as we have seen, the manifest or say ostensible link between image and sound is provided by Moondoc, as he fulfills the task assigned to him by Sala of improvising in the face of his extreme circumstances – as though his commitment to his playing, not to mention the use from time to time of his own voice, has the further, "structural" rationale of keeping image and sound together, of continually motivating each in relation to the other. (The moments of voice suggest that the point of linkage has suddenly migrated to inside his body, so to say in his throat.) The advent of the church bells, a sonic event based in the *hors cadre*, threatens to mark a break in this, but almost instantly Moondoc's inspired incorporation of the bells in his performance restores the status quo. It goes without saying that no such incorporation would have been possible had Moondoc been following a score rather than improvising; more broadly, it is the project of improvisation that under-

writes the moment-to-moment intensity – the sustained effect of present-tense motivatedness – that marks Sala's video from first to last.

(5) It is here that the highly charged distinction between presence and presentness, first drawn in "Art and Objecthood," comes into play. In the Introduction to this book I quoted my claim in that essay that with respect to a high modernist picture by Noland or Olitski or a sculpture by David Smith or Caro "at every moment the work itself is wholly manifest."[4] This by itself has no clear application to *Long Sorrow* for the simple reason that the latter is a work that reveals itself in time, but then I go on to say that presentness "amounts, as it were, to the perpetual creation of itself," a claim that is meant to hark back to the short passage from Perry Miller's *Jonathan Edwards* that I took for the epigraph of my essay:

> Edwards's journals frequently explored and tested a meditation he seldom allowed to reach print; if all the world were annihilated, he wrote . . . and a new world were freshly created, though it were to exist in every particular in the same manner as this world, it would not be the same. Therefore, because there is continuity, which is time, "it is certain with me that the world exists anew every moment; that the existence of things every moment ceases and is every moment renewed." The abiding assurance is that "we every moment see the same proof of a God as we should have seen if we had seen Him create the world at first." (p. 148)

I do not pretend that my account in "Art and Objecthood" of the presence/presentness distinction is transparent, or, even less, that I was in control of all the implications of my epigraph (fortunately I did not ask that of myself in order to feel justified in appropriating it), but I now want to suggest that something like presentness, precisely in the sense of a perpetual creation of itself at each successive moment, may be seen as being at stake in Moondoc's playing – more precisely, in Sala's presentation of his playing – in *Long Sorrow*. (This is the implication of my remarks about *Long Sorrow*'s "moment to moment intensity"

and "sustained effect of present-tense motivatedness." Sala's videos invariably convey the sense of taking place *in the present*, as opposed to the implied pastness of traditional narrative film. I touch here on another specific faculty of video as a medium, one that emerges with special force in Sala's work.)

Now consider the following statement by Sala in the same interview with Obrist cited earlier:

> I'm interested in sounds as they become music. *Long Sorrow* shows the mouth and not the saxophone. Although what one hears makes one "see" the sax, what one really sees is a mouth and a face [only at moments and only in fractions, I want to add]. Watching a mouth move and produce sax sounds fictionalizes the whole thing because a segment in the line of production is missing. It's never music as a final product, finished and available, that interests me, but music while it becomes, captured on the fly, before it reaches us for our pleasure. So that's why I film the part where the mouth touches the beginning of the saxophone, instead of the end of the saxophone and the beginning of the music. What interests me is this matter of air that becomes music. It's like filming the very moment, the fraction of the second, when it becomes music. It's like filming the intention, the need for music, rather than the music itself, the very fraction of a second when sound is still an activity and not music yet. I don't know how to explain it. Does it make sense? (pp. 21–2)

Obrist replies, "It's beautiful, yes." I would like to say, it makes superb sense above all within the framework of the issues I have been pursuing. As in the case of Thomas Demand's photographs analyzed in *Why Photography Matters* and discussed briefly in the Introduction, *Long Sorrow*, understood in these terms, thematizes intention – which is to say determinacy versus indeterminacy – with a vengeance. (Something similar will turn out to be true of a recent sculpture, *Hinoki*, by Charles Ray.) In this connection it is striking, to say the least, that Jennifer Ashton, in the last chapter of a brilliant book on modernist and postmodernist American poetry and theory, glosses Edwards's claim (in *The Great*

Christian Doctrine of Original Sin Defended) that the world's "existence in each successive moment, is altogether equivalent to an immediate production out of nothing" in terms of divine intention as opposed to a (materialist, Literalist, one might also say Minimalist) logic of cause and effect. This leads her to cite my epigraph (more broadly, her view of modernism is explicitly aligned with "Art and Objecthood"'s throughout her book), and to write: "To turn [Edwards's] idea around: that the world 'exists anew every moment' is what makes it an expression of intention as opposed to any series of effects that might or might not follow from it." As she also states: "In short, what distinguishes the presence of meaning/intention from any succession of effects is, finally, what distinguishes art from objects for Fried and divine from human knowledge for Edwards. Put in terms of the . . . conclusion of 'Art and Objecthood,' 'Presentness is grace'."[5] If my observations and arguments in the preceding pages are to the point, nothing less than all this is manifestly at stake in Sala's video.

(6) I do not feel that it is necessary to go on at length about the relation of *Long Sorrow* to previous works in the absorptive tradition. But consider: *Long Sorrow* opens with a slow traveling shot toward what turns out to be a saxophonist facing away from us, a denouement that recalls the basic structure of Chardin's *Young Student Drawing* (a student with his back toward us sitting on the ground copying a drawing) even as it radicalizes that structure by locating Moondoc outside the room, indeed outside the building, thereby providing a greater challenge for empathic projection (in the absence of his playing no such projection would be conceivable). The climactic intensification of both image and music in the portion of the video I walked in on at Marian Goodman might be compared with the becoming-dramatic of absorption that takes place in David's *Oath of the Horatii*, though of course in Sala's video there is no equivalent of the complex historical narrative in the painting. There is, however, as already noted, the airplane flying "into" the building, an image which cannot be thought innocent of the events of 9/11 and their aftermath, all the more so in that Sala himself can be understood as taking full responsibility for the held-note accompaniment in the sound track; it is he and we who register the plane, not, we are led to infer, the

departed Moondoc, whose point of view at that moment would be quite other. No doubt, too, there are "historical" implications to Sala's choice of the vast, somewhat notorious *langer Jammer* public housing project as a setting for the video, not to mention the very fact that the city is Berlin. Plus there is the reference in his conversation with Obrist to music as "an ongoing conciliation with emptiness in life." The precise political valence of any or all of this is unclear. At the very least, however, the inclusion of the airplane signals an awareness of a real-world framing context that threatens to explode the absorptive project of the video as a whole, even as the "capturing" of the plane by the vanished Moondoc's saxophone quietly makes the point that this time anyway it has been possible to stave off that fate.

Finally, the zeroing in on Moondoc's features, especially his mouth and eyes, invites comparison with what in connection with Manet's paintings of the first half of the 1860s I have called facingness, in spite of the sharp contrast between Manet's coolness and "indifference" (Georges Bataille's term) and Sala's almost literally invasive procedures. In the *Déjeuner*, *Olympia*, and related works, of course, facingness emerges as a dialectical response to a crisis within the Diderotian tradition, namely, to the increasing difficulty of depicting figures capable of striking contemporary audiences as truly absorbed instead of as merely seeking to appear so (see the discussion of Jean-François Millet's paintings of peasant subjects in *Manet's Modernism*). Whereas in *Long Sorrow* the fact that for long stretches the camera seems almost to be in Moondoc's face sets the stage for the overcoming of any observable awareness of being filmed and hence for the achievement of a singularly powerful evocation of absorption. (Compare the discussion of Gordon and Parreno's film *Zidane: A Twenty-First Century Portrait* in *Why Photography Matters*.)

Not that Sala had such art-historical comparisons in mind when he made *Long Sorrow*. Yet he would, I think, be open to considering them pertinent to his artistic decisions – and even if he were not, they nevertheless constitute a deep background to the latter that cannot be ignored. In any case, such a background is even more immediately relevant to the work I now want to discuss.

18-37, 41

In 2004, filming in two different locales in Paris, Sala made a silent video of a cymbal with a rather pockmarked surface being struck continually from beneath by two black-gloved hands (his own) while being lit up by strobe lights firing at a rate of approximately ninety flashes per second. Since the camera filmed at twenty-five frames per second, what the viewer sees is a markedly discontinuous sequence of images, most of which are illuminated to a greater or lesser degree but a surprising number of which – that is, a surprising number of frames – are dark, having been shot in the extremely small interval between the flashes of the strobes. Others are not entirely dark; it seems they register the fading of the strobes, as fleeting as that must have been. Sala's hands themselves are mostly unseen but at moments – more precisely, for a fraction of a second – we glimpse their ghostly image before it disappears. One's first impression is that the video is in black-and-white but then one becomes aware of brief bursts and then longer stretches of color; nevertheless, the light–dark contrast throughout is extreme, and the overall effect of the movement of the cymbal under the impact of being struck, the suddenness and brightness of the flashes, and the sense of discontinuity between individual frames is disconcerting, even disorienting. (No one prone to seizures should go near this work.) The camera, too, shifts its point of view from time to time, and there is at least one stretch when the cymbal appears unmoving – unstruck, in other words – under the bombardment of the flashes. While being struck the cymbal gyrates widely on its axis but for the most part it fills the frames or comes close to doing so, and now and then it even extends beyond the image edge. All this goes on for exactly three minutes, an authorial decision that gives the work its original title: *Three Minutes*. Three times sixty times twenty-five – minutes times seconds times frames per second – makes 4,500 frames, and although the viewer can hardly claim to have "seen" them all, the duration of the piece seems perfectly judged, that is, not overlong but not five seconds too short, either. The video ends with an extremely brief "still" (as it seems) of the cymbal

28–31 (*facing page*) Anri Sala, stills from *Three Minutes*, 2004. Video projection. Color and black and white, silent, dimensions variable, 3 min. cycle.

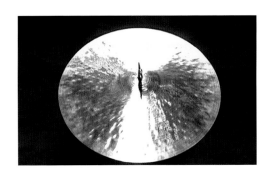

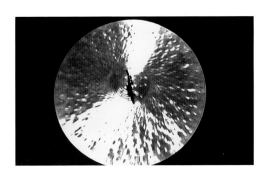

at rest. I saw *Three Minutes* some time after it was made and was impressed. I also thought I knew what it was "about," or perhaps I should say I thought I could give an account of its artistic significance. Yet I also felt a nagging qualm to the effect that there was something insufficiently articulated about it as a work of art – as if the cymbal and the strobes went together just a little too neatly, or as if once the video got under way I too quickly grasped its modus operandi, so that actually watching it from start to finish seemed more a deliberate choice on my part than properly speaking it should have been. (I ought to have felt unable to tear my eyes away, in the sense that the slightest flagging of attention might cause me to miss something essential.) So it was with considerable interest that I subsequently learned that Sala had in effect revised *Three Minutes* in a way that responded to these intuitions.

The occasion for that revision was a group exhibition at the Irish Museum of Modern Art (IMMA) in Dublin, curated by Sala's friend, the French artist Philippe Parreno. What Sala did was this: before the exhibition opened he projected *Three Minutes* on a gallery wall in the museum and then re-filmed it using two security cameras that took two photographs per second instead of the original twenty-five. In other words, whereas the initial filming imposed a rhythm of twenty-five frames per second on a sequence of ninety (or so) flashes per second, the re-filming imposed a rhythm of two frames per second on *Three Minutes'* twenty-five frames per second, which also meant that sometimes twelve frames went by in order that a single one be captured and sometimes thirteen – not that one perceives this extremely slight inequality but it is part of the subliminal structure of the new three-minute video (three times sixty times two equals 360 frames, each lasting half a second). As for the security cameras, they occupied fixed positions in the room – one on the opposite wall from the wall on which the original video was projected, the other on a side wall to the right of the projected image-stream – but they could be and were pivoted from time to time to change their angle of view. The result, in any case, is that we are given a strong sense of the room in IMMA where all this took place, and about a minute and a half into

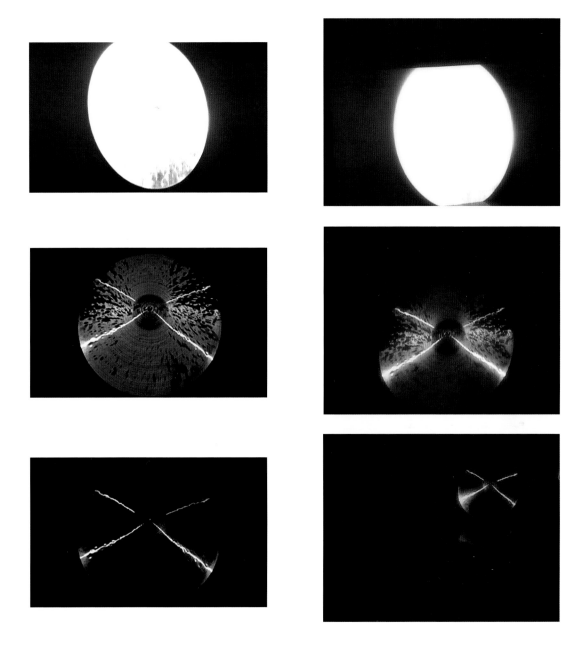

the new video the right-hand side camera unexpectedly reveals a large floppy doll – modeled on Parreno – propped up in a sitting position against the left-hand side wall, a further contextualizing move which introduces a certain sort of "persona," as if Sala both did and did not want to include an actual viewer (more on this below). The final work, which Sala calls *After Three Minutes*, consists in the double projection of the two videos alongside and synchronized with one another, the original at the left and the new, slightly larger one on the right. The proportions of the image-rectangles are also slightly different, nine to sixteen versus three to four; a distance of roughly three feet or a little more separates the two projections. After exhibiting *After Three Minutes* at IMMA in a provisional form – on monitors set above the security monitors at the entrance of the museum – Sala showed it at Hauser and Wirth in London in 2007 in its definitive, projected version. I first saw it there, in fact I watched it repeatedly in an attempt to bring my thoughts about it into focus. By the time I left the gallery, my earlier qualms had been resolved: there was nothing simple about the new work. (I have since watched it numerous times in three venues, the Museum of Contemporary Art in Miami, the Lois and Richard Rosenthal Center for Contemporary Art in Cincinnati, and the Marian Goodman Gallery in New York City.)

Basically, I take both *Three Minutes* and *After Three Minutes* to be investigations of a set of issues which, once again, goes back to the middle of the eighteenth century – the dawn of modern painting, if not yet modernist painting – when the notion was first unequivocally formulated that a painting – by which was meant a "history" painting (the highest category of painting as it was then understood), that is, a representation of significant human action – was by the nature of its signifying system (signs coexisting with each other in space rather than succeeding one another in time as in verbal language) restricted to depicting a *single moment* in an action, and that the task of the painter was therefore to make the best, strategically most astute selection of a moment out of all those which a given action (a given narrative) could be taken as presenting as possible

35a and b (*facing page, top*), 36a and b (*center*), and 37a and b (*bottom*) Anri Sala, stills from *After Three Minutes*, 2004. Video projection. Color and black and white, silent, dimensions variable, 3 min. cycle.

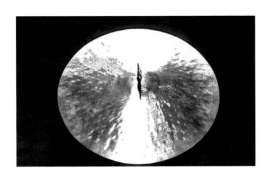 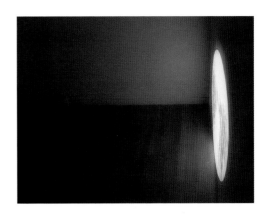

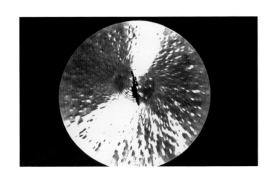 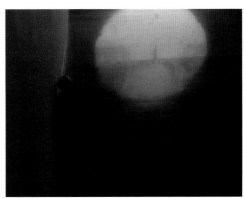

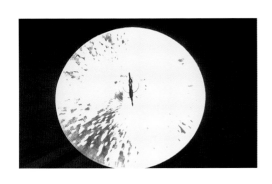

choices. For Gotthold Ephraim Lessing in his epochal theoretical treatise *Laocoon* (1766) – a text indebted to Diderot – this meant choosing the "most pregnant" moment available, by which he meant one in which the action was under way but had not yet reached its climax and yet in which the latter, the climax, was somehow implicit in what was shown – a moment of maximum tension and suggestiveness, let us say. Similar considerations must have led David in the *Oath of the Horatii* (1784–5), having in view the complex narrative that formed the basis for Corneille's tragedy *Horace*, to choose a moment that does not occur in the tragedy, the administering of an oath to fight and if necessary die for Rome by the elder Horatius to his three heroic sons. The combat itself, the death of five of the six combatants, Camilla's excoriation of her surviving brother on his return, his killing of her, and his father's defense of him before the citizens of Rome are all in the future, so to speak. (The later phases of the narrative are suggested by the grief-stricken responses of the women in the right-hand half of the composition, foreshadowing the events to come.) However, my point in mentioning Lessing and his theory in this connection has less to do with the notion of "pregnant" than with that of the moment as such. For what after all *is* a moment in an action? It is not, to begin with, a unit of time: how could it be? If it were, one could ask questions about its actual duration – clearly absurd in the case of painting. Nor is it precisely a unit of narration, as if a particular narrative – say the story of the Horatii – could be subdivided into a precise number of distinct, brief, narratively "equal" phases, each of which presented itself as a clear-cut tableau – as if (to take a single example) the temporally protracted encounter between the Horatii and the Curiatii in the course of which five of the combatants were killed could somehow be imagined to condense naturally into one or more representative images (or "moments"). Yet – this is what must be stressed – the idea that a painting represents a moment in an action proved indispensable not only to art critics and theorists for the better part of a century but also to several generations of ambitious painters, who appear to have found in its resistance to precise theoretical definition a provocation to or an enabling condition of radical

38 Théodore Géricault, *Raft of the Medusa*, 1819. Oil on canvas, 491 × 716 cm. Musée du Louvre, Paris.

solutions to the problem of pictorial construction. So, for example, Théodore Géricault's stupendous *Raft of the Medusa* (1819) evokes an excruciatingly pro-tracted "moment," that is, the extended span of time that would have gone by while the shipwrecked men on the raft struggled to attract the attention of poten-tial observers on the barely discernible ship, the brig *Argus*, on the far horizon. (That this was a strategy of desperation as well as genius is suggested by the fact that the young Eugène Delacroix in *Scenes from the Massacre at Scio* of 1824 sought to bypass considerations of "moment" entirely.)

38

39 Edouard Manet, *Old Musician*, 1862. Oil on canvas, 187.4 × 248.3 cm. National Gallery of Art, Washington, D.C

These brief remarks hardly encompass the full complexity of the issue in post-1750 painting, art theory, and art criticism. Leap now to the early 1860s and the advent of Manet in his breakthrough paintings, the *Old Musician* (1862), *Déjeuner sur l'herbe* (1862–3), and *Olympia* (1863). What we find in these, I argued in *Manet's Modernism*, is a kind of instantaneousness that I associate with the critical terms facingness and strikingness, both of which I originally extracted from the art criticism of the period. The basic idea is this: in these paintings the "action" itself is not especially momentary and the principal figures (everyone in the *Old Musician*, the naked woman and the two men in the *Déjeuner*, the naked courtesan in *Olympia*) are stationary to the extent of seeming to hold poses. It is all

39

10, 11

the more noteworthy, then, that all three paintings evoke a sense of a heightened instantaneous encounter between themselves and the beholder by mobilizing a defining material and formal feature of easel painting, namely, that such a painting comprises a delimited flat surface all of which, every bit of which, faces the beholder and which moreover in Manet's case – in part by virtue of the provocative deadpan frontal gaze of the principal figure in each of the three canvases (the old violinist, the naked bather, Olympia), seconded by the abrupt contrasts of light and dark and by a characteristic boldness of brushwork and astringency of color – is felt to do so as a whole, as if the entire painting in its facingness were presented to the beholder, one might say thrust upon him or her, in a single, indeterminately brief instant (a single blow), which is why facingness and strikingness, not flatness per se, are what chiefly mattered to Manet's commentators. Again, there is no way to rationalize such a notion of instantaneousness – in fact I suggested in *Manet's Modernism* that one small epitome of that fact is the contrast between the stationary but rapidly painted frog in the lower left-hand corner of the *Déjeuner* and the mid-flight but more deliberately rendered bullfinch hovering in the upper center. In any case, there can be no question but that precisely this aspect of Manet's art played a role in its initial reception, by which I allude both to the positive impact that it had on a handful of younger artists and critics and to the fierce resentment it inspired in almost everyone else.

My next point of reference – I am moving quickly – is the instantaneous photograph of the sort that first became possible in the late 1880s with the development of ever faster photographic film and that reached perhaps its peak with the invention of the small, easily portable Leica camera in the 1920s and '30s and the rise of the dual practices of "street" and combat photography in the work of, for example, Henri Cartier-Bresson, Robert Capa, and Garry Winogrand. (Or sport photography for that matter.) In an obvious sense, such practices mark the emergence of a mode of instantaneousness that lends itself to exact quantification: such-and-such a photograph implies a shutter speed (the time during which the shutter is open) of one-tenth of a second, another a speed of one-hundredth

40

40 Henri Cartier-Bresson,
Behind the Gare St.-Lazare, 1932.
Gelatin silver print, printed 1950s,
35.2 × 35.2 cm. The Museum of
Modern Art, New York, Gift of the
photographer, by exchange.

of a second, still another a speed ten times faster than that, and so on. Yet the photographs that result are themselves static, which is to say that there is the starkest imaginable contrast between the fleetingness of the "subject" and the unchangingness of the image-artifact. Barthes's way of putting this is that even in the case of a photograph taken at a millionth of a second, a certain sense of *posing* is inescapable. He writes:

> The physical duration of this pose is of little consequence; even in the interval of a millionth of a second (Edgerton's drop of milk) there has still been a pose, for the pose is not, here, the attitude of the target or even a technique of the *Operator*, but the term of an "intention" of reading: looking at a photograph, I inevitably include in my scrutiny the thought of that instant, however brief, in which a real thing happened to be motionless in front of the

eye. I project the present photograph's immobility upon the past shot, and it is this arrest which constitutes the pose.[6]

In *Why Photography Matters* (p. 111) I cite this passage in connection with the larger problem of the theatricality of the photograph as theorized by Barthes, but my point in citing it here is simply to underscore the deeply problematic character of all "pictorial" practices of the momentary or instantaneous, including photographic ones.

My last term of comparison is, predictably, the notion of "presentness" as deployed strategically in "Art and Objecthood," where (as already mentioned) I contrasted the Minimalist/Literalist preoccupation with duration – specifically, with the duration of the subject's experience of the total situation in which a given "work" is only one element – with the high modernist emphasis on something like an antithetical temporal modality. "It is as though one's experience of [modernist paintings and sculptures] *has no* duration," I wrote in that essay,

> not because one in fact experiences a picture by Noland or Olitski or a sculpture by David Smith or Caro in no time at all, but because *at every moment the work itself is wholly manifest.* . . . It is this continuous and entire *presentness*, amounting, as it were, to the perpetual creation of itself, that one experiences as a kind of *instantaneousness*, as though if only one were infinitely more acute, a single infinitely brief instant would be long enough to see everything, to experience the work in all its depth and fullness, to be forever convinced by it. (p. 167; emphasis in original)

(I did not refer to Morris Louis in that connection, but for me today any one of his magnificent Unfurleds – their bare central expanses of unsized cotton duck at once opening dramatically before the beholder and made abstractly taut and resistant by the banked rivulets of intense acrylic color to the right and left – epitomizes that quality.) Once again, however, the ultimate point of recalling these remarks is to underscore what might be called their metaphorical character: literal instantaneousness, whatever that might be taken to mean, is

obviously not at issue in them. Which is to say that "Art and Objecthood" had a considerable stake in the concept of "presentness" without having been able to define it precisely. But how much and in what ways does that inability matter?

My suggestion, it is probably already clear, is that *After Three Minutes* amounts to an inspired attempt to take up the artistic and ontological project associated with the works and writings I have just briefly surveyed. The original *Three Minutes* was a first stab in that direction, but the new work goes considerably beyond the older one in a number of respects it would be useful to spell out.

(1) At the heart of *Three Minutes* is the mismatch or interference between the speed of the strobe lighting and the slower speed of the filming, both of which enjoy something like equal importance in one's experience of the work. Now it was precisely that mismatch or interference that I wanted to associate with "Art and Objecthood" 's notion of "presentness" when I saw it for the first time, despite the fact that in 1967 I could not have imagined how such an association could be compatible with a filmic medium. However, on further viewings I came to feel (to paraphrase what I said earlier) that there was perhaps something too techno-logical-seeming about Sala's solution – as if once the basic *dispositif* was set in place (the fixed number of flashes, the fixed speed of the filming) the results, the video itself, followed just a bit too automatically. In point of fact, *Three Minutes* was strongly edited by cutting out various bright or dark images and sometimes rein-serting them in slightly different positions in order subtly to reorganize the image-flow, which no doubt is the main reason why it has nothing of the banality of the strobe experience typical of disco clubs. Yet, because the editing does not declare itself as such, it cannot quite neutralize one's sense that the mismatch or interference is a strictly technological effect (or so it seems to me). To be sure, there is another temporal factor in play, the striking of the cymbal by mostly invis-ible hands, and of course the rhythm of that striking can be identified neither with the speed of the strobes nor with that of the filming (it can only have been considerably slower than the latter). Plus there are the shifts of the position of the camera in the course of the filming. But these intentional elements as well

turn out to be not quite sufficient to compensate for the technological cast of the video as a whole. By introducing a second filming of the original video at the much slower rate of just two frames per second, a whole new set of mismatches and syncopations is put in place, including crucially the disparity – as it often seems – between the half-second image on the right and the rapid-fire image-flow on the left. That is, one repeatedly has the feeling of having "missed" the frame that was caught by the slower camera. In addition, the jarringness of the disparity in speed powerfully foregrounds the factor of artistic intention – on an instant-to-instant basis, so to speak.

(2) Much more is in play than simply a difference in speeds. The new video was made by projecting the original *Three Minutes* on a gallery wall and then photographing, at two shots per second, that projection. This too is self-evidently an artistic decision, one with multiple implications of a radical sort. Most important, perhaps, it amounts to a declaration by Sala of the nature of his preferred medium: not simply video – a certain kind of image-stream – but *projected* video, a significantly different affair. In contrast, *Three Minutes* had no way of acknowledging this fact about itself apart from the conditions of its exhibition. Moreover, the sense of place that accompanies this thematization of projection is further heightened by the use of not one but two security cameras, the second located high on a side wall near the "front" of the room so as to yield pictures of the projected *Three Minutes* at a sharply oblique angle – so oblique that the original image-stream seems less important than the intermittent reflected light it sheds or fails to shed on the rest of the room – as well as by the fact that, photographed from the rear wall and being projected toward the bottom of the gallery wall, the image-stream is reflected in the polished wood floor (for a few seconds we are shown only the reflection, not the projection itself). In addition, the changes in the orientation of the two cameras in the course of filming have the effect of disclosing reaches of the room that would otherwise have remained unseen, including windows screened so as to block light from outside. (There is also a door on the same wall as the projections and to their right.) I think of this as a still more

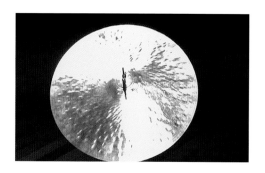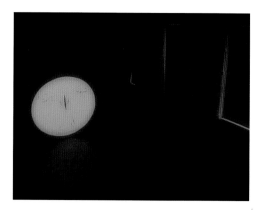

41a and b Anri Sala, stills from *After Three Minutes*, 2004. Video projection. Color and black and white, silent, dimensions variable, 3 min. cycle.

emphatic acknowledgment of the nature of the video medium as Sala practices it, by which I refer to his intense concern with the presentation of his works, their total installation in different venues, in ways that I have had to learn to appreciate, the risk being, to my previous way of thinking, that such a concern can seem to verge on the theatrical.[7]

(3) Then there is the doll, an artistic, quasi-human "presence," which turns up seated and propped against a side wall roughly half-way through the second video and which moreover we are shown in relative close-up, under shifting illumination, somewhat toward the end. (Further on it appears to be gone.) The question is what to make of the doll, I mean why Sala introduced it, and here one can only conjecture that he felt a need to assert that the room was in some sense occupied though not, it seems, by an actual person, one whose responses to the projection and more broadly whose physical and psychological presence would have ushered in a whole new range of problems with no bearing on the crucial issue. For example, would such a person most plausibly have been shown seated, standing, or moving around? In each case, the decision would have had to carry its own narrative and psychological rationale, of a sort that would have been dis-

tracting; certainly Sala could not simply have sat that person on the gallery floor, as he did the doll; the brief close-up of the latter late in the piece positively underscores the decision not to include a human subject even as it shows the doll with its head turned toward the front wall as if unblinkingly watching the projection, whose ongoingness is registered by the intermittent illumination of the scene. In addition the doll comically alludes to a specific figure, Parreno, who had organized the IMMA exhibition (the risk here is of a somewhat hermetic joke). Put slightly differently, the doll functions as a certain sort of distancing device relative to the actual viewer of the right-hand projection even as it temporarily gives that viewer something "real," not merely projected, to look at – but of course that "real" item has itself been filmed and projected: the point is that the doll does not start out as a projection as the image-sequence on the gallery wall does. (I am probably belaboring the obvious.) Plus there may be a somewhat anti-Minimalist/Literalist edge in this, the doll alluding to a human subject-in-a-situation even as it invites the actual viewer to do nothing except pay the closest possible attention to what is taking place before his or her eyes (as the doll seems to do, I have already implied). Not that the viewer actually is shown the arrival or the removal of the doll – one instant it is there and at another instant it is gone. What the viewer sees, in that regard, is the evidence of a certain artistic intention, period.

(4) Finally, decisively, the two videos, the original *Three Minutes* and the video that was shot in IMMA before the exhibition opened, are projected alongside each other, synchronized but with all their multiple rhythmic and scenic disparities – also their fleeting split-seconds of relative accord – in full view. This is the work Sala calls *After Three Minutes*. What I cannot do, however, is to provide even a minimally coherent account of how those disparities and fleeting split-seconds of accord play out in real time, as one's attention shifts back and forth from one projection to the other, or indeed takes in both simultaneously, to the extent that one can be said to manage that feat even for an instant – in short I am at a loss how to describe the experience, the perceptual and responsive activ-

ity, of paying close attention to *After Three Minutes*. (I have not even mentioned the subtle, shifting play of color throughout the piece, which enriches it immeasurably.) Apropos of Barthes's inspired phrase, "the arrest which constitutes the pose," might one say that at certain instants one has the sense of simultaneously glimpsing such an arrest of a bright image of the cymbal to the right and retinally registering the same fleeting image to the left? The thought is Sala's, after reading a draft of this essay; not quite the bullfinch and the frog in Manet's *Déjeuner* but close. Another term of comparison might be the sense in which the viewer of Louis's Unfurleds is said by me in a text of 1971 to be unable – disempowered by the paintings – to "bear down on" – look concentratedly at – both banks of rivulets of color at the same time, as a result of which "each bank enjoys a special autonomy relative to the other as regards color."[8] Yet taking in the painting as a whole consists in nothing else but being struck by the two banks simultaneously, in a single all-inclusive act of visual attention. Simply put, the particular brilliance of *After Three Minutes* is that it radicalizes the problematic of "presentness" evoked in "Art and Objecthood" as well as the different forms of "instantaneousness" that I earlier surveyed, all of which taken together indicate one of the obsessive concerns of modern art from its inception.

(5) One last point. Both *Three Minutes* and *After Three Minutes* are completely silent, a fact the viewer registers with special force because of what he or she is aware must be the noise made by the struck cymbal. Given the nature of Sala's project this makes perfect sense: if one heard the clanging of the cymbal, that would inevitably structure one's sense of what is shown to the extent of overpowering it. But it is also necessary to recall that sound as such, or rather the relation of image to sound, has from the first been one of Sala's central preoccupations, which suggests that another dimension of his project in these works has been to motivate a silence that amounts to far more than simply the absence of noise.

two: embedment

CHARLES RAY

Charles Ray, born in 1953 in Chicago to a family of art teachers, had a severely schizophrenic sister, a circumstance that led to his being sent away to a military school that suited him not at all. His liberation took place when he went to college at the University of Iowa and in his sophomore year came under the tutorship of the South African sculptor Roland Brener, then in his early thirties, who during the 1960s had himself been a student of the British sculptor Anthony Caro at St. Martin's School of Art in London. (Caro was born in 1924 and continues to make outstanding work. I stated earlier that my encounter with one of his early abstract welded steel pieces, *Midday* (1960), in the fall of 1962 was a decisive experience for me. I remember meeting Brener at St. Martin's in the 1960s.)

As Ray has explained in interviews, Brener was fiercely "formalist" – perhaps more accurately, "constructivist" – in that he purveyed a version of Caro's teach-

ing with great fervor and intensity. Students were invited to extract pieces of steel from a pile of raw material and then to work in a Caro-influenced manner, juxtaposing and relating individual elements to one another by a process of trial and error until a given abstract sculpture "locked esthetically," to use a phrase of Ray's from a conversation with Robert Storr.[1] At that point the piece was welded together and painted, and after it had been shown and critiqued – Brener was merciless – more often than not it was returned to the junk pile, to become fodder for the next round of student sculptures. Other students may have rebelled under Brener's singleminded pedagogy but Ray claims it suited him perfectly. From the same conversation with Storr: "That way of working really made sense to me. We had very strenuous and heavy critiques. I always preferred looking for a way to find out what was wrong. What was not working in the piece was always more interesting than what was" (p. 101). (Having spent countless hours over the years in the studio with Caro, I can testify that that corresponds to his own mindset: the only pieces of his that he is interested in talking about are ones that he feels are not working. If I report that a new piece seems to me marvelous, he has it moved out of the way so as not to distract us.) Not that Ray went on to become a Caroesque sculptor in any obvious sense, but Brener's tutelage gave him a discipline and it also imbued him with an exalted ideal of sculpture as an enterprise. In Paul Schimmel's words (Schimmel organized and wrote an excellent catalogue essay for Ray's 1998 retrospective exhibition at the Los Angeles Museum of Contemporary Art): "The relationship that Ray and Brener forged would become the single most critical encounter in his formative years as a sculptor. Brener provided Ray with a formal language – the high modernist sculptural syntax of Caro – that continues to inform not only how he constructs his work but how he speaks about it."[2]

In the middle of Ray's undergraduate career Brener left Iowa for Vancouver, and Ray followed him there, working on his own but seeking out Brener for further critiques. After a year, Ray returned to Iowa and got his B.A. (in 1975). During the years that followed Ray studied briefly at the University of Kentucky in Lexington, where he became close to the Iranian artist Siah Armajani, and

Rutgers University, where he received his M.F.A. in 1979. In 1981 he moved to Los Angeles to begin teaching at the University of California and has lived there ever since.

This is not the place for even a cursory survey of Ray's career; Schimmel's catalogue essay, just cited, provides an excellent account of the artist's development up to that moment. However, several points covered by Schimmel are worth stressing. First, Ray's earliest works in a Caroesqe idiom – I am referring to a group of pieces he made while still a student at Iowa – conspicuously broke with Caroesqe principles in significant ways. For example, in *Untitled* (1973) a 42
heavy steel ball lies on a flat piece of yellow steel on which it seems to have been dropped, seriously denting the latter; this sort of causal relationship could not be more foreign to Caro's way of working. In an even earlier piece, *Untitled* (1971), 43
a number of elements have been joined together and painted a uniform deep red so as to form a kind of compound object, like a large tool of some sort, in a way

42 Charles Ray, *Untitled*, 1973. Steel, plate and wrecking ball, 182.9 × 182.9 × 61 cm. Destroyed.

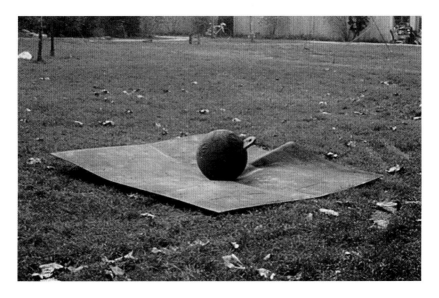

that once again could hardly be less Caro-like. Yet, as Schimmel makes clear, the very terms of the youthful Ray's defiance of Caroesque principles bespoke a connection with the British sculptor that continues to this day. (Both pieces rest directly on the ground, as Caro's abstract sculptures did from the first.)

Second, Ray early on – for a time starting in the early 1970s, a particularly "open" moment – was led to work in what has been called a "performative" manner. What I want to stress is that this aspect of Ray's work has been characterized by Schimmel and others in terms that place it in an antithetical relation to my views in "Art and Objecthood". "Through the elimination of welds and bolts," Schimmel writes of Ray's earliest pieces,

> Ray was transforming Caro's static formal language, in which the elements of sculpture were composed according to a syntax, into an intensely theatrical activity riven with theatricality – with the very properties of Minimalism that Fried had criticized so strongly. So theatrical was this sculpture that Ray allowed interested friends and colleagues [to] watch him as he worked – a relief from

43 Charles Ray, *Untitled*, 1971. Steel and paint, 213.3 × 61 × 30.5 cm. Dallas Museum of Art, DMA/amfAR Benefit Auction Fund and the Contemporary Art Fund: Gift of Mr. and Mrs. Vernon E. Faulconer, Mr. and Mrs. Bryant M. Hanley, Jr., Marguerite and Robert K. Hoffman, Cindy and Howard Rachofsky, Deedie and Rusty Rose, Gayle and Paul Stoffel, and two anonymous donors

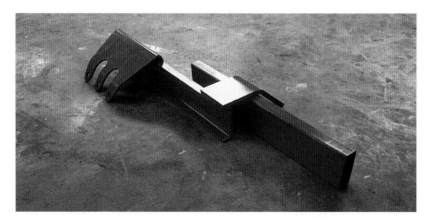

the intensely solitary periods he often spent in the studio, which extended the loneliness and isolation he had felt in high school. (p. 65)

This will be a major theme in the present essay: is or is not Ray's work theatrical, as the term is employed in "Art and Objecthood"? A preliminary answer is no. But it will take some doing to make this good.

Third, the "performative" aspect of Ray's early art-making went hand in hand with an emphasis on the body, an emphasis that is usually seen in the context of the phenomenological slant associated with Minimalism/Literalism as well as with certain post-Minimal figures such as Bruce Nauman, Dennis Oppenheim, Chris Burden, Dan Graham, Vito Acconci, and early Richard Serra. This is fine as far as it goes but it needs to be stressed that Caro too was from the first an intensely "bodily" artist. Caro's early plasters and bronzes – works such as *Woman Waking Up* (1955), *Man Holding his Foot* (1955), and *Man Taking Off his Shirt* (1955–6) – were inspired by a desire to render sculpturally what phenomenology calls the "lived experience" of performing those actions – what it *feels like* actually to do those things as opposed to what doing them *looks like* to someone observing from outside. In the late 1950s, however, Caro reached a crisis of sorts when he came to realize that there were strict limits to the capacity of figurative sculpture to "deliver" such feelings in any but a limited or notional way – as if the specificity of the images deflected his project almost before it could get started. In addition, the works in question were original only up to a point – stylistically they had a somewhat general look that ceased to satisfy him. His visit to the United States in late 1959, at which time he renewed contact with Clement Greenberg and met Kenneth Noland and David Smith, led him on his return to London to make a total change in his manner of working. Greenberg had said, "If you're going to change your way of thinking, change your habits," by which he meant that Caro should change his way of making sculpture. That was Greenberg at his best.

Specifically, Caro started working with anonymous elements of industrial steel, moving them about with the help of students from St. Martin's, juxtaposing them to one another, and then – when they had arrived at an abstract configuration that seemed to him "right" – welding or bolting them together, and then paint-

ing the result, most often with a single color though now and then with more than one; quickly it emerged that in this new medium, pioneered by David Smith starting in the late 1930s, Caro possessed a completely original vision, an unprecedented, for the most part not image-based, sense of relationality, form, and meaning – something artistically new under the sun that would never have emerged had he not had the courage to make a radical break with his artistic past. What also emerged – what turned out to be part and parcel of that original vision – was an unprecedented mode of "bodiliness," one liberated from the skeletal and muscular constraints of the human physique as well as from the limits under which the body ordinarily operates (gravity, above all). As much as anything else, this sense of abstract bodiliness came through to me when I first stood in Caro's courtyard taking in *Midday* and another work, *Sculpture Seven* (1961). This led me in an early text to describe one impression made by these and other early abstract pieces by Caro as that of an "achieved weightlessness," and to write, "One could imagine a gifted dancer dancing Caro's sculptures."[3] I find it impressive that Ray in his early twenties – on the basis of looking at reproductions, no doubt reading what was available, and of course talking with Brener – seems to have been fully sensitive to this aspect of Caro's achievement.

44, 45

Take for example two 1973 works, both called *Plank Piece* – known today from two black-and-white photographs – in which a single, angled, beat-up looking wooden plank is made to support Ray's passive, drooping body above the ground and against a white studio wall. In the first photograph he faces outward as the plank supports him in the region of his belly and his head, arms, and upper body droop forward. In the other he faces the wall in an upside down position as the plank supports him by intersecting with the backs of his knees. (Both arrangements, it seems clear, could have been achieved only with the help of at least one other person, who, however, does not appear in the photographs.) Again, it would be possible to place these works in relation to much else going on at the time – Serra's earlier wall pieces are an implied reference, and so may be John McCracken's technically impeccable colored planks leaning against gallery walls, a fixture in Los Angeles in the early 1970s. But Caro's work too, by virtue of its

44 and 45 Charles Ray, *Plank Piece*, 1973. Black-and-white photographs mounted on rag board, each 100.3 × 68.6 cm.

bodiliness and also of its inspired use of angled elements, played a formative role, as Ray immediately acknowledged when I suggested this to him at one point in a series of conversations we conducted in Los Angeles in February and June 2007. Not that I myself grasped the Caroesque resonance of the *Plank Pieces* when I first became aware of them (I am not sure when that was: Ray simply did not figure on my radar for the longest time); on the contrary, they seemed to me amusing but in the end not remotely serious – avant-gardist rather than

modernist, in Greenberg's useful distinction. Obviously I now think this was wrong, which is not quite to say that I see them as modernist *tout court*. Rather, they look back to modernism, as if posing the question: might there conceivably be a place in the canon of serious art for high-jinks of this caliber? The answer, it turns out, is yes.

Several other works by Ray can serve to indicate some further parameters of his involvement with Caro. First, *Oh Charley, Charley, Charley . . .* (1992), one of his best-known pieces, consists of eight life-size painted fiberglass body casts of his own improbably youthful-seeming naked self (Ray was then thirty-nine) sitting, lying, kneeling, and standing about while engaging in something like group masturbation. The bodies are anatomically accurate, though they also completely lack body hair except for their heads and genital areas; facial expressions are minimized and in some cases seem glazed, unfocused, as if Ray recognized that anything more expressive would be at odds with the larger meaning of the work; and gestures too are restrained, even delicate. The genitalia are semitumid, aroused but not quite erect. The question, however, is what is happening sculpturally. Schimmel writes:

46-8

> Using eight separate body molds, [Ray] created a complex, baroque composition representing an orgy of one, in eight parts, that conflated masturbatory sexuality with Minimalist seriality. He has stated that the result was ultimately "kind of sad. . . . I thought it would be more sexual than it was somehow." Indeed, the bloodless, lifeless, nonpenetrating sexuality of *Oh Charley, Charley, Charley . . .* was to prove how flat and iconographically deadened a highly charged, sexually provocative subject could be. Ray transformed the most private of acts, masturbation, into what he regarded as a radical, contemporary, multifigure, public sculpture in the tradition of Auguste Rodin's *The Burghers of Calais* (1889). (pp. 86–7)

Lane Relyea writing in *Artforum* referred to *Oh Charley, Charley, Charley . . .* as "a compositional tour de force" but added:

46, 47, and 48 (*above and following pages*) Charles Ray, *Oh Charley, Charley, Charley . . .* , 1992. Mixed media, 182.9 × 457.2 × 457.2 cm. Rubell Family Collection/Contemporary Arts Foundation, Miami.

Yet the composition is itself schizo. Like a porn remake of the raising of the American flag at Iwo Jima, the piece appears on the one hand classically ordered, its many individual parts subordinated within one coherent whole. On the other hand, though, its arrangement of bodies recalls the indeterminacy of Minimalist sculpture, in which identical units are repeated in seemingly endless succession (or, as Judd might say in this context, "one Ray after another").[4]

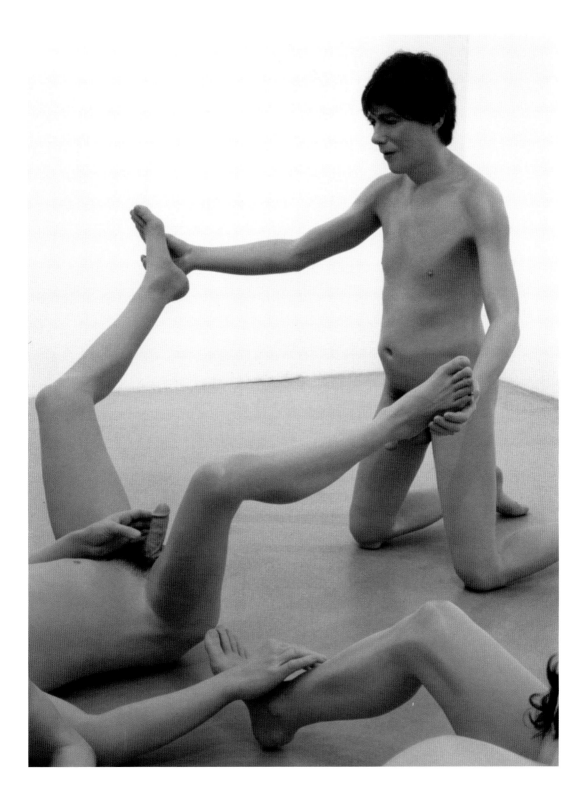

The last phrase, of course, is a reference to Judd's characterization of the structure of Stella's stripe paintings as "simply order, like that of continuity, one thing after another," a remark cited in "Art and Objecthood" and basic to Minimalist/Literalist thinking.

Without belaboring the topic, I suggest that Caro's multi-axial abstract steel sculptures placed directly on the ground, such as *Sculpture Two* (1961), are fully as much to the point as Rodin's *Burghers* and much more so than Minimalist repetition, seriality, or indeterminacy, and in fact Ray himself (in conversation) has stressed the importance of "gesture" in *Oh Charley, Charley, Charley* . . . (a notion I made much of in relation to Caro in the same 1963 text referred to earlier) and, even more, of the points of contact between the individual figures – not welds but junctures, loci of juxtaposition, places where a certain relationality most intimately "happens." As Ray remarked to Storr in another context, "Caro interested

49 Anthony Caro, *Sculpture Two*, 1961. Steel painted green, 208.3 × 360.7 × 259 cm. Private collection.

me early on, but I thought his work wasn't about overall shape or profile; it was about a relationship among parts – a way of building something and putting something together as a sequence, somehow" (pp. 102–3). Even the fact that the piece juxtaposes eight more or less identical elements (each of whom does something different from all the others) bears an interesting relation to the anonymity, the quasi-uniformity, of the basic elements of Caro's early abstract sculptures (the I-beam segments, steel flats, lengths of piping, and so on) – as if in this context the body casts of himself gave Ray comparably neutral or undifferentiated material to work with. Ray to Storr again: "The repetition of the image helps unify it. That all the figures are me helps tie it all together, somehow. You can't say, 'Oh, it would be better if it were boys and girls.' The whole thing would fall apart" (p. 104). As *Sculpture Two* would fall apart if all the elements were sharply different in kind. At the same time, obviously, the fact that the body casts are naked and that the theme of the piece is group masturbation makes *Oh Charley, Charley, Charley . . .* as unlike a sculpture by Caro in its appearance and, in the usual sense of the term, in content as it could possibly be. (It also matters – this is a larger topic than I can deal with here – that the figures in the sculpture are of Ray himself. Briefly, Ray is an artist – Douglas Gordon is another – for whom the self-portrait, in one form or another, is a primary vehicle of his art. For me, the most riveting instance of this in his oeuvre is *Puzzle Bottle* (1995), with its roughly eight-inch high painted wooden sculpture of a standing, anxious-seeming Ray behind thick flint glass.)

 Soon Ray himself began to cool toward what he sometimes calls the "psychology" of *Oh Charley, Charley, Charley . . .* The desire to "go deeper sculpturally" led him, in the first place, to make *Family Romance* (1993) with its identically sized father, mother, young son, and even younger daughter, all naked, all standing facing straight ahead, all holding hands; the result is uncanny but the violation of the expected relations of scale among the figures stops short of inviting a "psychological" reading of the piece as a whole. Rather, the difficulty of getting *Family Romance* right, Ray says, was above all a matter of finding the correct size for the figures (53 inches or 135 centimeters in height, as it turned out), while the

69

50

50 (*following pages*) Charles Ray, *Family Romance*, 1993. Mixed media, 134.6 × 243.8 × 61 cm. The Museum of Modern Art, New York.

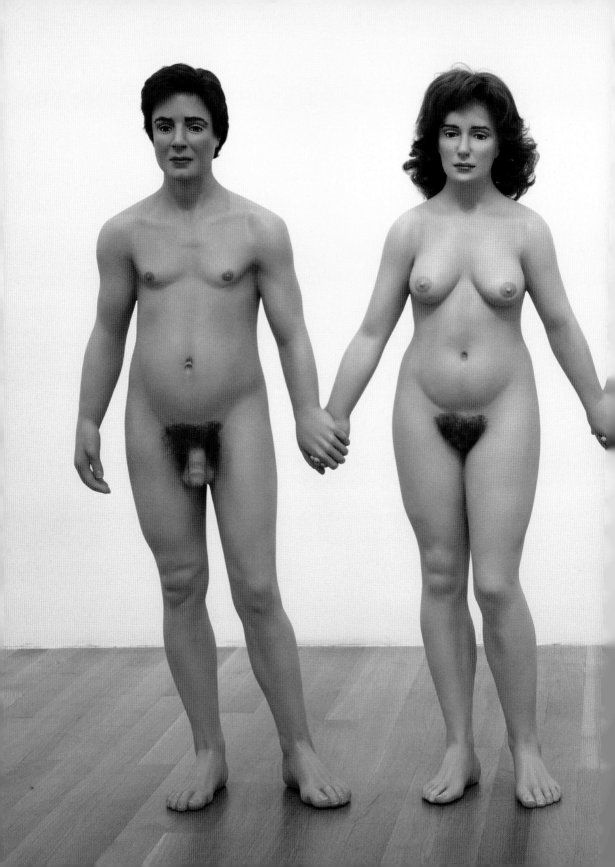

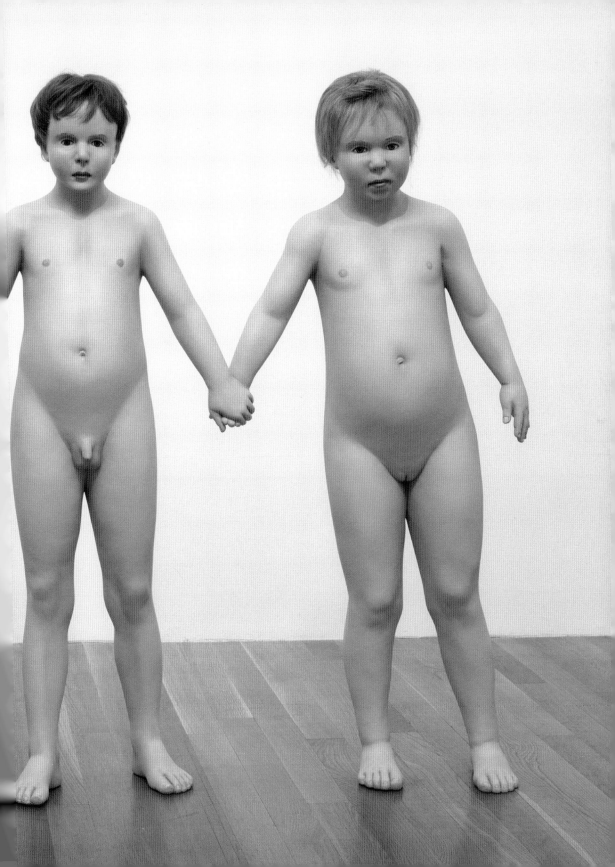

main interest of it for him lay in working out the junctures between them, where the pairs of hands meet. For Ray, those junctures come even closer to being Caroesque than the structure of *Oh Charley, Charley, Charley* . . . though he also finds *Family Romance* a bit too suggestive of Magritte – which is also to say too open, in its frontality and uncanniness, to being seen in pictorial rather than exclusively sculptural terms. The desire to work only in the latter register has been a constant throughout Ray's career.

Another work that bears directly on the question of Ray's relation to Caro is the inspired *Table* (1990). At first glance *Table* can strike one as dead simple – indeed it is not at all obvious what makes it a sculpture as opposed to simply an ordinary table with ordinary things on it. On a black steel frame rests a one-half-inch thick sheet of Plexiglas whose edges are shown; and on top of that sheet stand six ordinary colorless transparent Plexiglas objects of the kind that can be

51

51 Charles Ray, *Table*, 1990. Plexiglas and steel, 90.5 × 90.5 × 136.5 cm. Private collection.

bought in a department store (as in fact they were) – a jug with a handle, a tapering glass with a ridged surface, a bowl with a rim, a broader, squatter glass, a handle-less beaker, and a glass jar with a top of the sort used in a bathroom for holding balls of cotton or Q-tips. Only on approaching the piece and looking closely does the viewer come to realize that the six objects have been fixed into the table-top by cutting their bottoms away and also by removing the circular areas of the table-top directly beneath the individual items (the objects are in effect fused with those round holes). This means that when one looks down into the bowl, for example, one becomes aware that one's gaze is not arrested by either the bottom of the bowl or the plane of the table-top; what one expects to be a perception of doubled transparency (the gaze not blocked but momentarily stopped, as if delayed) is instead an unexpected perception of absence, a view onto a void – a sense of something like contained literalness (the hole or void),

52

52 Charles Ray, *Table* (detail of pl. 51).

53 Anthony Caro,
Table Piece VIII, 1966.
Polished steel,
68.5 × 33 × 50.8 cm.
Private collection, London.

54 (*facing page*)
Roland Brener, *Table Top
Sculpture QED*, 1981. Steel
pipe, steel rods, high-density
particle board,
104.1 × 185.4 × 139.7 cm.
National Gallery of Canada,
Ottawa. Purchased 1981.

in a manner of speaking. The result is at once extraordinarily subtle yet remark-
ably efficacious with regard to an evocation of *space*, all the more so under the
circumstances in which I encountered it in Ray's company several years ago, in
the home of a collector of contemporary works of art of a far more declamatory
and invasive stamp. Viewed in that milieu, in an alcove of its own, Ray's *Table*
appeared a shrine of gentleness and repose. Yet at the same time I had the dis-
tinct and to me surprising, even unsettling impression of powerful currents of
space invisibly but palpably flowing through and around it, as if it were some-
thing like (I am getting carried away here) a transparent engine block at the
bottom of an atmospheric sea, grounding or centering or – to use a verb that Ray

frequently employs when he talks about his sculptural aims and ambitions – *embedding* the table and its objects in the world – in any case making the sculpture as a whole seem immovable, a familiar yet also radically defamiliarized compound object of surprising ontological weight (not quite the right notion; maybe immovability is best). Put another way: *Table* in effect makes the outside world function as its internal space, something I am not aware of ever having perceived before.

One reason I was so struck by *Table* is that Ray's table sculptures of the late 1980s and 1990 (there are three in all, including this one) in an obvious sense pay homage to the hundreds of table sculptures that Caro began making in 1966 (and to Brener's *Table Top Sculpture QED* [1981], itself a tribute to Caro). Briefly, Caro at that time became engaged by the problem of how to make small sculptures that would be something other than reduced or maquette-like versions of the larger abstract pieces that he had been constructing with great conviction for the

53

54

previous six years. The problem, in other words, was how to make small sculptures whose smallness would be built into them, part of their form or essence or syntax (more on the last term shortly) and not merely an external, contingent, literal fact about them. And the solution turned out to be to run or extend at least one element in every table sculpture below the level of the table top on which it was placed, a move that meant that the sculpture in question could only exist as such on a table and not on the ground. In effect this built a distinction between tabling and grounding into the pieces themselves, a distinction evocative of and indeed ultimately based on the fundamental difference in scale between the sorts of objects we routinely encounter and use on tables and the often much larger objects we expect to find on the ground.[5] Ray was familiar with Caro's table sculptures and admired them enormously, but what I want to stress is that there is no equivalent in Caro's art for the sheerly spatial emphasis of Ray's *Table* and more broadly for the particular intensity of Ray's career-long preoccupation with considerations of space. (One index of that preoccupation has been his deep feeling for the figural pieces of Alberto Giacometti, a body of work I think of in distinctly non-Caroesque terms.) Put slightly differently, Caro's concern with syntax – which is also to say, his radically abstract artistic imagination – throws virtually all the emphasis in his pieces on the relations among constituent elements, including the table top or the ground, leaving the question of the relation of the piece as a whole to its ambient space a matter to be determined exhibition by exhibition. (It should be said that Ray himself finds the going-off-the-edge structure of Caro's table pieces spatially compelling.)

In contrast, what Ray sought in *Table* was a more neutral, self-effacing form of relationality, by means of which he hoped to activate the ambient space in a particular way. So for example selecting the six objects to go on the table top and then deciding on their precise placement relative to one another took more than a year. Not only did Ray consider hundreds of Plexiglas glasses, beakers, jars, vessels of all sorts, before making his final choices, there followed a months-long struggle to relate them to one another and to the table top in a way that seemed to him not to imply any narrative or "dialogic" content, however abstract, among

them – though he admits to being particularly pleased by the way the cotton jar with the lid almost surreptitiously introduces a note of stoppage of the flow of space that is otherwise absent. More broadly, Ray's search for a mode of relationality that would almost be one of non-relationality – that would be all but invisible – went against the grain of the entire still-life tradition in painting, in which relations of formal, material, and subject-matter-based similarity and contrast among objects on a table top are basic to the conception of individual works, and in fact *Table* is a deeply antipictorial piece. It is also why looking at a photograph or a slide or a computer image of *Table* tells one almost nothing about it.

"Everything in Caro's art that is worth looking at – except the color – is in its syntax," I wrote in 1963 (p. 273), a condition Greenberg subsequently equated with "an emphasis on abstractness, on radical unlikeness to nature" and further glossed by writing, "No other sculptor has gone as far from the structural logic of ordinary ponderable things."[6] Ray's vision, as exemplified by *Table*, is otherwise; one might say that he has made a specialty of subverting that structural logic as if from within while seeming to leave the appearance of ordinary object-likeness more or less intact. However, this too has much more to do with Caro's precedent – dialectically, as it were – than with the work of various artists Ray is often held to resemble: Duane Hansen, for example, or Robert Gober, neither of whom seems to me in his class artistically or philosophically. (I think of both as tainted by Surrealism, a quality Ray tends to avoid like the plague it mostly is, not that that is all there is to the superiority of his work to theirs.)

Finally, there is Ray's *Fall '91* (or *Big Lady*) (1991), an eight-foot high female fashion mannequin with long auburn hair, dark red lipstick, and painted nails, dressed in a bright rose jacket and skirt, and standing with her weight on one shapely leg and her hands on her hips – a figure of transcendent poise. (There also exist two similar mannequins in different poses and wearing different costumes also entitled *Fall '91*; I myself have not seen the one I have just described, but I did see the long-haired blonde wearing a blue suit and making an unreadable gesture with her partly raised right hand in a exhibition curated by Jeff Koons

55

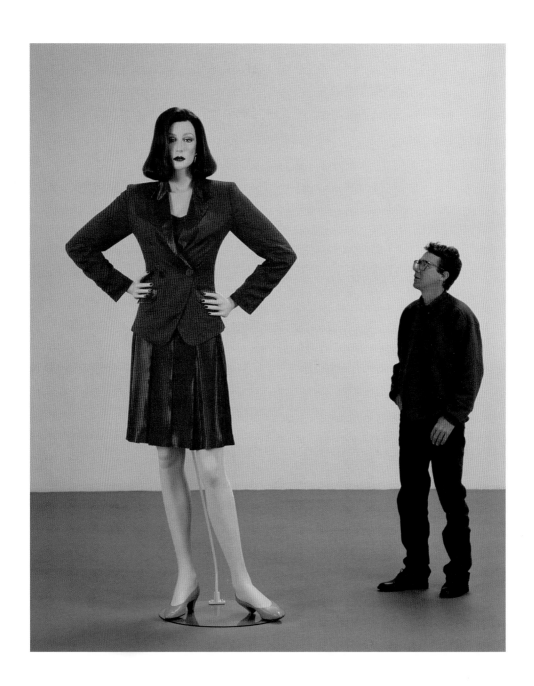

55 (*facing page*) Charles Ray, *Fall '91 (Big Lady)*, 1992. Mixed media, 243.8 × 66 × 91.4 cm. The Broad Art Foundation, Los Angeles.

56 Anthony Caro, *Early One Morning*, 1962. Steel and aluminum, painted, 289.6 × 619.8 × 332.8 cm. Tate Britain, London.

at the New Museum in New York in early 2010.) In interviews and conversations Ray has compared the experience of seeing the first of these at a distance and then close up with that of viewing Caro's *Early One Morning* (1962) in the Tate in London from the "front" (that is, from a vantage point that maximizes the separation among the individual elements) and then from the end opposite the upright flat, looking down the spine of the piece; as regards the Caro, Ray has said, the effect is of a dramatic compression of space as the viewer moves from the first angle of approach to the second. (Before getting to know Ray, I had thought that I was alone in relishing that accelerated second perspective!) This is not exactly what happens as one walks toward the *Big Lady*, but Ray feels there is a comparably dramatic shift of spatial relations relative to the viewer's sense of the size of his or her own body as the scale of the sculpture increasingly makes itself felt. Of course, in the case of *Early One Morning* the effect of compression is the result of relationships internal to the piece, whereas in that of *Big Lady* the shift mainly concerns the relation of the sculptor to the viewer, which may seem to belong to the esthetics of Minimalism/Literalism as I have characterized them. But the *Big Lady* I encountered at the New Museum is not at all a generic object

56

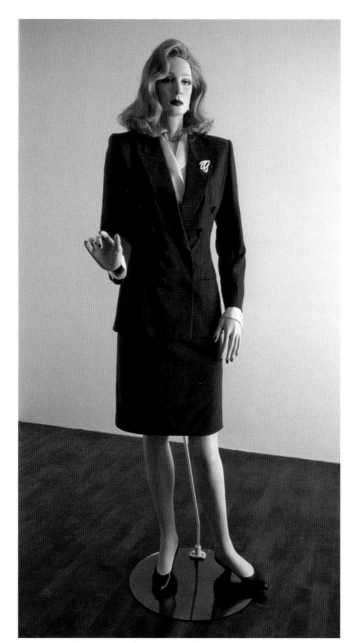

57 Charles Ray,
Fall '91 (Big Lady), 1992.
Mixed media,
243.8 × 66 × 91.4 cm.
DESTE Foundation for
Contemporary Art,
Athens, Greece.

along the lines of Tony Smith's *Die* and comparable works. Rather, its activation of the viewer's sense of embodiment has everything to do with the fact that it is an oversized department-store mannequin (exactly how oversized is, of course, crucial; Koons's installation of the blonde version in a much too crowded space along with disparate works of no quality did everything possible to blunt its precision). Indeed *Big Lady*'s stylishly and aloofly representational character along with its refusal of eye contact – basic to the manikin formula – achieve an equivalent to the internal self-sufficiency of the Caro while also negating the abstract anthropomorphism of *Die*, thereby further "legitimating" the effect on the viewer that Ray describes. If this seems dialectical with respect to both Caro and Minimalism/Literalism, it is. In any case, Ray's fascination with *Early One Morning* led him to illustrate it on the cover of the catalogue for his 1998 retrospective in Los Angeles.[7]

57

Much more might be said about the Caro–Ray connection but instead of pursuing that topic further I want to consider four recent pieces by Ray, each of which in its own way exemplifies his concern with embedment, a concept that I believe makes a serious contribution to sculptural reflection generally. These are: *Hinoki*, a remade fallen oak tree, shown in the spring of 2007 at Regen Projects in Los Angeles and today in the modern wing of the Art Institute of Chicago; and a trio of works, *Father Figure*, *The New Beetle*, and *Chicken*, which he showed in the fall of that year at Matthew Marks in New York. In the course of dealing with these, other works will come up as well.

58, 59
68, 70, 74

First, *Hinoki* (2007; the name comes from that given to cypress wood in Japan). The story of the genesis of *Hinoki*, a thirty-two-foot long, carved "reproduction" of a fallen oak tree or log, is by now fairly well known owing to numerous articles and interviews with the artist. Here, to begin with, is Ray himself in *Artforum*:

> I found the log when I was going back and forth up the Central Coast one winter. I could see it from the road, embedded in this very green meadow. I

was immediately attracted to it and stopped the car. I liked its decomposed state. It had been maybe thirty years on the ground. Another ten and I think it would have disappeared back into the earth. I kept going back to look at it, knowing I wanted to do something with it, and not a naturalistic version of the car wreck [a reference to Ray's *Unpainted Sculpture* (1997), about which I shall have more to say in a moment]. But I couldn't figure out what its sculptural armature might be. Everything has an armature, every idea, every object. Once you locate the structure of something, you can start to think about it.

I tried to purchase the log, and the property owners wouldn't sell it to me. So I hiked for about a year on the Southern and Central Coast, hoping to find another beautiful log. But I realized that it wasn't *a* log so much as this particular log's form I was after – it had almost a platonic form, whose integrity I wanted to re-create. It was partly rotted, and there was this magnificent chamber through it – your eye just drifted right through.[8]

So Ray one day drove to the field with a truck, some men, and a saw, and cut up the log and hauled the pieces – some as large as a table, others, including hunks of bark, quite small – away to his studio. Now he had to figure out what he wanted to do with it all. At first he considered reproducing the log in inflatable material (pursuing the thought, based on the hollowing out of the center of the log, that the latter's armature was *pneuma*, breath), using external print for the surface detail, but soon realized that that was not practicable (he would in effect have gained a balloon but lost the tree). Eventually he decided to have the log remade in wood by a team of expert craftsmen in Japan, one normally occupied in recarving traditional Japanese sculptures, Buddhas and the like, when they had to be replaced.

This involved making silicone molds with plaster mother molds and casting the log in fiberglass, both inside parts and outside parts. Then the "log" was fitted back together, at which stage Ray built a large saw that could cut it into pieces again. He cut it into five barrels, which in turn were mounted on steel panels that allowed the barrels to be reassembled so that the original form would lock into

58–62 (*above and pages 94, 96–8*) Charles Ray, *Hinoki*, 2007. Cyprus wood, 172.7 × 970.3 × 609.6 cm. The Art Institute of Chicago. Through prior gifts of Mary and Leigh Block, Mr. and Mrs. Joel Starrels, Mrs. Gilbert W. Chapman, and Mr. and Mrs. Roy J. Friedman; restricted gift of Donna and Howard Stone, 2007.771.

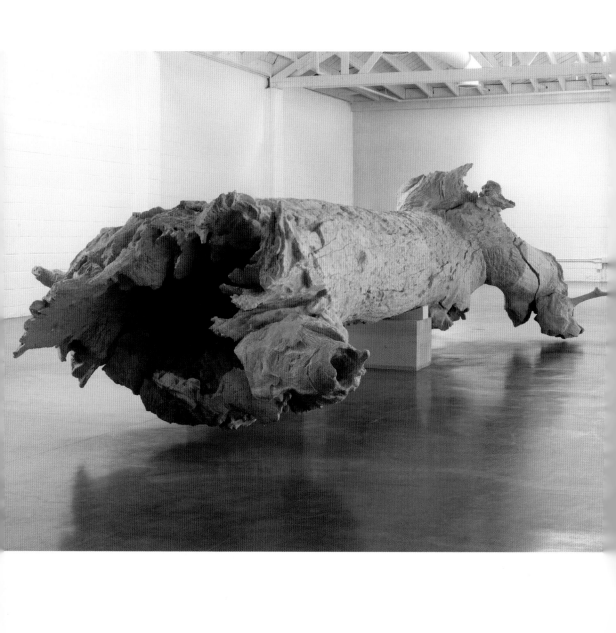

place. These were then shipped to Osaka and the work began of using that form as the model for carving the new log barrel by barrel in laminated blocks of cypress wood or hinoki. The separateness of the barrels enabled the carvers (a team of perhaps seven in all under the master carver Yuboku Mukoyoshi) to study the interior grain patterns, which Ray cared about deeply. Over the next years the carvers finished the inside of the log and then laminated the barrel forms together and worked on the exterior. The carving of the whole piece took about five years, during which time Ray visited the workshop every two and a half or three months, spending roughly a week there on each visit studying the remade log's progress to date and talking with the carvers.[9]

Three decisions proved crucial. The first, at the start, concerned the light-colored cypress wood itself, which initially Ray did not like but in the end accepted as inevitable, since it was the material of choice for the carvers with whom he was working. In his words:

> It felt nice, but it was weird, off-putting. But then I thought, "Well, this *is* a carving material." And I had been looking for a material shift [from the rotting oak tree to walnut or some other familiar wood]! So I decided to go along, to follow where I didn't know what would bring the sculpture to completion. I thought: "Well, it's going to really have to carry itself on the form," not on the transformation of material . . . And so everything shifted for me. (pp. 46–7)

A further aspect of that shift occurred when Yuboku explained that after 400 years the wood would go into crisis for 250 years, after which it would emerge from the crisis but go into a slow decline for another four centuries or so. In effect Ray had to set the piece adrift in his mind to undergo that fate, which unlike the fate of works of art in the West could be predicted with relative certainty.

The second decision (in fact the third but I am placing it second) had to do with how to exhibit the work as a whole once it was done. When the tree was first raised from the earth in which it had partly sunk Ray saw that it was not absolutely straight but rather slightly bowed or curved. As a result there was about a foot between the bottom part of the tree and the ground; the question was how

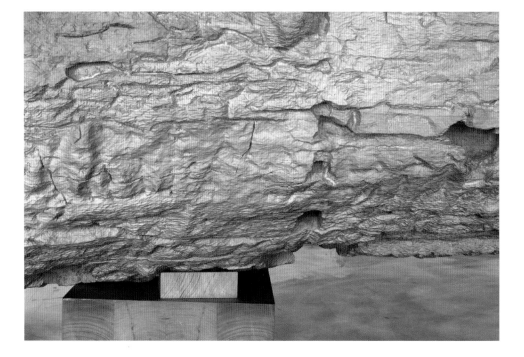

to deal with this sculpturally. Ray felt that the recarved log would look beautiful just bridged, but he also realized that it would not hold over time in that position but would inevitably collapse. Eventually the decision was made to support the piece from below at two strategic points with simple cypress blocks, an essentially "Asian" option – another "going along" on Ray's part – which in my view works perfectly.

The third decision, the most difficult, had to do with the degree of finish to which the sculpture was eventually to be brought, which is to say with the question of how faithful to the surface detail of the original log Ray wanted his remake to be. At first he imagined an almost photo-realistically accurate finish, perhaps with the middle left more generalized and the ends made more exact. But as time went on that became less attractive to him. About a year and a half from the end

of the process, he arrived in Osaka to discover that the work had been taken to a stage he positively disliked: the entire surface had been covered with shallow marks all oriented in a single direction like fur or metal filings under a magnet. This was unacceptable, and at his request the carvers spent another year eliminating those marks, returning the surface to a less regimented, more diversified state, with deep and shallow gouges, cuts, chisel marks, drill holes, even numerous bits of wood shaving left in place along with stretches of glossy surface of a sort that the carvers, on the basis of their own esthetic ideas, found difficult to let stand (but Ray made them do so). Finally Ray asked the team to stop working on the log for a few weeks, during which he thought hard about precisely how he wanted it to look. Then he had the carvers return to it again for perhaps another two weeks, at which point he decided it was finished.

61, 62

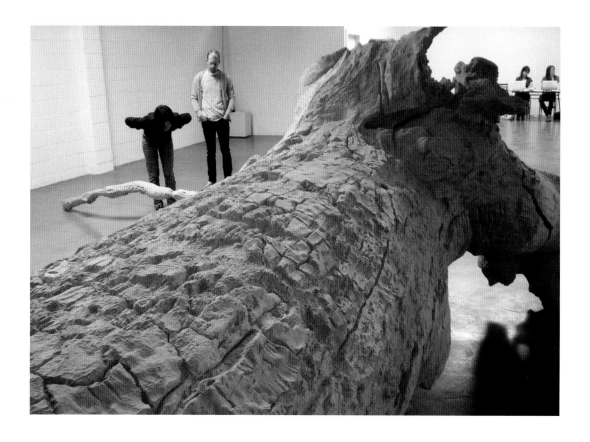

Anyone in the least familiar with Ray's career will have already recognized that *Hinoki* is one of a series of works, including *Unpainted Sculpture* (1997) and *Untitled (Tractor)* (2003–5), the basic proposal of which involves remaking something that already exists – in the case of the former a wrecked Pontiac Grand Am (circa 1991), in which the driver had died, in that of the latter a somewhat ancient broken tractor with an exposed engine abandoned in a field. His way of proceeding was different in the two cases. In both he had the original vehicle taken apart piece by piece, but to remake the car he cast the individual pieces in fiberglass and painstakingly reassembled the whole; the substitute wreck with its

crumpled, slammed back hood, battered door, and twisted body was then uniformly painted with a grayish primer that gives the sculpture a strangely unmetallic, almost immaterial character. As for the tractor, once it was completely disassembled Ray handed the individual pieces over to a team of assistants, with instructions to reproduce those pieces by hand in clay; when this was done he had the reproductions cast in aluminum and, using these, reassembled the new tractor inside and out, though he also omitted some internal elements for the sake of simplicity (also because he preferred the look of the inside with less clutter). The "feel" of each of the works is also quite distinct: as Ray himself has noted, the viewer relates to *Unpainted Sculpture* as to a flowing three-dimensional configuration, almost as if it were a single complex abstract form. (Unfortunately, the roping off of the piece at the Walker Art Center – necessary to keep visitors from touching it – impedes perception of this.) In contrast, the viewer of *Untitled (Tractor)* – no vehicle could be less streamlined – finds himself or herself looking closely and lingeringly at individual elements – the tire treads, for example, or the detached radiator grill or the many components of the exposed engine – registering, knowingly or otherwise, the subtle inflections and irregularities, marks of personal handling, bestowed on each by the assistant who made the clay model used for the final casting. In other words, *Untitled (Tractor)* invites a slowness and an intimacy of perception entirely consistent with one's sense of the overall gravitas of the sculpture as a whole. As is perhaps already evident from my brief account of the labors of the carvers in Osaka, *Hinoki* has much in common with *Untitled (Tractor)* in this regard.

Another point worth stressing is that both *Unpainted Sculpture* and *Untitled (Tractor)* show a concern for relations of inside and outside: in the case of the first, this is mainly a matter of the flow of space between the two (Ray has compared the piece to a Klein bottle), though it also mattered to Ray that the interior of the car's trunk be cast precisely, along with the detachable spare tire contained within it. The trunk, however, is sealed – it cannot be opened – and even at the time Ray suspected that that was a limitation. (One might say: the treatment of the inside of the trunk and the detachable tire was a literal rather

than a sculptural feature of the piece.) *Untitled (Tractor)* goes further in the same direction, but *Hinoki*, with its hollowed out center running from end to end, goes further still: Ray's initial response to the fallen tree in its unreconstructed state was above all to that dimension of its form, and no aspect of the project of remaking was more important in his view than the task of rendering the inside of the carved log with fully as much thought and care as the outside, despite the fact that much of the former would inevitably be inaccessible to ordinary viewers. In his words:

> The air underneath *Hinoki* [because of its curved form] is its location embedment, its embedment in the room, while the air inside it offers a kind of space that's much harder to define, a spatial embedment disconnected from location. People talk about architecture, placement in a room, but I think the artfulness of a work is how it's spatially embedded, its geometry. From there, other things,

63 Charles Ray, *Unpainted Sculpture*, 1997. Fiberglass and paint, 152.4 × 198.1 × 434.3 cm. Walker Art Center, Minneapolis.

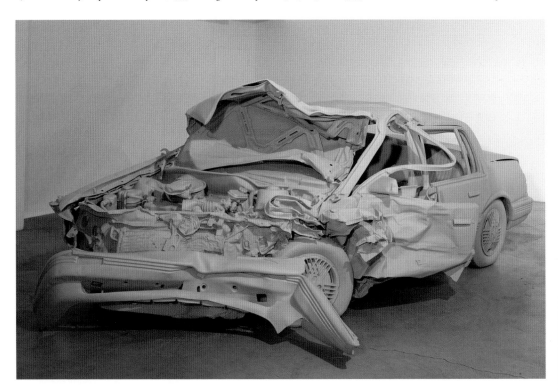

like its poetics, sprinkle out. There are some great David Smiths whose spatial embedment makes you feel that if you were to turn them, the whole world would turn with them.[10]

Ray's hope, naturally, is that *Hinoki* might be like that, and in its initial showing at Regen Projects, where it was by itself in a large space penetrated by natural light, its command of its enviroment – of that quarter of the world – was indeed tremendous. (Embedment, one might say, concerns the placement of a sculpture in the world rather than simply in a room; or if in a room or gallery, the latter are imagined as a region of the world.[11])

Finally, crucially, more needs to be said about the quality of *Hinoki*'s densely worked, extraordinarily varied, and yet marvelously consistent-seeming material surface, which the viewer apprehends as man-made at virtually any distance but truly takes in as the product of considerable labor only at very close range, as with

64 Charles Ray, *Untitled (Tractor)*, 2003–5. Cast aluminum, 158 × 278 × 137 cm. Astrup Fearnley Museum of Modern Art, Oslo.

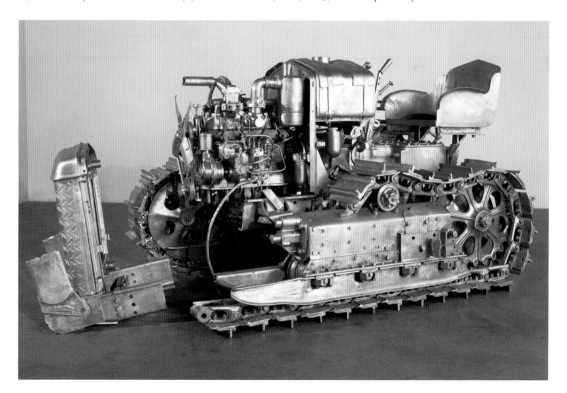

Untitled (Tractor) only more intensively. For me (I said as much to Ray, who immediately agreed) what is most compelling about the surface is the extent to which the viewer perceives literally everything that has been done to it – every join, gouge, cut, or hole, every smoothed patch or area, every tiny curl or remnant of wood shaving, in short every mark or trace of making, however large or minute – as a signifier or, better, a carrier of authorial intention. (This has since become part of the standard account of the piece. Ray, lyrically: "You can see those traces as you travel around the sculpture – it's almost like music, these swirls of intentionality. That's what gives it its life."[12]) Here the relevant comparison is with the work of the contemporary German photographer Thomas Demand, who since the mid-1990s has proceeded by reconstructing in colored cardboard lifesize models based on media images of actual rooms or other locales in which something notorious or otherwise newsworthy has taken place, and then making large-scale color photographs of those models – after which the latter are allowed to collapse; they are of no further interest to him. As commentators have not failed to remark, perhaps the most striking fact about his photographs is that the remaking in cardboard of the original scene is carried out in a manner that subtly but unmistakably signals the fact of Demand's own handiwork. The question is why he does this – more broadly, why he chooses to operate in so labor-intensive a manner – and the answer I propose in *Why Photography Matters* (see chapter 9) is that Demand's project has been precisely to choose scenes of places that one expects to be filled with historical traces of one sort or another and, by remaking them in the way I have described, to produce photographs that are saturated with traces of nothing other than his own artistic intentions – not just the general intention to reproduce the scene but the specific intentions involved in remaking it at every point, so to speak. A further, more medium-specific dimension of that project emerges when it is borne in mind that photography as an image-making technology has traditionally been viewed as "weak in intentionality," in John Berger's phrase, but that need not detain us here (though it is of the greatest importance with respect to Demand's project, and indeed to the present significance of photography in a larger sense). What I want to stress at this juncture

is that the thematization of the artist's intentions in Demand's photographs invites comparison with the treatment of the wood surface in Ray's *Hinoki*, and that both stand in the sharpest, most emphatic opposition to the bias toward indeterminacy in Minimalism/Literalism. Caro's sculptures, too, are anything but indeterminate, as are those of David Smith and countless other sculptors and painters prior to Minimalism; the difference is that none of those artists, Caro included, ever felt called on to *thematize* intentionality as both Demand and Ray, and in a different register Sala (in the presentation of Moondoc's playing in *Long Sorrow*), have found it necessary to do. Indeed *Hinoki*'s remarkable authority as a work of sculpture is for me inseparable from my sense of it as an ontologically extremely dense intentional artifact, the intentions in question belonging in the first place to Ray – who discovered and became obsessed by the original log, removed it from its resting place, sawed it into pieces and carted them away, reconstructed a model of the log in his studio, then closely oversaw the long process of remaking it in another material in a distant country, and finally figured out how best to support it physically and sculpturally – and in the second place, through a far from simple act of delegation on Ray's part, to Yuboku and his team of carvers who worked for five years as a collective expression of Ray's artistic will but whose traditional training and perhaps also whose personal inclinations are inevitably and everywhere inscribed in the surface of the piece, including, consistent with Ray's instructions, the surface of its hollow core. For all the quasi-transcendental magnificence of *Hinoki*'s overall configuration, the project of giving it artistic form in the fullest sense of the word and at the same time seeking to embed it in the world turns out to have required nothing less. As if the weight or density of so much concentrated intentionality functions as an ontological counterforce to Ray's original empathic sense of the years of sun, rain, and ultraviolet radiation that had hammered down on the original log – "the pressure was just incredible," he once said to me – and in another five or ten years might well have driven it to the point of collapse.

In the remainder of this essay I want briefly to discuss three sculptures that Ray showed at the Matthew Marks Gallery in New York in the fall of 2007: *Father Figure*, a massive enlarged replica of a child's toy, a green plastic tractor and driver; *The New Beetle*, a "realistic" sculpture of a naked four-year old boy sitting on the ground and playing with a toy car (a Volkswagen, hence the title); and *Chicken*, a sculpture of an egg within which, through a small opening in the shell, one

65 Charles Ray, installation at the Matthew Marks Gallery, New York, November 2007.

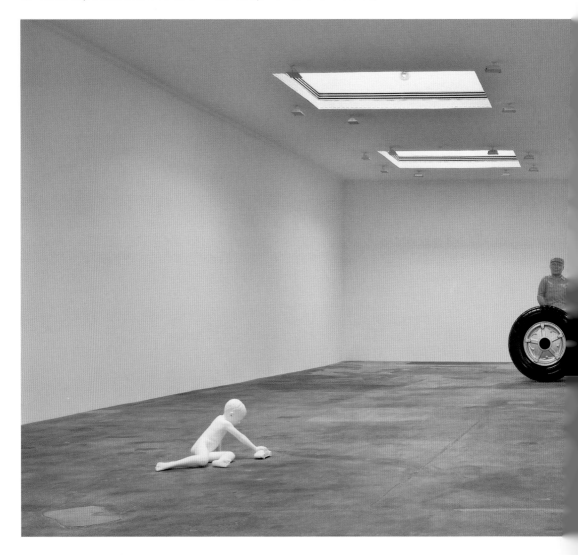

glimpses an embryo chicken come to term and ready to hatch. The ensemble of the three pieces in a single large space was a *tour de force* of presentation in that the viewer's relation to each was utterly distinct, and yet the three together seemed to charge the entire room with a sense of sculptural energy that the viewer registered as such almost before he or she could take in the individual pieces themselves. (Ray is a superb installer of his own work.)

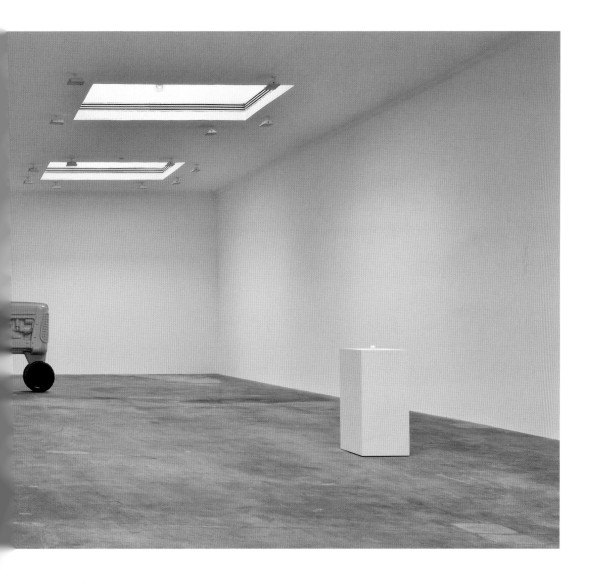

First *Father Figure*. The original "source" of *Father Figure*, the tractor and driver, was a smallish and somewhat crude, indeed old-fashioned-looking, green plastic toy that was sent to Ray by his friend the artist Kiki Smith some years ago (probably responding to Ray's enlarging of a toy fire engine in an earlier sculpture). The whole issue in Ray's practice of remaking already existing objects or artifacts – *Hinoki* being a spectacular case in point – deserves more attention than it can be given here. On the one hand, Ray insists, no doubt correctly, that he has no stake in the existence of the source objects as such. "I don't care about the tree," he has said in conversation, though in all sorts of ways he cared about it passionately, but not strictly for itself – rather for the sculpture he sensed could be brought into being on its basis. On the other hand, remaking has increasingly turned out to be an indispensable medium of sculptural production for him, even as he has also found himself thinking hard, at least intermittently, about whether there might be some way for him to work abstractly with equal originality and force – one more respect in which the example of Caro remains compelling for him. (The whole issue of the difficulty of abstraction for Ray is another fascinating topic that will have to wait for a future occasion.)

66 A table-top in Ray's studio; the original toy (right) and an early enlargement of it.

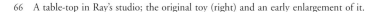

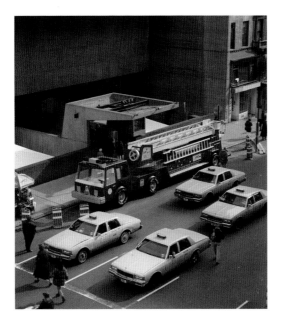

67 Charles Ray, *Firetruck*,
1993. Painted aluminum,
fiberglass, Plexiglas,
365.8 × 243.8 × 185.4 cm.
The Eli Broad Family
Foundation, Santa Monica;
Courtesy Gagosian Gallery,
New York and Los Angeles.

In the case of *Father Figure*, Ray was struck by the crudeness of the original toy, with "[its] unusual stylization, akin to ancient sculpture: the figure's legs face forward in the seat, while his torso and head turn 90 degrees outward" (a quotation from the Matthew Marks press release, no doubt drafted by Ray). Simply put, what Ray eventually came to apprehend in the toy – after years of having it around and thinking about it – was the possibility of remaking it at a much larger scale, eight feet high and ten feet long, and in a material, solid machined steel, so as to embed (that word again) the final sculpture in the world – in the first place in whatever room or exhibition space in which one encounters it – through the viewer's intuition of its sheer mass and weight. (The basic insight being that that particular form with its archaic feel would lend itself to the making of such a sculpture. The remade fire engine, *Firetruck* [1993], by way of contrast, is fabricated chiefly in aluminum painted red; it carries no equivalent connotations and is in every respect a less compelling work.) What in the end underwrites that intu-

67

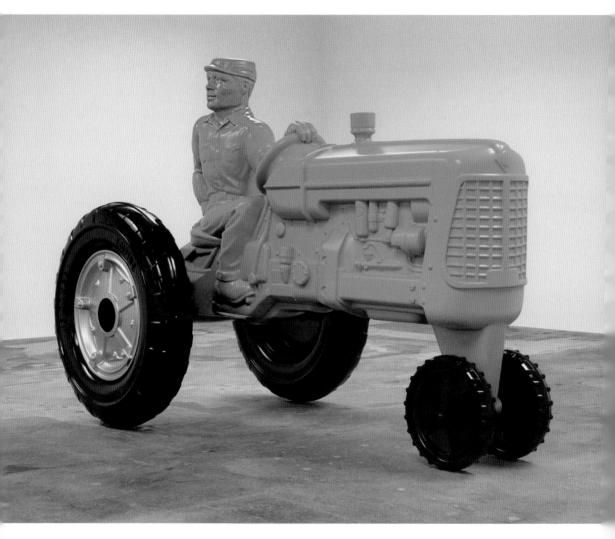

68 Charles Ray, *Father Figure*, 2007. Painted steel, 239.4 × 353 × 118.1 cm. Private collection.

ition, if my experience is any guide, is less the empirical fact of *Father Figure*'s actual weight – eighteen-and-a-half tons! – than the way in which the crudity and rigidity of the figure of the driver, the stylization but also the precision of the treatment of mechanical detail, and, not least important, the surprising narrowness of the tractor in its long dimension, combine to rule out the least suggestion of hollowness as well as any hint that the work has simply been blown up to the monumental scale it now occupies. Furthermore, Ray suspected that machining the solid steel from a steel block rather than seeking to cast the tractor and driver from a mold would contribute to the impression of massiveness, along with boldly spraypainting the otherwise finished work in bright green, black, and silver. And of course it was essential to get the scale exactly right: too small and the archaic note would not have come off; too large and the piece would have dissipated its potential force.

In general, Ray's remade or say reproductive sculptures depend for their success on exact rightness of scale before all else. This is also true of certain non-reproductive works: as regards *Puzzle Bottle*, for example, no decision was more important than that of the exact size of the painted wooden sculpture of Ray relative to the dimensions of the bottle: too small and the effect would have been pictorial, the bottle serving simply as a kind of container or frame; too large and the figure of Ray would feel confined, cramped, straining to burst out. For the piece to come off, to be truly sculptural, which in this case meant to be about the space inside the bottle, the scale relations had to be exactly right, and my sense is that they are.[13] Then they depend on the correct choice of material transformation, which in the case of *Father Figure* meant not only steel but also machining rather than casting. Then on the precise degree of stylization in certain details – a point of extreme, nearly unresolvable difficulty, it often turns out (hair being a particularly difficult feature to get precisely right). Finally there is the matter of the correct choice of color and surface texture. Put it this way: nothing could be further from such pieces than the least hint of improvisation, arbitrariness, or compromise once the source object has been selected; their success as art depends absolutely on their conveying a sense of total determination, which is also to say that experiencing them as art involves assessing the rightness of all the

69

69 Charles Ray, *Puzzle Bottle*, 1995. Glass, painted wood and cork, 33.9 × 9.5 × 9.5 cm. Whitney Museum of American Art, New York.

decisions (all the intentions) that went into their making. There exists no more unabashedly "esthetic" art than Ray's reproductive sculptures, for all the seeming accessibility, the user-friendliness, of their external appearance. Ray's attitude, in other words, is worlds apart from Koons's autograph blend of lowest-common-denominator feel-good esthetics with merely technological perfectionism, just as it is from Serra's overbearing but all too often ultimately undemanding monumentalism.

It is also important to note that although *Father Figure* is closely based on the original toy, Ray thoroughly reworked the forms of the tractor and driver as well as various details with the aid of a computer program that turns three-dimensional information into virtual clay that can then be "sculpted" with a stylus that allows the user actually to feel resistance as he or she employs it – in other words, Kiki Smith's gift was a source of inspiration rather than a model in the strict sense of the term. (The original tractor was green, as mentioned above, but the particular shade of green of the final piece perfectly suits Ray's aims, for reasons that defy explanation.) In any case, there is no piece quite like *Father Figure* in Ray's previous work; Caro's *Night and Dreams* (1990–91), an epitome of massiveness and density in a wholly abstract idiom, would make a fascinating comparison if the two could be placed on view together.

Next, *The New Beetle*, arguably the most impressive of the three sculptures at 70–72 Matthew Marks and one that represents a new departure for Ray. According to Ray, the inspiration for it goes back a long way, but actual work began with searching for the right toy with which to set off the figure of a boy. Once the Volkswagen was chosen it was a matter of settling on the boy's pose, which Ray did by trying various poses himself and, in his words, "feeling himself into the sculpture." At that stage Ray began working with a four-year-old boy (the son of a friend), taking numerous photographs while the boy sat on a turntable; measurements of various body lengths were also taken over a period of time. A figurative sculptor was hired to rough the figure out in clay; following that, one of Ray's assistants took over. After a year or two, during which Ray tried to find out all he could about children's proportions at that age, he cast the clay into Forton (a plasterlike substance). The next stage, a protracted one, involved taking

70, 71, 72a and b (*above, facing page, and page 114*) Charles Ray, *The New Beetle*, 2007. Painted stainless steel, 52.7 × 107 × 58.4 cm. Private collection.

the Forton version to San Diego where Chris Pardell, a professional sculptor, would correct the anatomy, then returning it to his studio and removing the "hand" that Pardell had brought to the work. This process went back and forth several times and various new molds were made. The final two pulls were in plaster, which is easier to tool than Forton. "The process of working on the sculpture was a bit like bouncing a ball back and forth between people; the trick was in guiding or directing the ball" (Ray, naturally). When the plaster sculpture was finished a new mold was made and waxes pulled. From there it was cast in stainless steel and reassembled at Carlson's, the fabrication factory Ray uses for all his heavy work. (Or rather, the one he used until, in April 2010, it suddenly and without warning went out of business.) The toy car, in Ray's mind a crucial element, was sculpted in his studio by one of his assistants in a more tight or technical manner than the boy and then cast separately. Once again the juncture between the two elements, where the boy's hand grasps the car, was a focus of particular concern. Finally, the entire piece, boy and car together, was painted white (finding the exact shade of white was far from easy). I mention all this so as to spell out some portion of the long and complex series of decisions, operations, delegations, and reflections – of intentions and their modifications – by virtue of which *The New Beetle*, for all its seeming simplicity, came into existence.

As for the finished sculpture, let me begin by suggesting that partly owing to the boy's pose and no doubt also his air of self-containment, about which I shall have more to say, the viewer is led to walk around the piece so as to view it in the round, to take it in from every available angle of vision, to appreciate at close range its deeply pondered marriage of sculptural realism and slightly abstracted or virtualized finish. As well as to take in the delicate stylization involved in the

rendering of the boy's face and hair, not to mention the figure's seemingly just faintly smaller than lifesize scale – but that may be an illusion – and its perfect proportions, a consideration to which, as the above remarks suggest, Ray devoted the minutest attention. Again, taking my own experience as a guide, all these together exert an undeniable magnetism that gains in strength the more closely one looks, until one finds oneself – I am not alone in this – actually squatting or kneeling on the ground so as to scrutinize as intimately as possible the boy's expression or the treatment of his hair or the precise manner in which he supports his upper body with his left arm and hand and extends his right to grasp and presumably, in a moment, to move the car. I mean that it comes to feel imperative to do these things, at the risk of otherwise settling for an insufficiently serious engagement with the work and therefore, to use Ray's language once more, of missing the force of its embedment, which at Matthew Marks seemed to me

prodigious. By now it should go without saying that I regard the placement of *The New Beetle* directly on the ground as bearing a relation to Caro's breakthrough abstractions, the originality of which included the fact, much discussed in the early 1960s, that they were so presented. (It was usually said that Caro had "eliminated the pedestal," for which of course there were precedents, but his true accomplishment in that regard was that he made sculptures whose structure and syntax were such as to require their placement on the ground. *Midday* on a pedestal would be travesty of itself; likewise *The New Beetle*.) But I know of nothing in Caro's oeuvre comparable to the forcefulness with which, if I am right, *The New Beetle* is felt to dictate the terms in which the viewer relates to it. The result, I need hardly add, is a resolutely anti-Minimalist/Literalist emphasis on the determination of the viewer's response to the work, which is also to say on the primacy of the sculptor's intentions with respect to how the work is properly to be seen.*

One further aspect of *The New Beetle* is perhaps the most momentous of all relative to Ray's prior development and that is the young boy's apparent state of

*Having contrasted *Hinoki*'s and then *The New Beetle*'s thematization of intention with Minimalist/Literalist indeterminacy, I should however acknowledge that Ray is on the record as admiring at least one work by Donald Judd, *Untitled* (1968), which he comments on in the last sentences of a publication accompanying an exhibition that he curated at the Matthew Marks Gallery the summer of 2006. "If you can imagine a fourth direction perpendicular to the three that we know," he writes, "you could understand why shoelaces can only be knotted at home in our three-dimensional space. Looking at the beautiful Judd sculpture reproduced in this book, one sees a three-dimensional structure. I am not a four-dimensional creature but while looking at the Judd I am privileged to see its internal and external structures simultaneously. Like a being from any dimension this sculpture is totally and completely embedded in the space of its existence. I am reminded of Aristotle's disbelief in the fourth dimension: his proof of its nonexistence was that he could not point in its direction" (Charles Ray, *a four-dimensional being writes poetry on a field with sculptures*, exh. cat. [New York, 2006], n.p.). Ray's interest in the simultaneous visibility of internal and external structures in Judd's piece has obvious implications for his own practice.

mind as he plays with his car. The press release from which I have already quoted describes him as "intently playing with a toy car," while one critic speaks of his "rapt concentration,"[14] a choice of words that plainly goes too far but, precisely by doing so, testifies to what I have called the "magic" of absorption. In fact the topic came up in the Introduction to this book apropos of Martin Schwander's equally excessive response to Wall's *Adrian Walker* (Schwander described Wall's protagonist as "a young man who is concentrating so intensely on his work that he seems to be removed to another sphere of life"). I went on to comment on the prevalence of the theme of absorption in much recent art photography, and added that "the resort to absorptive themes and motifs goes hand in hand with an implicit address to the viewer," and although that is not exactly what one finds in the case of *The New Beetle* it is close enough to warrant drawing the connection. (Ray has spoken of having been partly inspired by Thomas Eakins's magisterial *Baby at Play* [1876] in the National Gallery of Art in Washington, D.C., which depicts a very young girl seated on the floor playing with lettered blocks, though a parallel association might be with certain works of antique sculpture such as the famous *Spinario*, a Hellenistic study of a seated boy engrossed in drawing a thorn from his foot, or indeed with various genre paintings by Chardin.) In any case, the young boy's seeming state of mind, focused on the car, marks the new departure referred to above.

Again, some context will be helpful. Starting in 1990 Ray based a series of sculptures on department store mannequins, all of which – following the so-called Sears standard for their manufacture – appear to be gazing off into the distance rather than making eye-contact with the viewer. As Ray explains in the interview with Storr cited earlier, only if that is the case does the viewer feel free empathically to "project" into the mannequin; otherwise the "projection" is aborted and the result seems merely uncanny – not a result department stores actively seek (p. 103). Something like the same strategy is in force in the strongest of Ray's figural sculptures prior to *The New Beetle*, the marvelous *Aluminum Girl* (2003) – a standing, naked, lifesize figure in cast aluminum based on the artist Jennifer Proctor. (*Aluminum Girl*, another deceptively simple-seeming work, is in my view

73 (*facing page*) Charles Ray, *Aluminum Girl*, 2003. Cast aluminum, 158.8 × 47 × 29.2 cm. Astrup Fearnley Museum of Modern Art, Oslo.

a masterpiece of the integration of stance, scale, material, stylization, and color – of total determination; it is worth a trip to Oslo's Astrup Fearnley Museum of Modern Art just to see it together with *Untitled [Tractor]*.) By the time Ray came to make *The New Beetle*, however, a new possibility had presented itself, one related to his interest in interior spaces and relations of inside to outside as it had found expression in different ways in *Unpainted Sculpture*, *Untitled (Tractor)*, and, most explicitly, *Hinoki*. Ray in conversation has emphasized what he regards as the contrast between the "internal matrix" of the downward-looking boy and the "external matrix" of the somewhat more realistically rendered Volkswagen, presumably on the grounds that despite notionally possessing an interior as well as, again notionally, a transparent set of windows, the toy car in the sculpture nevertheless strikes the viewer as definitively closed to imaginative penetration. I am not sure I would have discovered the contrast on my own, but I have not the slightest doubt – I felt from the first – that the boy's exquisitely nuanced inwardness contributes decisively to the truly astonishing impression of groundedness, centeredness, and immovability – in short, of embedment – that radiates from the sculpture as a whole.

74

Finally, *Chicken*. To quote again from the press release: "The smallest work on view, *Chicken*, is a two-and-a-half-inch long sculpture of a bird egg. Ray began his process by raising chickens in an incubator in the studio. He produced many versions, differing in scale and media, over nearly five years [as always with a team of young assistants working under his direction], until finally settling on the finished work, in which a round opening in the cast steel eggshell exposes a tiny beak and single claw of a porcelain bird, ready to press out into the world." Ready, one might say, to explode into the world, which is what John Kelsey implies when he characterizes an egg as a "bomb of life."[15] What required nearly five years, it might be asked. To answer that question would require documenting the many stages the project went through, with its trial pieces and false starts, but one difficulty that arose toward the end is particularly illuminating. It took a long time but Ray eventually came to realize that the potential explosiveness of *Chicken* as a kind of space-grenade about to go off depended on inducing the viewer to peer

74　Charles Ray, *Chicken*, 2007. Painted stainless steel and porcelain, 6.35 × 5 × 5 cm. Private collection.

into the egg at the still sleeping chick, and that this was not only not facilitated, it was actually forestalled, when the hole in the egg's surface was made jagged, as in actual circumstances – real chicks hatching from real eggs – was invariably the case. At that point Ray had the inspired thought of changing the opening from jagged to round, an "unnatural" shape to which the viewer instinctively responds by approaching closely and looking in. (Ray: "You and the chick meet, so to speak.") Who would have imagined that this could be the solution to a *sculptural* problem?

One last observation goes back, once again, to Caro, whose table pieces turned out to "work" only above a certain minimal size, on the order of feet rather than of inches. Ray's *Chicken*, in other words, is a much smaller sculpture than any Caro has been able to make, and that too, because of the spatial dynamic by which the smallness has been secured, is a notable achievement.

three: color

JOSEPH MARIONI

I said in the Introduction to this book that my basic claim in *Why Photography Matters as Art as Never Before* is that the work of at least sixteen ambitious art photographers from the Bechers to the present may be understood as taking part in a collective exploration of one or another aspect of the core problematic of picture and viewer that I have been tracking in my art-critical and art-historical writings since I first moved away from Greenberg's theory of modernism in 1966–7. The logic of events that led to that exploration is as follows: as the French critic Jean-François Chevrier observed, starting in the late 1970s young photographers in different countries and with diverse formations began to make photographs that not only were larger than serious art photographs had previously tended to be but also – the decisive point – were from the outset intended to be hung on

the wall (that is, they were conceived and executed with such a hanging in view).[1] Crucial figures in the initial stage of that development include Jeff Wall, Jean-Marc Bustamante, and Thomas Ruff (a Canadian, a Frenchman, and a German), though in fact Ruff only began to print his color portraits in large format around 1986; but the blandly confrontational character of the early portraits themselves – perfectly deadpan, for the most part frontal "passport style" head shots of fellow art students against plain-colored backgrounds – epitomizes what Chevrier called the new "tableau form." What Chevrier did not say, however, is that the double development he identified – the making of large photographs intended for the wall – had the immediate consequence (and I mean immediate, from the very first) of compelling the photographers taking part in it, as it would many of their successors, to engage in one or another specific respect with the issue of the relationship between the photograph and the viewer, which in general terms – as the relationship between picture and beholder or, in the 1960s, between work of art and experiencing subject – is the core issue of the entire antitheatrical tradition from Diderot to "Art and Objecthood." My larger claim is that precisely that issue had never before been crucial to the practice of photography as an art, and my further suggestion – hence the title of my book – is that it is above all because starting in the late 1970s the situation changed so radically in this regard – because the relationship between picture and viewer became a matter of fundamental concern to photographic practice – that photography came to assume a deeper or say more central artistic significance than it had ever previously possessed. (Let me be clear: I am not suggesting that Wall, Bustamante, Ruff, and others are better photographers than were Eugène Atget, August Sander, Walker Evans, André Kertész, or Bill Brandt, to mention some giants of twentieth-century photography. Wall in particular has always insisted on the artistic greatness of those and other predecessors. I am saying that the work of Wall and his peers counts artistically – also art-theoretically – in the contemporary situation in a way that the unsurpassed work of the earlier men never came close to doing in theirs.)

What makes the artistic centrality of recent photography especially intriguing to someone with my history is that it has not come about through any direct con-

frontation with issues of literalness and objecthood as far as the material existence of the photograph is concerned. On the contrary, photography seems to have been able to bracket those issues by virtue of its continued reliance on what Wall usefully calls depiction: after all, what to begin with most nakedly exposed high modernist painting to the Minimalist/Literalist critique was precisely its concern by one set of abstract means or another to acknowledge the literal properties of the support, crucially including the latter's overall shape. Simply put, once Stella made his black and metallic paint stripe paintings of 1959–60, in which the organization of the picture could be seen as "deduced" from the shape of the canvas (my claim at the time), the stage was set for a polemical "surpassing" of painting – a "going beyond" it – in the direction of objecthood. Greenberg's notion of the modernist "reduction," and his theorization of modernism in the arts as the continual testing and discarding of inessential conventions, also could be read as supporting such a development. In Judd's words, cited in "Art and Objecthood," moving into three dimensions "gets rid of the problem of illusionism and of literal space, space in and around marks and colors – which is riddance of one of the salient and most objectionable relics of European art. The several limits of painting are no longer present. A work can be as powerful as it can be thought to be. Actual space is intrinsically more powerful and specific than paint on a flat surface."[2] Also *a fortiori* more powerful than the piece of bare canvas tacked to a wall that Greenberg in "After Abstract Expressionism" argued already exists as a painting, "though not necessarily as a successful one."[3]

The new art photography, in contrast, has remained as committed to depiction as earlier photography ever was (which is not to say that it eschews abstraction; the examples of James Welling and Wolfgang Tillmans suffice to show that that is not the case, but depiction remains its primary mode), and in fact the large scale of its colored images, together with the frequent use of Plexiglas affixed to the photographic surface as a means of protection or simply the framing of the images behind Plexiglas, has enhanced the sense of illusory spatiality far beyond anything hitherto known. (I am illustrating Andreas Gursky's *Salerno* [1990] but I could just as well have chosen works by Wall, Ruff, Höfer, Demand, Dijkstra,

75 Andreas Gursky, *Salerno*, 1990. Chromogenic process print, 188 × 226 cm.

Delahaye, or a host of other post-late 1970s photographers.) Wall as a matter of fact has not hesitated to endorse the very notion of opticality that, taking off from Greenberg, I elaborated in my first writings on Pollock and Morris Louis, and that subsequently became a target of choice for post-Minimalist/Literalist critics of the *October* school, Rosalind Krauss especially. (I do not say this aggressively but I invite the reader, when the opportunity next presents itself, to stand ten to fifteen feet – normal looking distance – from a great Pollock of 1947–50 such as *Number 1, 1948* or *Autumn Rhythm: Number 30, 1949* or indeed *Out of the Web: Number 7, 1949*, with its cut and scraped away areas of paint on Masonite, and try to see each of those works as exclusively a material surface rather than, to a significant degree, as an optically illusive field. It cannot be done.) In Wall's essay

"Frames of Reference" (2003), in which he reviews his thinking about photography in the 1970s and '80s, he paraphrases my argument in "Art and Objecthood" as follows: "[Fried] proposes that, when works of art allow themselves to be reduced to their apparently fundamental ontological status as physical objects and relinquish the illusionism that has always distinguished them, something significant is lost." He continues:

> Fried understood "illusionism" to mean not traditional perspectival illusion but its subsequent form as the "optical" qualities of what he thought to be the best abstract painting of his time. I understood opticality to refer both to abstract painting as Fried intended but also to traditional pictorial illusionism and, as part of that, to the optical character of photographs. I was fascinated to watch Fried abruptly shift his focus from abstract art to nineteenth-century pictorial art at the end of the '60s. I intuited that there was an important affinity between his interests and mine.[4]

(Wall in the 1970s and 1980s was well ahead of me in this, but starting in the mid-1990s I began to catch up with him.)

One more quotation from "Frames of Reference" is pertinent:

> I read "Art and Objecthood" to say that if an artwork simply cast its lot with physicality and immediacy, it lost its essential possibility as serious art and was reduced to a repetitious staging of the encounter between an object or group of objects in the world and a person looking at that object. It soon became obvious that it was arbitrary what the object was. To those who wanted to go beyond the canonical criteria of Western art, this "staging" of the encounter with the remnant of an artwork appeared to be a new and profound direction. But time has not treated that attitude well. Fried showed that illusion is essential. That aspect of his work connected for me with the problem of the size of photographs, and I realized that, in making photographs in or near life scale, photography could be practiced to a certain extent differently from the way it had been. (p. 178)

Wall's invention of the lightbox transparency as a medium for his art contributed to that different practice, though it is important to note that along with its enhanced powers of illusionism and indeed its modernist foregrounding of the physical constituents of the making of his pictures the backlighting was thought of by him "as a sort of preservation of some aspect of literalism in the construction of the picture" (p. 179) – a formulation that belongs on the side of what I call to-be-seenness. More broadly, Wall retained a basic appreciation of certain aspects of the Minimalist/Literalist intervention, which he recognized could not simply be gainsaid. "So even though I wanted my work not to be literalist," he writes in the same essay, "I appreciated the way Judd or Andre forced the issue of present time and present space; it made the question of life scale more complex and interesting to me than it would have been if it were just a reworking of seventeenth- or nineteenth-century pictorial approaches" (p. 178). In particular, Minimalism/Literalism forced the issue of the present-time, present-space relation of the picture to the viewer, an issue which, as Wall's reflections imply and as *Why Photography Matters* tries to spell out, could not be resolved by illusionism alone. (It is also at work in different ways in the art of Sala, Ray, and, as will be seen, Gordon.)

So much, at this juncture, for the new art photography. The question I now want to raise is a different but related one, namely, what has been, how should one understand, the fate of *painting* in the wake of Minimalism/Literalism and subsequent developments (Conceptualism, Post-Conceptualism, Post-Modernism generally, and indeed the rise of the new art photography)? This is a large and complicated question. The short answer is that painting has suffered badly – that with the exception of a handful of famous names (almost all artists now in their sixties or older) it has largely been relegated to a subsidiary place in the world of art – this after having been by far the dominant "visual" art form of the 1940s, '50s, and first half of the '60s, though it is also clear in retrospect that during those last years it was already under severe pressure. Two of those exceptions, Robert Ryman and Brice Marden, will be of interest shortly; a third exception, Gerhard Richter, deserves mention in this context for the simple reason that his

entire oeuvre, abstract and representational, has been predicated on the impossibility of contemporary painting living up to its glorious past, including the heroic age of earlier modernity. Put slightly differently, Richter's canvases (and "windows," mirrors, and so on) are place-markers for a painting he himself regards as no longer possible, or perhaps even desirable.[5] This is why it makes little sense, standing before a group of stylistically similar pictures by him (such as the early "Pop" canvases, the large smeared abstractions, the allover gray canvases, the blurry photographic paintings, the color charts, the mirrors), to ask oneself which of them is the best; they are all, essentially, individual instances of one or another general proposition of an elegiac sort. In other words, his decades-long project, carried out with formidable energy, ingenuity, and persistence, has not been to make paintings that can stand comparison with the great painting of the past – the modernist mantra – but rather to provoke the viewer to a different sort of understanding of his intentions, which is also to say that his paintings actively raise the question of the intentions behind them, of their generic if not specific motivatedness. (Even the series of pictures entitled *October 18, 1977*, based on the deaths of Baader-Meinhof gang members in prison, is reticent as regards its underlying attitude toward its subject.) Obviously this is much too simple but it suffices to remove his work from the orbit of modernism, which, as Greenberg never tired of stressing, is concerned with quality above all else; at the same time, precisely by raising the question of intention, Richter's work distances itself from the clichés of Minimalist/Literalist or indeed Post-Modernist indeterminacy, and to that extent looks back to modernism in a certain sense.[6] Richter's is a curious achievement and probably a unique one.

Not that prestigious New York galleries with spectacular spaces no longer show new painting – that cannot quite be said – but almost all of the painting regularly on view is so devoid of quality or seriousness or even interest as to stun belief (this has been true since the 1980s, the age of Neo-Expressionism); today's art-world hype in support of figures like John Currin and Lisa Yuskavage, to name two younger "stars" (both happen to paint representationally but that is not the point), suggests a crisis of sensibility so profound it can scarcely be exaggerated.

Against this background, which I have barely sketched, I want to focus in the remainder of this essay on a single figure, Joseph Marioni, whom I regard as the strongest painter of whom I have knowledge at work anywhere today. Let me say right off that this will be a somewhat different sort of essay from the others in this book. For one thing, abstract paintings like Marioni's lend themselves hardly at all to detailed interpretations of individual works of the sort I have tried to provide for two of Sala's videos and a number of Ray's sculptures, and as will be forthcoming in the essay on Douglas Gordon. For another, of all the traditional parameters of painting color in particular is universally recognized as the most difficult to talk about meaningfully, and the very heart and soul of Marioni's art consists in its handling of color. Then, too, I will be making use of two earlier texts by me on Marioni, reviews of shows by him at Brandeis University (1998) and at the Peter Blum Gallery in New York (2006).[7] Finally, there is bound to be in my remarks at least a hint of frustration that the magnitude of Marioni's achievement has not been more widely recognized, but I will try to keep this last under control.

Some basic facts, then. Marioni was born in Cincinnati, Ohio in 1943 (making him the oldest of the four artists in this book), and studied at the Cincinnati Art Academy between 1962 and 1966, and at the San Francisco Art Institute from 1966 to 1970. While in Cincinnati he also worked in the restoration department of the museum there, an experience that gave him early first-hand knowledge of materials and pigments. In 1972 he moved to New York, where he continues to live, though since late 2004 he has also owned a building, a former lodge, in Tamaqua, Pennsylvania, which he quickly converted into a studio space that has enabled him to make larger paintings than were feasible in his much smaller studio on Eighth Avenue. He dates his mature production from 1970, when he was 27, which is to say that that production now comprises forty years of work.

Marioni himself identifies four main roots or sources (my term) for his art. First, his father, a doctor, was an amateur painter and had numerous art books

in the house. The youth pored over them; Marioni recalls especially loving the volumes with illustrations of Renaissance art, portraits in particular. He remembers with pleasure an illustration of Giovanni Bellini's great portrait of the Doge Leonardo Loredan in the National Gallery in London. What makes this recollection all the more interesting is that Marioni's abstract paintings are for the most part more like portraits than landscapes, while his technique, to be described in a moment, amounts to a modern updating of traditional glazing, Bellini's method of working until late in his life (*Loredan*, however, is in oil and tempera).

The second root or source is Abstract Expressionism, especially the abstract color-oriented wing of Rothko, Still, and Newman, as opposed to the more figurative wing of Gorky, de Kooning, Kline, and others, which Marioni became impressed by in his late teens and twenties. One memorable experience in this regard was seeing Still's *1951–52* (1951–2), a commanding thirteen-foot wide, mostly black painting in the Chicago Art Institute at some point in the early 1960s and being struck by its scale, surface, color – its overall force. Subsequently Marioni met Still and for a time gave his widow informal advice about the condition of Still's paintings. It took longer for Marioni to find his way to Newman; Rothko, like Pollock, was always a staple for him. His first visit to New York took place in 1964, and predictably MoMA was a revelation.

The third key event followed Marioni's move to New York from San Francisco in 1972, when he was 29. Almost immediately he established a connection with Robert Ryman, whom he had met the year before, and in 1974 with Brice Marden, who at Artists' Space gave Marioni his first gallery show in the United States. Once again the sense of dialogue was important to him. The somewhat strange position in which I find myself with respect to this straightforward historical fact is that as a champion of Color Field painting (about which more in a moment) and an opponent of Minimalism/Literalism, I failed until recently to recognize the merits of Ryman and Marden; whatever appreciation I now have of their importance I owe largely to Marioni. In particular Ryman's seemingly unending "Realist" investigations of the various material means and conventions of painting – surface, pigment, paintbrush or other implement, signature and date,

76, 77

support, nails or fasteners or other devices for attachment to the wall, indeed the relation to the wall as such, considerations of lighting and of the larger room or (Ryman's term) "situation" in which the work is encountered, and so on potentially ad infinitum – all of them conducted on the basis of an arbitrarily extremely restricted palette (white with occasional traces of other hues, mainly from underneath) – tended to leave me cold, or at least cool. I could see the intelligence and beyond that the "theoretical" interest of his operations but the pictorial reward, at least after the early years, which is to say after the "Realist" project got under way, seemed to me, perhaps wrongly, somewhat meager. (It is no accident that a characteristically brilliant essay on Ryman by Yve-Alain Bois ends with a mini-

76 Robert Ryman, *Untitled*, 1972. Enamelac on canvas, 152.5 × 152.5 × 3.6 cm. © Robert Ryman, image courtesy of Collection Lambert en Avignon.

dialogue with himself that goes as follows: "– And what about beauty? You didn't speak about beauty in Ryman's work. – This is a most important, most difficult question. But that will be for another time."[8] Apropos of beauty, on a recent trip to New York I saw at Yvon Lambert two 1972 Rymans, both five-foot squares, both fluidly executed in enamelac with horizontal strokes, in other words both paintings in the simplest and fullest sense of the term, which rank for me at or near the very top of his oeuvre.) Worse, until a few years ago I simply failed to give Marden's early monochromes, both single canvases and matched sets of two or more canvases in closely related subdued hues, and painted in a mixture of oil paint and hot wax, the consideration they deserve – largely because they were monochromes, which I indiscriminately thought of as a Minimalist/Literalist alternative to ambitious painting rather than, in certain hands, as ambitious painting in its own right.

77 Brice Marden, *D'Après la Marquise de la Solana* Monochrome. Oil and wax on canvas, 195.6 × 297.2 cm. Three panels. Solomon R. Guggenheim Museum, New York, The Panza Collection.

The fourth crucial experience took place in the late 1970s with Marioni's first forays to Europe, especially Germany and Switzerland. It was then that he connected with the strain of postwar European painting, strongly inclined toward though not restricted to the monochrome, that has gone by various epithets, including "absolute," "radical," and "concrete"; among the painters associated with this loose denomination are Helmut Federle, Raimond Girke, Gotthard Graubner, Peter Tollens, Gunter Umberg, and (later) Rudolph de Crignis. Marioni became especially friendly with Umberg and for roughly ten years they were in dialogue with one another; their joint essay of 1986, *Outside the Cartouche: The Question of the Viewer in Radical Painting*, marks an epoch in Marioni's thinking and will be discussed below. Besides offering a sense of community that had been lacking for him in the United States, the "absolute" group opened to Marioni the work of other European artists he had known about but had not adequately seen, such as Lucio Fontana, Pietro Manzoni, and Yves Klein. Marioni's maximum European involvement belongs to the years 1978–88; in 1988 the Museum Abteiberg in Mönchengladbach (West Germany) gave him his first one-man museum show, and to this day his art is probably more present on the European scene than in the United States. More than anything else, his European experiences served to confirm his own growing involvement with the monochrome, or painting of a single color, in his case layered in a manner to be discussed below. In addition, between the respective orientations of Ryman and Marden on the one hand and the "concrete" painters on the other there was a partial consonance of purpose and attitude that was helpful to Marioni.

A fifth factor, not a root or source but rather the absence of one, is also worth noting. Despite his intense commitment to color from an early date, Marioni's art had in the first place nothing directly to do with Color Field painting – the art of Helen Frankenthaler, Morris Louis, Kenneth Noland, Jules Olitski, and Larry Poons, to name its major practitioners. This for several reasons: first, by 1972, when he arrived in New York, the heyday of Color Field was over in that the period of maximum innovation was past (Olitski, the key figure after Louis, had begun painting with spray guns as early as the spring of 1965); and second,

a reaction against what had been the dominance of Color Field as the last phase of high modernism in painting was already under way. Initially this took place under the impetus of Minimalism/Literalism, but quickly became widespread and indeed continues to this day. (Frank Stella, a main focus of my early art criticism, was never a Color Field painter but his stripe paintings and protractor series pictures bear a close relation to the work of the painters I have just named, especially Noland and Poons. The fate of his reputation during the past few decades is a somewhat different story that I cannot go into here.) Another factor working against Color Field – understandably, though also, it must be said, largely mindlessly – was and continues to be a violent reaction against what had been for a time the tremendous personal authority of Greenberg, the "discoverer" and early champion of Louis, Noland, and Olitski, and former mentor to Frankenthaler, a reaction usually framed in terms of a repudiation of "formalism." But of course Greenberg's theory of modernism and indeed his "formalist" mindset have not the least bearing on the quality or lack of it of the art he supported. Undeniably, however, Color Field failed to develop painters younger than Larry Poons (b. 1937) whose art sustained the level of that of the older figures, not that its detractors would have noticed if it had. Mixed with all this there has also been a much more general, even cultural, decades-long turning against color, or perhaps I should say against adventurous or expressive color, "deep" color, color that is asked to bear the burden of artistic reflection – as opposed to the use of merely primary or cosmetic or lurid or technical-industrial color in (for example) Andy Warhol's silkscreen pictures, in the work of Pop artists such as Robert Rauschenberg, Roy Lichtenstein, and Jim Dine, in John Chamberlain's sculptures made out of crumpled automobile parts, in Jasper Johns's flags and maps (his basic color, of course, is gray, while the overall sense his work conveys is of an indifference to color as such), in Stella's colored stripe and protractor paintings, in John McCracken's planks, in various pieces by Judd, in Richter's color sample pictures, gray pictures, and "painterly" abstractions, in Ellsworth Kelly's shaped canvases, and so on and on; Ann Temkin's 2008 MoMA exhibition catalogue, *Color Chart: Reinventing Color, 1950 to Today*, surveying the impact of commer-

cially available paints on the American and European art of the period, usefully documents the latter tendency – presented as a flowering of color, not a reining in, naturally. Finally, Marden's work since the late 1980s has depended crucially on drawing rather than color; this is also true of the work of two other widely admired older artists, Cy Twombly and the late Agnes Martin. At least in the United States, Marioni's art has had to make its way against this prevailing bias from the very first.

It is high time to begin to turn to Marioni's paintings themselves – in the first place, to one of the works that made so powerful an impression on me when I first saw the survey exhibition of his art at the Rose Art Museum in the spring of 1998: *Red Painting* (1996), a work acquired shortly before by the museum. By the standards of Marioni's art at the time, it is relatively large, 72 inches high by 69 inches wide. As has remained characteristic of his work, it was made by the layering of waves of translucent acrylic paint into and atop a linen support. More precisely (and shifting to the present tense), Marioni proceeds by first preparing the support: a slender wooden framework is made for him to exact specifications – more on these in a moment – and the linen – one or another weave of Belgian linen graded from very fine to coarse carefully chosen depending on the kind of painting he has in mind – is washed and then ironed by him before being stretched (in the course of stretching he often tugs it slightly out of straight, to build a certain tension into the canvas itself). The paint is prepared by mixing one or more pigments into an especially pure and clear water-based acrylic medium, and is then transferred to the linen with a long-handled lambskin roller which he wields with both hands. He thinks of this as a "full-body" transfer, which seems right; the painting process is actively physical, without the painter seeking for a moment to impress the evidence of his body into the finished work. (On a visit to his studio in Tamaqua in the spring of 2007 I painted a large red "Marioni" under his direction, in order to understand the process corporeally and not just intellectually. Toward the end, on the second day and while applying the fourth paint layer, I began to get the hang of what I was doing.) In any case, a single color is applied, rolled on, from the top of the canvas down, in sufficient

78 Joseph Marioni, *Red Painting*, 1996. Acrylic and Linen on Stretcher, 182.9 × 175.3 cm. Rose Art Museum, Brandeis University.

quantity to establish a downward flow. The paint layer is therefore thinner toward the top of the canvas than toward the bottom, and when a lower layer is darker than a subsequent one, as is almost always the case, it makes itself felt accordingly. I mean the underlayer shows through more toward the top of the canvas than toward the bottom; there is something slightly counterintuitive about this – the paint being thinner and the color darker toward the top – but because it makes sense materially it subtly underscores the material reality, the actualness, of the painting as a whole.

A particular painting might comprise anything between two and six layers of paint – four is probably the norm. As the paint descends, it tends physically to draw in from the side edges of the canvas; except in his largest paintings Marioni partly compensates for this in advance by having the sides of the support taper very slightly inward from top to bottom. Similarly, as the paint flow reaches the bottom edge it tends to collect there, a tendency he seeks to counteract by rounding that edge so that excess paint will drip off; there is still a certain amount of "collection" but less than would otherwise be the case, and in the form of individual droplets rather than a raised ridge or line. All these tendencies are visible in *Red Painting* and its details. Sometimes he gently sandpapers portions of a paint layer if he feels it will help the reception of the layers to follow. Finally, the painting is hung in a manner that at once quietly declares its separation from the wall (unlike Ryman he distinguishes sharply between the wall and the work) and tilts it very slightly toward the beholder. Marioni in the act of painting is also not averse to tampering with the flow of paint, by redirecting it here or there with a finger, by nudging it more aggressively with the roller, or even by pushing some of it back up toward the top of the canvas and allowing it to descend once more. But he regards it as crucial that nothing in the finished work feels drawn or marked in any way, and more broadly the overall impression, as numerous commentators have not failed to observe, is of the painting's having "made itself" – an impression much like the one I attributed to Morris Louis's stained acrylic paintings more than forty years ago. (I compared that aspect of Louis's art to the French poet Stéphane Mallarmé's notion in his essay "Crise de vers" of the "pure

work [that] implies the elocutionary disappearance of the poet, who yields place to the words, mobilized by the shock of their inequality; they take light from mutual reflection, like an actual trail of fire over precious stones, replacing the old lyric afflatus or the enthusiastic personal direction of the phrase."[10] I went on to quote a remarkable passage from the American poet Hart Crane's "General Aims and Theories," written in 1925, in which in a somewhat Mallarméan spirit he imagines a kind of poetry he calls "absolute," of which he says, "Its evocation will not be toward decoration or amusement, but rather toward a state of consciousness, an 'innocence' [Blake] or absolute beauty" [p. 127]. Both citations seem to me apposite to Marioni's art.)

Each painting by Marioni bears the title of a single color – blue, red, green, yellow, white, black, or (a recent addition) violet. To that extent they are indeed monochromes, as they are often called, even by the painter himself. However, each layer of paint in a single painting differs from the others in hue, density, and transparency/translucency/opacity (though on rare instances two layers are more or less identical), so the term monochrome is to that extent a misnomer (not that the question of terminology matters in the least). Indeed nothing is more decisive for the final result than the choice and preparation of the individual layers; it is precisely Marioni's long experience working with these materials that enables him to envisage in advance the way in which the different applications of paint will interact and bond in the course of making the picture, though of course the result is often at least somewhat surprising to him, for better or, from time to time, for worse. (His New York studio is carpeted in fine Belgian linen, the painted sides face down.) Thus *Red Painting* comprises four separate waves of acrylic paint: a black underlayer, which was not at all usual in Marioni's work, another dark layer on top of that, and then two translucent rather than transparent reds, probably, he now thinks, Cadmium Litho Red rather than more violet shades, his intuition at the time being that since the picture was so close to square in format – usually his red paintings were and are more strongly vertical – the color itself needed to be more opaque, more resistant to the eye, in short more "blocky," than his red paintings tended to be. As can be seen even in a

reproduction, the final wave of thinned pigment was somewhat lighter in hue than the penultimate one; its downward flow is everywhere palpable, as is the difference in thickness of paint of different areas of the surface. The dark under-layers are visible at the left- and right-hand edges of the canvas (especially the right; looked at long and hard, Marioni's pictures almost always imply a certain lateral movement, usually from left to right, derived no doubt from the fact that he is right-handed, along with the downward flow of the paint) as well as at the bottom of the canvas, where the red layers gather in drips that go off the edge.

To take an example from a few years later, *Blue Painting* (1998), a smallish work – some twenty-four by twenty inches – briefly discussed in my *Artforum* review of the Rose Art Museum show, comprises four separate waves of acrylic paint: an indathrone ground, blue-black; a layer of ultramarine, a reddish blue, thin, completely transparent, virtually substanceless; a layer of thalo blue, a green-blue, relatively thick; and finally an extremely thin layer of cobalt blue, an opaque color but at that degree of dilution rendered translucent, almost but not quite a glaze. Yet the different layers of paint bind together both materially and visually so as to give rise to a single, prolonged, intensely engrossing "experience" of darkish blue, one that implies a sense of space or depth and indeed of contained lumi-nosity but at the same time continually returns the viewer to the material surface in all its sensuous immediacy. (Going through the Brandeis exhibition it became apparent that Marioni's development over the years had been away from opacity toward translucence, from resistant, laterally spreading surfaces to ones that invite the viewer "in," as with the passage of time he became all the more explicitly a painter of glazes. I am not the only person who, viewing the more recent can-vases, has thought repeatedly of Vermeer.) Especially in *Blue Painting*, as in numerous other works of the past dozen or more years, the surface, approached closely, reveals itself as vertically "ribbed," as though the tendency of the descend-ing paint to gather toward the middle of the canvas resulted in a kind of fine-grained curtaining. Indeed when one looks even more closely, the horizontal weave of the stretched linen is also in evidence – this too is a common trait in Marioni's work. In any case, as has already emerged, the viewer of a particular

80

painting invariably is aware of the layering that went into it, above all because toward the edges and along the bottom of the canvas especially in the corners – more rarely, within the heart of the painting as well – underlayers are allowed to show. The effect at times is of an impersonal but exquisite touch not unlike that in certain Asian ceramics. Moreover, the result of this highly refined interplay between the physicality of the support (the precise quality of the linen, the subtle shaping, the rounded bottom edge, the separation from the wall, the slight hanging bias toward the viewer) and the materiality of the pigment is double. It gives rise to an impression of esthetic coherence and autonomy, that, again, is almost Eastern in its very impassiveness; at the same time, that interplay, which a patient viewer of Marioni's paintings comes increasingly to savor, compels a recognition of the separateness of the elements, which is to say of the composite nature of each individual work (as in Ryman's "Realist" paintings but in a wholly different, sensuous rather than "theoretical" spirit). Some of this can be intuited in reproduction but no illustration can begin to capture the absolute specificity, in the two paintings under discussion, of the ultimate hue, or the tensile integrity of the paint surface, or the suggestion of depth within or behind that surface, or, least of all, the transfixing intensity of the whole. By the way, it is by no means accidental that *Red Painting* is much larger than *Blue Painting*: one of Marioni's discoveries over the years has been that the different colors are also, in effect, so many archetypes, dark blue as a color requiring formats of limited size while red turns out to call for a more expansive way of working (green and yellow are more expansive still). There is also a certain seasonal aspect to his enterprise, blue lending itself to work during the winter months and yellow in particular to the light and the heat of the summer.

Until several years ago Marioni's paintings almost without exception were vertical rectangles, sometimes, as in *Red Painting*, approaching the square – "portraits" rather than "landscapes," to his way of thinking. Then with the acquisition of the Tamaqua studio it became possible for him to make more ambitious paintings than ever before, and as the paintings have grown in size – eleven feet in height seems to be the maximum of his painter's reach – they have also in some

80 Joseph Marioni, *Blue Painting*, 1998. Acrylic and Linen on Stretcher, 60 × 50 cm. Private collection.

81 Joseph Marioni, *Painting 2006*, 2006. Acrylic and Linen on Stretcher, 330.2 × 304.8 cm. Private collection.

instances explored the horizontal rectangle format. The first show of Tamaqua paintings took place at Peter Blum in New York in 2006. What was immediately striking, at first almost jolting, about the new work (I wrote at the time) is that it departed from the delicately layered and sensuous coloristic and factural register of his most characteristic paintings of the previous ten or more years. Not that multiple layers of transparent and translucent acrylic were not everywhere in evidence; but the overall effect of the layering, at the new scale, was less overtly sensuous than it was revealing of the internal structure, the constructedness, of the individual paintings. So for example in a magnificent large dark canvas (gray-

82 Joseph Marioni, *Painting 2006*, 2006. Acrylic and Linen on Stretcher, 274.3 × 335.3 cm. Private collection.

blue over orange over white over ochre) just slightly more vertical than square, 81
jagged, flamelike internal figuration unexpectedly recalled the forms in certain of
Louis's dark Veils (such as *Terranean* and *Tzadik*), though with an altogether more
material facture. (Even more Veil-like in its figuration and proportions was an
incandescent green canvas that struck a coloristic note unlike anything in 82
Marioni's work before that time. Both canvases, incidentally, bore the title
Painting 2006, like all the other new work in the show.) Moreover, the dark
picture's sheer size – eleven by ten feet – in combination with the perceptual
difficulty caused by its extreme darkness, had the effect of calling into question

the apparent seamlessness associated with Marioni's previous work, only to arrive at a different sort of pictorial integration that stood at the very limit of viable scale. I felt strongly at the time that the dark painting might well be on a par with the best Stills, let us say.

More recently Marioni has made two series of four large yellow paintings (the second of which I have not seen in the flesh; it was shown in the Basel Art Fair in June 2009); three from the first series, each titled *Yellow Painting* (2007), were part of an exhibition of eighteen paintings by Marioni held at the McNay Museum in San Antonio between October 2008 and January 2009.[11] All were horizontal rectangles and each had a distinct character of its own: one, extremely pale, had a singularly delicate surface, with striations visible throughout; the flow of pigment was downward, as always, but the color seemed to rise and not to stop so much as evanesce, become dematerialized, in the upper reaches of the canvas. The other two were more robustly yellow or even yellow-ocher, but they differed from each other with respect to surface quality and above all density, one of the two comprising only three transparent layers of paint with no body color at all; not surprisingly the weave of the linen made itself felt even more than usual. Also at the McNay was a beautiful dark violet painting from 2004 (one glimpsed a darkish green/blue layer underneath, as the last dark red frontal glaze stopped short near the top), three ravishing white paintings (2001, 2003, and 2006, each markedly different in color-feeling from the others), a dark red and a lime green painting hanging alongside each other (both 2000), two strong dark green paintings (both 2004, one more olive than the other), and a group of smaller canvases in a range of different hues. It was an extraordinary ensemble, lit in part by natural light, and deserved to have been seen by a wider audience than found its way to the McNay.

Earlier I said that Marioni's inspiration as colorist and more broadly as a painter lies in the first place in the work of the great American colorists of the Abstract Expressionist generation, Still, Newman, and Rothko (Still especially, because of the materiality of his paint); and in the second, in a dialogue not just with the early work of Ryman and Marden, both of whom he came to know after moving

83 Joseph Marioni, *Yellow Painting*, 2007. Acrylic and Linen on Stretcher, 271.8 × 299.7 cm. Gifted to the Museum of Fine Arts, Houston. Exhibited: *Joseph Marioni: Liquid Light*, McNay Art Museum, San Antonio, Texas, 22 October 2008–18 January 2009.

84 Joseph Marioni, *Yellow Painting*, 2007. Acrylic and Linen on Stretcher, 266.7 × 259.1 cm. McNay Art Museum, San Antonio, Texas. Exhibited: *Joseph Marioni: Liquid Light*, McNay Art Museum, San Antonio, Texas, 22 October 2008–18 January 2009.

85 Joseph Marioni, *Yellow Painting*, 2007. Acrylic and Linen on Stretcher, 276.9 × 305 cm. Paul Rodgers, 9W, New York, and Collection of the artist, New York. Exhibited: *Joseph Marioni: Liquid Light*, McNay Art Museum, San Antonio, Texas, 22 October 2008–18 January 2009.

86 Joseph Marioni, installation photograph, Wade Wilson Gallery, Houston, 2007–8.

to New York, but also with the strain of postwar European painting variously characterized as "absolute," "radical," and "concrete". The chief hallmark of the "radical" or "concrete" attitude – to use the two terms that Marioni has favored – has been its emphasis on the painting as material object, a cast of mind that departs fundamentally from Minimalism/Literalism precisely in its commitment to painting as an art rather than to the "surpassing" of painting in and through the projection of objecthood as such. Yet the concern with objectness on the part of "radical" or "concrete" painters also has meant that their work has been armed not only against certain obvious kinds of external critique to which Color Field painting found itself exposed but also, ultimately more significantly, against the *internal* imperative the latter found itself facing – so I argued in my essays of 1966–7 – to defeat or suspend its own objecthood. A crucial dimension of that

87　Joseph Marioni, *White Painting*, 2003. Acrylic and Linen on Stretcher, 132.1 × 106.7 cm. Collection of the artist, New York. Exhibited: *Joseph Marioni: Liquid Light*, McNay Art Museum, San Antonio, Texas, 22 October 2008– 18 January 2009.

88　Joseph Marioni, *Green Painting*, 2000.　Acrylic and Linen on Stretcher, 81.3 × 76.2 cm. Collection of the artist, New York.　Exhibited: *Joseph Marioni: Liquid Light*, McNay Art Museum, San Antonio, Texas, 22 October 2008–18 January 2009.

89 Joseph Marioni, *Red Painting*, 2002. Acrylic and Linen on Stretcher, 61 × 50.8 cm. Collection of the artist, New York. Exhibited: *Joseph Marioni: Liquid Light*, McNay Art Museum, San Antonio, Texas, 22 October 2008–18 January 2009.

imperative concerned what I called the continued viability of shape, by which I meant

> [shape's] power to hold, to stamp itself out, and *in* – as verisimilitude and narrative and symbolism used to impress themselves – compelling conviction.
> . . . These are powers or potentialities, not to say responsibilities, which shape never until now possessed, and which have been conferred upon it by the development of modernist painting itself. In this sense shape has become something different from what it was in traditional painting or, for that matter, in modernist painting until recently. It has become, one might say, an object of conviction, whereas before it was merely . . . a kind of object [ellipsis in original]. Stella's new pictures are a response to the recognition that shape itself may be lost to the art of painting as a resource able to compel conviction because – as never before – it is being called upon to do just that.[12]

This was, as I recognized at the time, an account of an art in a state of crisis or at least approaching such a state, which is what made the clash with Minimalism/Literalism as significant as I took it to be.

In Stella's Irregular Polygons of 1966, I argued, depicted shape found itself compelled to seek justification from the literal shape of the support, not by wholly matching itself to the latter but by partly doing so, the idea being that there would be a certain transfer of authority from one to the other and back again, so to speak. Thus for example in *Moultonboro II* (1966) the literal shape of the support is that of a triangle having wedged itself into a square but the larger of the two painted triangles only partly coincides with the framing edge while the smaller, internal one does so not at all; and yet both gain the strength to "hold" from their relation to the literal shape of that portion of the canvas. At the same time, the viewer does not perceive the literal shape of the entire painting as a distinct entity. Rather, it is perceived "segment by segment, each of which is felt to belong to one of the smaller shapes that constitute the painting as a whole" (p. 90), the smaller shapes serving to help justify the literal shape in that nonholistic way. The result of *this*, I went on to claim, is that in such works the very distinction between

90

90 Frank Stella, *Moultonboro II*, 1966. Fluorescent alkyd and epoxy paints on canvas, 279.4 × 305.5 cm. Collection Mr. and Mrs. David Mirvish, Toronto.

literal and depicted shape tends to be dissolved – "as though in a painting like *Moultonboro II* there is no literal shape and, therefore, no depicted shape either; more accurately, because none of the shapes that we experience in that painting is wholly literal, there is none that we are tempted to call merely depicted" (p. 90).[13] As a solution to the shape problem this was, I think, incontestably brilliant but it was also nongeneralizable, nonrepeatable. A more widespread solution in Color Field painting during the mid- and late 1960s and after – starting with Olitski's spray paintings, the first of which belong to the spring of 1965 – involved laying down a large expanse of color by one means or another and then *cropping* that expanse in an attempt to discover one or more paintings within it

91 Jules Olitski,
7th Loosha, 1970. Acrylic on
canvas, 273 × 155 cm.
Private collection.

that would precisely, in my words, "stamp themselves out" as shapes, an approach
that resulted in numerous outstanding works by Olitski and Poons in particular
but that at the same time perhaps had something worryingly ad hoc about it,
given the historical logic of the situation. At the same time, cropping as a solu-

tion to the problem of shape had one important consequence: in effect it implied a separation between color and drawing, the latter now understood as taking place exclusively at the limits of canvas (by the delimiting of the canvas, so to speak). Indeed the point soon was driven home by Olitski's use of colored drawing – at first in pastel but soon in paint – in the immediate neighborhood of the edge, as if (I wrote at the time[14]) the vicinity of the edge now provided a zone of something like freedom – for marking, let us say – that once belonged to the heart of the picture.* (Speaking of Olitski, Greenberg in a late interview commented on "how terribly tender the surface of the abstract picture has become. It's why Jules can't come too far into the picture with linear drawing or abrupt changes of hue or value."[15] Something of the kind occurs in certain Stills and, as Greenberg remarked, certain Mondrians.) All this is worth noting if only because for Marioni the difference between painting and drawing, applying color and marking, is very nearly absolute. Not only are his paintings devoid of deliberate marks of any kind, he has also made a large number of superb abstract drawings with oil pastels that combine color with marking in various quasi-systematic ways, as if to demonstrate in practice the fundamental difference, as he understands it, between the two media. (For reasons of space I am not discussing the drawings in these pages.) I might add that the recent art photography examined in *Why Photography Matters* has come up with no "deep" solution to the problem of framing; its attitude toward framing is necessarily conventional, and the frames themselves are inevitably compromises with an elusive ideal.[16]

The "radical" or "concrete" attitude was and remains fundamentally different. So for example in Marioni's and the German painter Günter Umberg's jointly published short essay *Outside the Cartouche* (1986) one finds statements such as:

*Apropos of Olitski, in March 2008, Marioni and I visited the warehoused collection of David Mirvish in Toronto, and there saw a number of large horizontal rectangle Olitski spray paintings from the late 1960s, all of which included drawing in paint along one or more edges. These were new to Marioni, and I was fascinated (also heartened) to see that they greatly impressed him. In effect they became part of a usable past for him from that moment on.

"In the past 100 years painting has made a transition from representing an object to being the object."[17] And: "The radical painting exists as a concrete object in the real world" (p. 20). And: "The question for the painter is – how does a painting today, as a knowable object, present a primordial sensation within the context of its own objectness?" (p. 19). (Objectness, please notice, not objecthood: a choice of words that implicitly directs attention to the particular material and sensuous qualities of the object in question.) The answer, they suggest, has everything to do with color. Thus they write:

> Since the radical painting claims that its meaning is in its experience [a potentially problematic claim, but wait], then its content is inseparable from the material body of the object. Access to its meaning is within the experience of the actual material of the painting [in other words, experience so conceived is as a channel of access to the painting's meaning]. The material itself has perceptual content that is intrinsic to its function. The radical painting is involved with the conscious awareness of the intrinsic structural relationship between paint and support. The support structure is an object whose specific purpose it is to-be-painted. [Note by the way how antithetical this is to Greenberg's notion of a piece of bare canvas tacked to the wall already existing as a picture.] Both the paint and support materials have a physical logic and a logical relationship. That relationship is revealed as the structure of the image in the experience.
>
> The image of radical painting is defined by the essence of its material – painted color. The root source of painting is a color-image. . . . It is important to note that the determination of its being is not a question of the color of the object but rather it is a question of the function of an image whose objectness is color. It is not an issue of an independently existing object whose concrete features can be perceived. It is an issue of essential experience within a relationship of the viewer with a painting. (pp. 23–4)

(They also state: "The meaning of the painting focuses on the painter's aesthetic intention" [p. 18].) This essay was, as mentioned, jointly authored but the empha-

sis on color – the definition of painting as "an image whose objectness is color" – has special relevance to Marioni in light of his subsequent development. Umberg's development over that same period has been much less dramatic, consisting mainly in the production of densely painted black paintings with extremely fragile velvet-seeming graphite surfaces in square formats and of limited size. Not that he has lacked admirers of the stringency of his approach. In Jochen Poetter's words: "The panels absorb the light so consummately that the observer's gaze veritably drowns in their surface – night falls for our eyes, blotting out our vision."[18] And: "Because the picture expresses nothing more and nothing less than itself, its location (the wall surface and room) acquires key significance. It is visible and definable only through the boundaries of the format, the black cut-out on the wall. Only through these does it gain an identity" (p. 104). And, more recently, in James Elkins's *Six Stories from the End of Representation*:

> In order to perceive Umberg's paintings as obdurate flat surfaces, it is necessary to be so close that your nose is almost touching the surface. . . . He lavishes attention on his ground . . . covering it with dozens of layers of powdered pigment, mixing just the right combination of nearly black pigments, all in order to achieve the most concentrated effect of painting within the smallest possible compass of hues, gestures, and values.[19]

As has been seen, Marioni's practice has an altogether more expansive aim, and in any case the "dialogue" between the two artists has long been over.

In subsequent essays and interviews Marioni has amplified his views, mainly by putting further pressure on the notion of the painting's objectness as such. "What is the difference," he asks in an unpublished essay that takes off from a footnote in "Art and Objecthood,"

> between a color in its container and a painted color on the canvas? It cannot be the simple fact of the color, for this would not distinguish the creation of a painting from an industrial product. What distinguishes the Painting has to be the presentation of a color *as image*. And since the image of the actual paint-

92 Joseph Marioni, *Yellow Painting* (detail of pl. 83).

ing is dependent on the condition of its physical being, it would have to be then *the painted quality of the color within the gestalt of its objectness*. That quality is dependent on how it is materially structured. In order for color to determine the image identity of the Painting there must be a corresponding relationship between our feeling response of the visual experience of a color [I take this to mean: there must be a corresponding relationship between our visual and emotional experience of a color], to that of the physical manner in which it is painted. This includes all physical conditions of the Painting's objectness. And this means you cannot paint blue the same way you would paint red or yellow or green [emphasis in original].[20]

It also means that the paint cannot be laid down first as in certain Color Field work and the painting subsequently "extracted" from it by artful cropping, a procedure that implies, as it were in principle, an insufficient regard for the problem of fitting the support to the color image; for Marioni the design and construction of a receptacle, the support, for the liquid pigment, in that sense the "framing," must come first, not last, though of course only the final painting can retroactively justify, make good on, the initial choice of format. Put slightly differently, Marioni aspires to the liberation of color from all sense of limit: at its farthest extent (top, bottom, sides) a painting by him comes to an end, but the flow of color never presents itself as cut short – one's conviction is rather of color fitting itself perfectly to its container (the congealed drips at the bottom of many of his canvases virtually allegorize this state of affairs as one of metaphysical fullness), in effect subsuming the latter in its expressive life. In the language of my argument in "Shape as Form," Marioni's paintings almost palpably bring "literal shape" and "depicted shape" into total, mutually motivated attunement, a relationship, Rex Butler suggests, that may be even "closer" than what I there called "acknowledgment."[21] No wonder I was at once caught offguard and swept away when I first encountered Marioni's work at Brandeis in 1998. As Butler recognizes, his paintings also give a new turn to the distinction between "opticality" and "materiality," each of which, even at close range, may be seen as somehow implying, one might almost say containing, the other.

93 Joseph Marioni, *Yellow Painting* (detail of pl. 84).

Finally, in the course of the past several years there has taken place in Marioni's art a decided shift of emphasis toward an increasingly explicit concern with considerations of light (hence the title "Liquid Light" of the McNay exhibition of 2008–9). "[F]or the practice of painting," he writes in the essay just cited, "color is not just a set of different pigments, it is a system of differentiating light within the atmosphere of its environment. . . . The movement of color is the visual breath of painting." This corresponds in practice to an ever greater exploitation of and control over effects of transparency and translucence, with the uppermost layer of pigment sometimes seeming all but detached from – floating in front of – those "behind" it. Thus Marioni is now able to locate or "place" the light at various apparent inner distances from the paint-surface in a group of canvases

94 Joseph Marioni, *Yellow Painting* (another detail of pl. 83).

of a similar range of overall hues: in one work it appears to come forward, in another to retreat, in a third simply to hover suspended somewhere "behind" the surface or indeed coincident with it; together with the differences in hue and surface that are always present from work to work, this means that superficially similar paintings (yellow ones of like dimensions, say: I have in mind six or seven middle-sized canvases of 2007 that I looked at one after another on a single afternoon in his New York studio) often differ sharply in overall effect, almost as if despite sharing a vertical format they after all belonged to different genres (portrait, landscape, interior, and so on). Within the past few years, too, he has begun to make paintings that actively court an impression of dematerialization, especially in their upper reaches: one of the smaller yellow

95 Joseph Marioni, *silver Yellow*, 2008. Acrylic and Linen on Stretcher, 61 × 58.4 cm. Collection of René Paul Barilleaux and Timothy Hedgepeth, San Antonio, Texas. Exhibited: *Joseph Marioni: Liquid Light*, McNay Art Museum, San Antonio, Texas, 22 October 2008– 18 January 2009.

95

paintings in the McNay show had been painted on a silver ground and seemed to volatilize as one stood before it. One last quotation from Marioni is apposite here: "The real game I'm playing is about light, the placement of light, the ability to squeeze and contract the light, push the light to make it cooler, make it warmer, where is the light?"[22]

96 Joseph Marioni, *silver White*, 2008. Acrylic and Linen on Stretcher, 61 × 58.4 cm. Collection of the artist, New York. Exhibited: *Joseph Marioni: Liquid Light*, McNay Art Museum, San Antonio, Texas, 22 October 2008– 18 January 2009.

It is hard to imagine the Marioni of *Outside the Cartouche* speaking of his intentions in those terms. In any case, I know of no comparable degree of internal individuation from work to work in the art of other "radical" or "concrete" painters, and it may be that Marioni's Americanness – by which I mean not at all the simple fact of nationality but rather his career-long admiration for the ambi-

tious, large-scale painting of Pollock, Still, Rothko, Newman, and the others – has been a vital factor in leading him away from the European predilection for smallness of scale and hyperrefined distinctions of format, hue, surface quality, and so on that has tended to confine "radical" or "concrete" painting as a movement to the margins of modern art. By the same token, the fact that his art matured a full generation later than that of Ryman and Marden has meant that he has been able to pursue without inhibition a far more direct mode of expressiveness, indeed (I want to say) a far more openly exalted conception of the art of painting, than Ryman, for all his originality and resourcefulness, has found it feasible to do. Similarly, Marden's early monochromes with their restricted palettes and encaustic surfaces depend for their success on their ability to hold the picture plane against all but the most attenuated suggestion of depth; this remains an impressive achievement, but it belongs to its historical moment, even as its coloristic restraint continues to resonate with contemporary taste. In contrast, what Marioni has been in pursuit of for the past forty years, with ever-increasing mastery – depth of expression of color without losing the concrete reality of the painting – has something almost old-fashionedly heroic about it. What remains uncertain, what will become clear only with the passage of time, is whether younger painters, or indeed painters still to discover their vocation, will take heart from his achievement and find some means of going on from it, or whether . . .

four: antitheatricality
DOUGLAS GORDON

Douglas Gordon was born in Glasgow in 1966. He went to art school there and then studied for two years at the Slade in London, graduating in 1990. Until a few years ago he maintained an apartment in New York, but then bought an apartment in Berlin, where he currently lives. He also maintains a base in Glasgow. As most readers of this book will not need to be told, his breakthrough to art world fame took place in 1993 when he was invited to create an exhibition at Tramway, a former tram depot in Glasgow that had become a venue for contemporary art; for that occasion he made a large-scale video projection of Alfred Hitchcock's classic suspense/horror movie *Psycho* (1960), starring Anthony Perkins and Janet Leigh, with the sound track eliminated and the image track greatly slowed down so as to last twenty-four hours from beginning to end. This means

that instead of the standard twenty-four frames per second the film goes by in silence and in extreme slow motion at not quite two frames per second (so in a sense not in motion at all), a double modification of the original that turns out to give rise to an altogether different viewing experience from the ordinary one. Gordon called his projection *24 Hour Psycho* and it remains the work by which he is most widely known. In 1996 Gordon, then just 30, won the Turner Prize, one of the many annual awards that official British culture cunningly bestows on its artists and writers as a never-ending, constantly self-renewing publicity *coup*. Normally the Turner Prize, like many others in the arts, is given to figures of no more than passing interest but Gordon was an inspired choice. (So would have been one of the other finalists his year, the photographer Craigie Horsfield.) Starting in the early 1990s, too, Gordon has had numerous one-man exhibitions in North America and Europe, has taken part in countless museum shows, and has received other prizes and awards, all of which together have consolidated his reputation as one of the most original and alluring figures in contemporary art.

play dead; real time

As I report in the Introduction, my personal acquaintance with Gordon's art began relatively late when in March 2003 I happened upon his video installation – shot in 35-mm film and transferred to video – *Play Dead; Real Time* at the New York Gagosian Gallery in Chelsea. As I also report, I found myself transfixed by it; what I want to do in the first part of this essay is try to say why. This will involve inviting the reader to watch several excerpts from its three video loops by means of the DVD included with this book. First, though, I need to explain that in the darkened gallery – a large space – there stood two large semi-transparent screens at a right angle to each other, and that a different projection featuring the elephant was shown on each; in addition a third "projection," featuring repeated close-up views of the elephant's head, ran on a TV monitor off to one side. So the excerpts from *Play Dead; Real Time* on the DVD, which the reader is now invited to play, cannot convey a sense of the installation, which is to say of the work, as

97

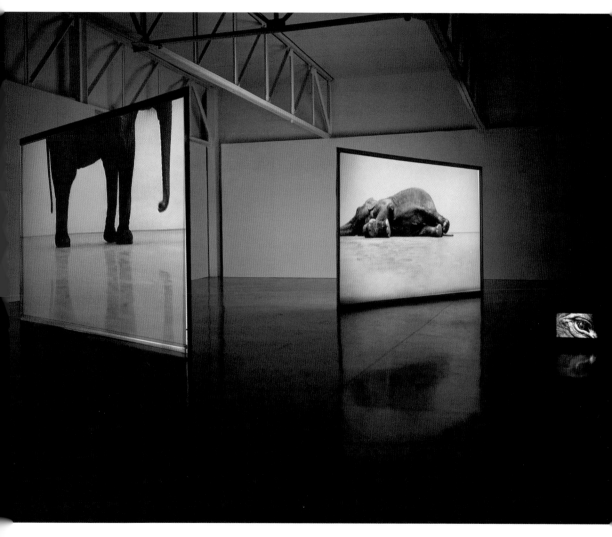

97 Photo of the two screens in Douglas Gordon's *Play Dead; Real Time*, 2003. Video installation with screens and monitor, dimensions variable.

a whole. The first two sequences are from the screen projections, the third from the TV monitor.

As it turns out, the elephant's name is Minnie, and in May of 2002 Gordon arranged for her to be brought into the empty gallery, where her trainer (who is never seen) commanded her to stand still, back up, walk around, lie down, and get up, while a cameraman and an assistant circled her on a dolly filming all the while (needless to say, they too are not seen). Now and then one or the other screen goes black and when it lights up again Minnie is always lying on the gallery floor – "playing dead," as a matter of fact. (It was not made explicit that the videos were filmed in the same gallery space where the show took place, but it was possible to infer as much, if one thought about it.) In the projection on one screen the camera/dolly circles to the left, in that on the other to the right, though of course when the viewer looks from the "other" side of the semi-transparent screens, the direction of movement on each appears reversed. In the TV monitor sequence, which after each blackout begins again with an extreme close-up view of one of Minnie's eyes (the camera then pulls back and eventually she rises to her feet), there is no circling movement involved. Given the overall arrangement I have described – two large screens at ninety degrees to each other, each semi-transparent, plus the TV monitor on the floor – there was no possibility of the visitor at Gagosian, or indeed on subsequent occasions when this piece has been shown, coming to feel that he or she could arrive at a definitive viewing of the work as a whole. On the contrary, the viewer is invariably made aware both that at every moment he or she is choosing where and at what to look (and from what distance), and that the price, or at least the complement, of being allowed – actually of being compelled – to make such a choice is that much else, much more than one is actually taking in, is necessarily being ignored, left to go on by itself without for the moment being viewed. (I am not suggesting, by the way, that the use of multiple or semi-transparent screens is unique to Gordon; on the contrary, both have been a feature of numerous video presentations during the past decade

or more. But neither device has in my limited experience been utilized to better advantage.) Moreover, as the DVD sequences show, nearly all the images on the screens and the monitor are cropped, sometimes quite severely; thus when the elephant is standing or walking and the camera is relatively close by only the legs and perhaps the trunk and underbelly are shown, but even when the camera is relatively far away we only rarely are given a framed view of the entire animal. This matters. Further on I shall try to say why.

At this point I need to refer again to my argument, first put forward in *Absorption and Theatricality*, that starting around the middle of the eighteenth century in France there emerged a powerful current or tradition of absorptive painting, by which I mean a concerted attempt to make paintings that depicted one or more figures so deeply engrossed or absorbed in what they were doing, feeling, and/or thinking that they seemed unaware of anything else, specifically including the beholder standing before the canvas. This latter point means that the absorptive current or tradition was in essence an antitheatrical one (I am following Diderot's lead here), the painted figures' seeming obliviousness to being beheld serving as a device for establishing what I have called the supreme fiction or metaphysical illusion of the beholder's nonexistence – the fiction or illusion that there is no one there, standing before the painting. The least hint in the action or demeanor of the painted figures that this is not the case, that they are aware of being beheld and therefore that they are acting or simply "being" with a view to making a particular impression on the beholder, is felt to be intolerable. When that happens, Diderot insists and countless critics after him will agree, action is replaced by posing, expression by grimace, grace and naïveté by mannerism, and the entire painting is infected by falsity. As Diderot wrote apropos of stage drama, "Think no more of the beholder than if he did not exist. Act as if the curtain never rose." And apropos of painting: "The canvas encloses all the space, and there is no one beyond it [i.e. standing before it]." And: "If you lose your feeling for the man who presents himself in society and the man engaged in an action, between the man who is alone and the man who is looked at, throw your brushes in the fire. You will academicize all your figures, you will make them stiff and unnatural," and the painting will become . . . "a theater."[1]

As I showed in *Courbet's Realism* and *Manet's Modernism*, in the course of the following 120 years the difficulty of achieving and maintaining such a fiction or illusion became ever more acute as the basic truth (or primordial convention) that paintings are in fact made to be beheld became ever more impossible for painters to deny. The advent of Manet in the 1860s is precisely the moment when the absorptive tradition as such reaches a stage of overt crisis, and the ineluctable presence of the beholder comes to be acknowledged by a strategy that, as mentioned earlier, I call radical facingness. From Manet onward some such acknowledgment of the beholder becomes central to ambitious painting, which, however, is not to say that absorptive motifs and effects wholly disappear from the modernist painter's repertoire. Nor, it turned out, was the Manet moment equivalent to the triumph of theatricality in Diderot's pejorative sense of the notion; rather, the very nature of that acknowledgment – the inclusion of the beholder-function within the painting itself – effectively leaves the actual beholder altogether uncertain as to his or her relation to the painted scene, which I take as a major reason why Manet's paintings gave rise to widespread hostility among the viewing public. (The *Bar aux Folies-Bergère*, Manet's valedictory masterpiece, develops that uncertainty with unmatched lucidity.)

This is not the place to say anything more elaborate about Manet and his successors. What now needs to be remobilized are my claims, first, that the issue of antitheatricality versus theatricality returned with a vengeance roughly one hundred years later, in the clash between high modernism and Minimalism/ Literalism in the mid- and late 1960s, and second, that starting in the late 1970s the situation with regard to that issue was dramatically transformed by the rise of art photography, or at any rate by the recent tradition of art photography that I discuss in my book *Why Photography Matters as Art as Never Before*. A further point (already stated in the Introduction) is that in *Why Photography Matters* I argue that the resort to absorption and other antitheatrical strategies on the part of photographers such as Wall, Struth, Dijkstra, Gursky, Delahaye, Höfer, Demand, the Bechers, and others has gone hand in hand with a mode of acknowledgment of the viewer that I call to-be-seenness and associate with the very con-

ditions of the medium. Thus in Wall's *Adrian Walker* the viewer senses instinctively that the draftsman could not have been literally unaware of being photographed – and of course he was not. On the contrary, he cooperated willingly with the photographer over more than a week to help make the picture we see. Even apart from such considerations, the lightbox apparatus itself is inevitably perceived as directed toward the viewer, which is one way of understanding what Wall means when he writes in "Frames of Reference" that the backlighting was important to him less as a modernist device to call attention to the physical constituents of his pictures (a common interpretation, he implies) than "as a sort of preservation of some aspect of literalism in the construction of the picture."[2]

So much by way of background; the question now is exactly how the considerations I have just rehearsed bear on Gordon's video. Several points deserve emphasis:

(1) At least provisionally, Gordon's elephant Minnie may be described as absorbed in what she is doing. This is especially true during those stretches when she is lying on the ground and "playing dead" and then begins to make the seemingly enormous effort required in order for her to rise to her feet. Yet even once she is on her feet and takes a few steps forward or back or indeed stands still, our sense of her attending to her trainer's presumed instructions is very strong. Interestingly in this connection, Diderot noted that actors playing subordinate roles often did better in the sense of remaining within their roles than the leading actors who, much to his disgust, consistently played to the audience. "It seems to me that the reason for this is that [the actors in subordinate roles] are constrained by the presence of someone who governs them," he wrote. "They address themselves to this other, toward him they orient all their action" (p. 95). "Constrained by the presence of someone who governs her" exactly describes one's sense of Minnie's state of mind.

(2) At the same time, *Play Dead; Real Time* offers a powerful thematization of to-be-seenness on several counts. In the first place, right from the start the viewer is in no doubt that everything in the projections was deliberately staged for the camera. In the second (a related point), the viewer is led to intuit the presence

in the depicted space of others whom he or she never is shown – the elephant's trainer plus the cameraman and his helpers – no less than four people, it turns out, not that the viewer is clear about the total. (The artist remained outside, monitoring the scene as a whole.) Indeed the fact that all these presences never appear on any of the screens comes increasingly to weigh on the viewer's mind, if my own experience is any guide. Then, too, the unrelenting and often extreme cropping of the projections refuses to allow the viewer simply to lose himself or herself in the presentation of the intensely photogenic Minnie, as compelling, even moving, as the images on the screens are felt to be. This is also true, to a lesser extent, of the repetitive circling movement of the camera in the two main sequences, and even of the gleaming gallery floor. Finally, perhaps most important, the organization of the exhibition – the darkened room, the two screens, the TV monitor to the side – functions as a constant reminder that the entire work not only exists for the viewer but also, as I have described, calls for his or her active engagement throughout the entire duration – the "real time" – of the gallery visit.

This last point raises the question whether or not Gordon's use of such a strategy in *Play Dead* is in the end simply an extreme Post-Modern or Post-Post-Modern version of the Minimalist/Literalist trope to the effect that the viewer's "experience" stands in for, replaces, the work itself. My answer is no. The work in this instance comprises the screens, the monitor, and the projections (indeed the original gallery announcement spoke of three works, not just one), as well as their relation to each other in the darkened space of the gallery; the viewer's exploration of the gallery space, his or her decisions to view the projections on one or the other screen or from one or the other side of those screens or indeed on the monitor, are, as Gatsby might have said, merely personal; indeed there is a strong sense in which the viewer's "activation" by the overall arrangement serves mainly to emphasize – to throw into relief – the structural indifference to the viewer of the projections themselves. In particular, the fact that the large projections appear reversed on opposite sides of the screens – that each of the two projections is *singular* in this respect – may be understood as almost programmatically making the point.

(3) Here the further question arises: What is the significance of the fact that the subject of *Play Dead* is an animal, a large animal, specifically an elephant, an intelligent, trainable creature with an astonishing head and heavy, almost comic-seeming legs, about which sophisticated persons like those who would visit an exhibition at Gagosian are bound to have intense and even somewhat confused feelings? It is not at all clear how one might get to the bottom of so simple-seeming a question. At the least, the fact that *Play Dead* depicts an animal (and such animal) puts a new and different complexion on the whole topic of the subject's awareness of being beheld, and *a fortiori* of being photographed or filmed. That is, we cannot doubt – the projections leave no room for doubt – that Minnie was aware of her trainer and the others sharing the gallery space with her. But in what precisely, with respect to the issues that interest us, did that awareness consist? For example, is it remotely conceivable that she understood that she was being filmed for subsequent exhibition? Obviously not. Nor do her actions as one follows them convey the least sense of self-consciousness, mannerism, or theatricality – it seems ridiculous to imagine that they might. (But why? To paraphrase Wittgenstein, is she too sincere?) At the same time, it makes a big difference, in fact it is crucial, that she was placed by Gordon in a situation where she was called on to follow certain commands – as if precisely that scenario gave rise to the impression of something like absorption which in turn one perceives, if I am right, in something like an antitheatrical light. I say "something like" because Minnie's absorption in what she is doing cannot quite be understood as overcoming the risk of theatricality; as was just noted, the latter was not an option for her. I am, I acknowledge freely, on ontologically shaky ground here. But I am not alone: the problem of the status of the nonhuman animal continues to give serious philosophy fits and is likely to go on doing so forever. What *Play Dead* suggests is that serious art has come to find in that problematic status a field for esthetic investigation. Indeed the particular genius of *Play Dead*, one might say, resides in the contrast between the simplicity and ordinariness of what Minnie is called on to do – also the directness with which she is filmed and the projections are screened – and the almost unfathomable depth of the artistic and ontological issues with which the work as a whole turns out to engage.

98 Douglas Gordon and Philippe Parreno, still from *Zidane: A Twenty-First Century Portrait*, 2006.

Another, closely related point: one way the notion of absorption was thematized by Diderot and other critics and theorists in the antitheatrical tradition has been in terms of the seeming aloneness of the depicted person or persons relative to a viewer or viewers inside or outside the picture. Yet in *Play Dead* our sense of Minnie's absorption, or "something like" absorption, correlates precisely with the (invisible but implied) presence of others – specifically of persons – in the original space of representation. This anticipates the basic premise of a remarkable work that Gordon together with the French artist Philippe Parreno went on to make, the full-length movie *Zidane: A Twenty-First Century Portrait* (2006), in which the great French soccer player Zinedine Zidane was filmed during an entire Spanish league match by seventeen separate 35-mm cameras; the aim of the film, I argue in *Why Photography Matters*, is to depict, often at extremely close range, Zidane's ferocious and, until near the end, unflagging absorption in the match under conditions of maximum public exposure. "You are never alone," the subtitles quote him as saying, almost as thinking, at one point in the film. Nor, in this case, is Minnie.

(4) One final aspect of *Play Dead* deserves mention before moving on, and that is the extent to which the viewer is made acutely aware of his or her own strong but also, if I am right, distinctly ambivalent feelings toward the projections on the screens. In part this has to do with an inevitable concern as to whether there might be something not quite ethically right in Gordon's having "exploited" Minnie in this way, and in particular having her repeatedly lie down and then make the very considerable, it may appear to some quite appalling effort – first rocking back and forth to build up momentum, then shifting her weight to her knees, then pushing up from there – that turns out to have been necessary in order to rise time after time from the floor. In part it is a matter of an irresistible tendency of the viewer toward what might be called, adapting a concept entertained though in the end discarded by Stanley Cavell in *The Claim of Reason*, "empathic projection,"[3] an intense but also in the present instance largely gratuitous or unearned emotional response to Minnie the elephant (what do we know of her, after all?), which is to say to the freakishness but also the nobility of her massive head, to her curiously fixed and inexpressive eyes with their large irises and oversize tear ducts (was that a tear one saw trickling down her cheek on the TV monitor, and if so what did it signify?), to her heavy legs, prolific wrinkles,

99 and 100 Douglas Gordon, stills from *Play Dead; Real Time.*

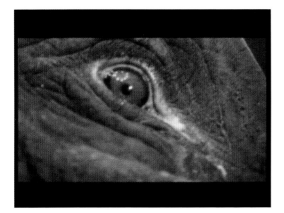 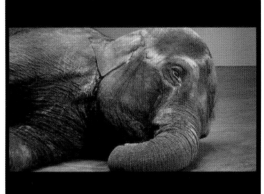

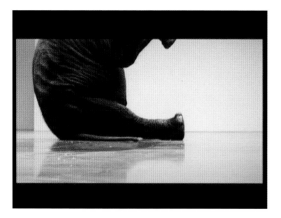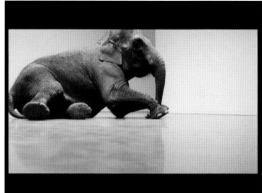

101 and 102 Douglas Gordon, stills from *Play Dead; Real Time*.

ratlike tail, slack and streaky skin, plus – overarching all this – her apparent docil-
ity, as evidenced in her willingness to follow her trainer's unheard instructions
without a moment of demurral that we can see. In short the viewer's response to
Minnie is intensely anthropomorphizing, never more so than when the cropping
of the images leaves only the legs to be seen and the absurd idea occurs to one
that just possibly they might actually be two pairs of human legs in elephant
costume. (The last upward heave she takes in rising to her feet also seems particu-
larly humanoid.) My suggestion is that *Play Dead* seeks actively to elicit such feel-
ings, and beyond that to promote a consciousness in the viewer of his or her
tendency to project empathically in the way I have just described onto or into
the images on the screen (it is significant that we do not quite know which prepo-
sition to use; neither seems exactly right). The TV monitor sequence all but spells
this out as Minnie's head comes to seem more nearly humanly expressive, almost
thoughtful (almost sad), as the camera pulls back and we see it in its entirety not
once but again and again. In fact I want to go further and propose that *Play Dead*,
together with other works by Gordon (and other contemporary artists), marks an
epoch in the absorptive tradition, the moment of the laying bare – a basic modern-

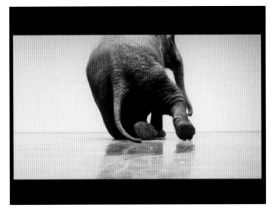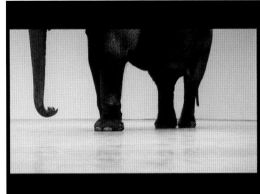

103 and 104 Douglas Gordon, stills from *Play Dead; Real Time*.

ist trope – of the empathic-projective mechanism on which the tradition has depended from the first. I return to this topic toward the end of this essay, and again in Postcript 1, where I discuss briefly another work by Sala. (Like the "activation" of the viewer, the notion of a laying bare of empathic projection may seem to imply an appeal to the viewer's "experience" in the Minimalist/Literalist sense of the term but, here too, I do not think it does. Rather, the force of that laying bare is structural, intentional, one might almost say abstract; it is a specific effect, built into the work, and in principle is the same for all viewers – there is no question of incommensurability, of an appeal to different viewers' subject positions, of an "experience" standing in for the work, or anything of the kind.*)

*"I felt that I had never looked seriously at an elephant before," Peter Schjeldahl writes in his review of the Gagosian show. "Was her gaze, as she did her dopey trick, pained and reproachful? I felt embarrassed for her and for myself" ("Europeanism," *The New Yorker*, March 24, 2003, p. 86). The point is not whether one's own responses to the piece exactly match Schjeldahl's; it suffices that we understand perfectly what he means, or to put this slightly differently, that however one might wish to describe one's own feelings, they exist on a continuum with his.

I do not doubt that more might productively be said about *Play Dead; Real Time*, but what has been said provides the elements of a reading and in any case I want to devote most of the remainder of this essay to a discussion of what is for me perhaps the most fascinating of all Gordon's works involving movies, *Déjà vu* (2000). Here is how it goes. Very simply, Gordon took a well-known film noir, the director Rudolph Maté's *D.O.A.* (dead on arrival) of 1950, starring Edmond O'Brien and Pamela Britton, and projected it in triplicate – the three projections running alongside each other – on a wall. (Let me move to the present tense.) The essence of the work lies in this: the projection at the left runs at 25 frames per second (one frame per second faster than standard), the one in the middle at 24 frames per second (standard), and the one at the right at 23 frames per second (one frame per second slower than standard). The differences in speed would not be registered by someone viewing each projection separately. All three projections start out together, but as the work progresses they more and more separate out temporally, hence narratively, until by the end they are roughly seven minutes apart (in other words, there is a fourteen-minute gap between the left- and right-hand projections). The sound track too is in triplicate, each track keyed to one of the three projections; the result is often confusing, a clash of voices, music, and background noise, though often too individual lines of dialogue and even whole exchanges come through clearly enough – it all depends on what is taking place on the adjacent "screens." I think it is fair to say that a viewer who unexpectedly comes across *Déjà vu* in an exhibition tends to be at a loss to understand exactly what is going on; assuming, as is likely, that the work is already under way, he or she finds himself or herself shifting attention from projection to projection and hence losing track of the overall narrative, and instead focuses on brief individual scenes which, he or she soon becomes aware, are repeated twice but on different "screens." However, taking my experience as typical, such a viewer never quite grasps the temporal structure I have just described (the version on the left going fastest, the one in the center following after, the one on the right lagging

behind), which is to say that he or she remains in the dark as to the basic principle of the work, as elementary as that principle turns out to be.

Moreover, the viewer's sense of disorientation is compounded by the complexity of the plot, which even under ordinary conditions is not easy to follow – often the case with noirs. Briefly: the movie opens with the protagonist, Frank Bigelow (Edmond O'Brien), entering a police station in Los Angeles and reporting a murder: his own. The police detective invites him to explain and the movie unfolds as a long flashback, which the entry on *D.O.A.* in Wikipedia helpfully summarizes as follows:

> The flashback . . . begins with Bigelow's deciding to take off from his hometown of Banning, California, where he is an accountant and notary public, for a one-week vacation in San Francisco. This does not sit well with Paula [Gibson (Pamela Britton)], his "confidential secretary" and love interest, since he is not taking her along.
>
> After crossing paths at his hotel with a group from a sales convention, Bigelow accompanies them on a night on the town. He ends up at a jazz club, where unnoticed by him, a stranger swaps his drink for another. The next morning, Bigelow is feeling ill. He visits a doctor, where tests reveal that he has swallowed a "luminous toxin" for which there is no antidote. (Its luminosity and later references to iridium imply a form of radiation poisoning.) A second opinion confirms the grim diagnosis.
>
> With at most a few days to live, Bigelow sets out to untangle the events behind his imminent demise, interrupted occasionally by phone calls from Paula. She provides the first clue; a Eugene Philips had been trying to contact him, but had died the previous day. Bigelow travels to Philips's import–export company [in Los Angeles], meeting Miss Foster, the secretary, and Mr Halliday, the comptroller, who tells him that Eugene committed suicide. From there, the trail leads to the widow, Mrs. Philips, and Eugene's brother Stanley.
>
> The key to the mystery is a bill of sale for what turns out to be stolen iridium; Bigelow had notarized the document for Eugene Philips six months earlier.

Bigelow connects Eugene's mistress, Marla Rakubian, to gangsters led by Majak. They capture Bigelow and, as he knows too much about the theft, Majak orders his psychotic henchman Chester to dispose of him. However, Bigelow manages to escape.

At first, Bigelow thinks that Stanley and Miss Foster are his killers, but when he confronts them, he finds that Stanley has been poisoned as well. However, in Stanley's case, prompt treatment may be able to save his life. Stanley points Bigelow to the real poisoner: Halliday [the comptroller]. He had engineered the theft and had also been carrying on an affair with Mrs Philips. When Eugene found out, he struggled with Halliday and was pushed over a balcony to his death. Halliday had to dispose of Bigelow to tie up the loose ends. Bigelow tracks him down and shoots him to death in an exchange of gunfire.

The flashback comes to an end, Bigelow finishes telling his story at the police station, and dies, his last word being "Paula." The police detective taking down the report instructs that his file be marked "D.O.A.," or "dead on arrival."

That's the story; knowing it will help make sense of the excerpts from *Déjà vu* on the DVD. There are four in all, starting with the opening two minutes and forty seconds (approximately), in the course of which the three projections start out together but quickly separate.

The second excerpt comprises just under four and a half minutes first in the hotel room with a group of conventioneers and then in the nightclub called "The Fisherman," with shots of the jazz band, of Bigelow (from now on I shall call him Frank, as Paula does) shaking off the woman he picked up in the hotel and moving in on another at the bar, of the substitution of poison for his glass of bourbon, and finally of his unknowingly drinking the poison (the point of the scene).

The third excerpt comprises almost five minutes mainly in two different doctors' offices, where Frank first is told and then confirms the truth about his condition.

Finally, there are just over two minutes following the scenes in the doctors' offices. We see Frank running through the streets, banging on the door of the hotel room where the partying began the night before, then taking a call from Paula in his own room in the course of which he learns that Philips is dead and impatiently demands to know the address of the latter's office (which turns out to be in Los Angeles).

It would be useful to have still more scenes at our disposal but the four on the DVD are sufficient for my purposes. Let me say this, then: when I first came across *Déjà vu* at the Hirshhorn Museum in Washington, D.C., in February 2004, after a few minutes of understandable confusion I suddenly had a revelation, an understanding, that reinforced my sense – first stimulated by *Play Dead; Real Time* – that Gordon was an artist of some considerable brilliance and originality. To explain what this means I need to go back once more to "Art and Objecthood," specifically to some brief remarks about the status of movies with respect to the linked issues of modernism and antitheatricality. "The success, even the survival, of the arts has come increasingly to depend on their ability to defeat theater," I wrote toward the end of that essay, and went on to claim:

> It is the overcoming of theater that modernist sensibility finds most exalting and that it experiences as the hallmark of high art in our time. There is, however, one art that, by its very nature, escapes theater entirely – the movies. This helps explain why movies in general, including frankly appalling ones, are acceptable to modernist sensibility whereas all but the most successful painting, sculpture, music, and poetry is not. [Basically, I was saying that this is why

I could enjoy even mediocre movies whereas all but the greatest high art left me cold.] Because cinema escapes theater – automatically, as it were – it provides a welcome and absorbing refuge to sensibilities at war with theater and theatricality. At the same time, the automatic, guaranteed character of the refuge – more accurately, the fact that what is provided is a refuge from theater and not a triumph over it, absorption [in the sense of the viewer's being absorbed in and by the movie] not conviction – means that the cinema, even at its most experimental, is not a modernist art.[4]

There are problems with this formulation, in particular with the use of the phrases "automatically, as it were" and "the automatic, guaranteed character of the refuge," both of which can be taken to imply, first, that it is simply the mechanical (in that sense the automatic) aspect of film that counts in this regard, and second, that *all* movies, even, as I say, "frankly appalling ones," provide the kind of refuge I was trying to evoke. The emphasis on the automatic and guaranteed fails to make clear that the successful construction of what might be called a "movie world" is an extremely complex achievement, requiring the cooperative work of a large team of artists and technicians (in that sense there is nothing automatic or guaranteed about it), just as the reference to "movies in general" ignores the fact that such attempts at construction may fail, most conspicuously owing to the presence of certain actors and actresses whose seemingly innate theatricality is such as to defy the best efforts of even the most competent directors to subordinate them to the demands of the art. (My all-time candidates for this are Richard Burton and Jack Lemmon, both of whom I find unwatchable; a movie-wise friend adds Rod Steiger, Anthony Hopkins, and the later Al Pacino – all men, I notice.) Nevertheless the basic idea – that there are countless successful movies, many of them mediocre or worse, and that such movies escape theatricality by involving or indeed immersing the viewer in their narratives (more broadly in their "worlds;" from now on I shall drop the quotation marks), and that therefore they cannot be said to defeat or overcome theatricality in the ways that "Art and Objecthood" maintains works of high modernist painting and sculpture crucially do – still seems to me right. (Cavell makes a comparable claim in *The World*

Viewed, and in my chapter on Roland Barthes's *Camera Lucida* in *Why Photography Matters* I argue that Barthes's preference for photography over film has a similar basis – unrecognized by him, however.) Put slightly differently, movies – I am referring basically to Hollywood movies of the classic sort, such as *D.O.A.* – tend on the whole to be "transparent" to their audiences, though of course like all works of art they remain open to sophisticated analyses that deliberately go against the grain of that "transparency." In the words of one critic, D. K. Holm,

> the camera would move or track or pan [when it needed to], but almost always such movements were "invisible" in the sense that the action being photographed was so vivid that the viewer was distracted from the operation of the camera. The lens was going where the narrative demanded it be in order to continue the tale with clarity. The viewer wants to see what is going to happen next, and rides the camera obliviously.[5]

Or in those of the film theorist V. F. Perkins in his influential book *Film as Film* (1972):

> Film [by which Perkins means narrative movies of the type of *D.O.A.*] is distinguished by the directness with which the [film-maker's vision of the world] is presented. There seems to be no intermediate stage between the artist's statement and our reaction. We are not aware of "reading" the image. No act of interpretation, no effort of imagination or comprehension seems needed. It's all there in front of us. Film narrative bypasses description. We react directly to instantaneous visual presentation, to event, character, and place.[6]

And one more sentence from Perkins: "In the (ideally) comforting, self-forgetting darkness of the movie-house we attain faceless anonymity, a sort of public privacy, which effectively distances the real world and our actual circumstances" (p. 134). In other words, the involved viewer seated in the darkness loses himself or herself in the story (the diegesis, as a certain sort of theorist puts it), which is to say in the fictive world of the movie as a whole – a process made possible by the fact that the viewer has no place in that fictive world: the movie unreels as if wholly

indifferent to his or her existence. Cavell goes further, writing in *The World Viewed* that the viewer is not present to that world, that its existence is screened from him or her, in effect making the viewer invisible and facilitating the mode of involvement I am trying to describe.[7] It goes without saying that such a viewer will be concerned with the fates of the characters, not the finer nuances of the movie acting on the part of the stars or lesser players – a point that will become important shortly. (None of this goes against the notion that certain films of a more or less classic type rest on a kind of tacit agreement with the experienced viewer that he or she is to respond to the filmic narration – for example, to the film's "point of view" – in a particular manner, as has been argued by Perkins and George Wilson, among others.)

In the light of the above, it becomes possible to summarize Gordon's achievement in *Déjà vu* in the following terms. By juxtaposing and progressively staggering the three projections as he does, he effectively "opaques" the movie while at the same time not quite rendering it wholly unintelligible to the viewer. Put the other way around, the viewer repeatedly follows small stretches of dialogue and cinematic narrative in one projection or another. Yet as the DVD will have allowed the reader to imagine, the soundtracks often mix confusingly, and in any case one's attention continually shifts from projection to projection, never more involuntarily than when the contents of one projection repeat those of another –

105 Douglas Gordon, still from *Déjà vu*, 2000. Triple video projection, dimensions variable.

which of course never ceases happening, but at longer and longer intervals – or when the different projections show actions taking place in entirely different settings, for example Frank banging on a hotel door, running through the streets, talking loudly and agitatedly to doctors. (Something else that occurs when the projections differ strikingly from each other is that at odd moments one sees them from "afar," almost as if they formed an animated triptych.) Altogether, then, the viewer is continually expelled from whatever modest toe-hold he or she might momentarily have gained with respect to one or another of the projections, which is to say that one's experience of *Déjà vu* takes place almost entirely in the realm of the real world and of one's actual circumstances: standing in a gallery or museum exhibition space, looking in considerable puzzlement at the three projections, becoming momentarily "hooked" by an event taking place in one or another of them and almost immediately becoming distracted or ejected, whereupon one seeks to regroup, to latch on to something else, above all to bring one's baffled responses into conceptual focus . . .

Now something extraordinary happens: instead of feeling simply shut out or alienated from the content of the projections, the viewer discovers *another source or basis* of interest and involvement, namely, the exemplary absorption of Edmond O'Brien, Pamela Britton, and their colleagues *in the performance of their roles*. That is, being distanced from the narrative and being denied the kind of unself-

106 Douglas Gordon, still from *Déjà vu*, 2000. Triple video projection, dimensions variable.

aware involvement with the characters on which movies of the *D.O.A.* type are predicated, the viewer nevertheless becomes first conscious of, then interested in, and then (going by my own experience) fascinated by the projections' presentation of especially the leading actors' commitment to the by no means simple task of delivering an honest and effective day's work in front of the camera and the lights, under the eye of the director and, often, numerous others. The basic movie device of the close-up facilitates this shift of attention, precisely because it places the actors under maximum pressure to appear to stay "within" their roles. At the same time, the fact that the viewer of *Déjà vu* in a gallery or museum setting is able physically to approach the projections means that he or she is encouraged to study the actors' performances as closely – in every sense – as might be wished. Then too Gordon's choice of a classic noir was perfect for his project, both because of the characteristic complexity of the story line (anyone who has seen *D.O.A.* just once and is clear about why Frank was poisoned deserves an honorary degree) and also because of the particular demands it places on the actors – above all to bring as much emotional urgency as possible to their performances without at any stage going over the top. Also acute was the choice of a movie that did not feature a famous star like Bogart, Cagney, Mitchum, or Edward G. Robinson, in which case our attention would be drawn away from their work in one or another role toward a recognition of their familiar mannerisms and somatic styles. All the scenes on the DVD showcase O'Brien, in some ways an unlikely leading man but partly for that reason an ideal subject for such an exercise: it is impossible, I think, not to be impressed by the sheer consistency of the effort he makes to convey emotional intensity in a wide range of fictive situations all the while submitting himself to the extremely stringent requirements of convincing movie acting, which *Déja vu* in effect places under a lens.

(A brief excursus in this connection about *24 Hour Psycho*: it too may be said to anatomize movie acting, but the import of the two-frames-per-second slow motion in combination with the absence of a sound track is precisely to show – to bring to the viewer's awareness – the extreme difficulty, verging on impossibility, of distinguishing between the intentional behavior of the actors in their

roles and a whole range of unintentional actions such as breathing, blinking, swallowing, and other automatisms taking place before the camera at the same time. In part that difficulty has to do with the deliberately understated character of effective movie acting, which aims at an ideal of naturalness, of gestural and expressive minimalism, altogether unlike the histrionism of the stage. [This is what makes movie acting a particularly rewarding ontological object for Gordon's operations.] Equally important, it stems from the fact that the accomplishment of intentional actions even of the simplest, most natural-seeming sort – turning one's head to look at something, reaching for a glass of water, walking across a room, speaking normally, and so on – inevitably involves the support of countless automatisms, as Friedrich Schiller seems to have been the first to emphasize in an artistic context [for Schiller it was precisely that which provided a basis for the quality of movement he called "grace"[8]], together with the further fact that the mobilizing of such automatisms turns out to be made visible or say perspicuous by cinematic slow motion to an extent that is simply not the case under ordinary circumstances. Not surprisingly, the revelatory power of Gordon's radicalization of slow motion in this regard is most evident in quiet scenes such as the early one between Janet Leigh [as Marion Crane] and John Gavin [as her lover, Sam Loomis] in a Phoenix, Arizona hotel room, in which their movements back and forth as they dress, talk, embrace, and continue dressing and even their

107 and 108 Douglas Gordon, stills from *24 Hour Psycho*, 1993. Video installation, dimensions variable.

unheard conversational exchanges become visually gripping in a way that has almost nothing to do with the original narrative, or the slightly later one in which Leigh, filmed from directly in front at close range, ruminates in her car at a red light following her theft of the money. One's impresssion watching the movie is that she is beginning to have serious qualms about what she has done, qualms which for a moment turn almost to panic as she is recognized by her boss as he crosses the street and then stops and turns back to look at her once more. The original scene at the stoplight goes by in just twenty highly charged seconds. But in *24 Hour Psycho* it lasts fully four minutes and feels endless, the subtle play of Leigh's facial expressions serving mainly to bind the viewer's attention to the smallest discernible features of her behavior, all of which, intentional or automatic, are felt to be on the side of absorption. [The replacement of the anxiety-reinforcing musical soundtrack by the video's unbroken silence contributes to this effect.] This is not the same dynamic as the one at work in *Déjà vu* but in both the actors' absorption in their roles is made the basis for a new form of cinematic or paracinematic fascination. The further topic of the effect of the extreme slow motion on the viewer's awareness of the movements of the camera and indeed the cutting from shot to shot would require a much fuller discussion than I can provide here; one can say, however, that their usual "invisibility" is seriously disrupted by Gordon's procedure, and that this too becomes a source of para-

109 and 110 Douglas Gordon, stills from *24 Hour Psycho*, 1993. Video installation, dimensions variable.

III Douglas Gordon, still from *Déjà vu*, 2000. Triple video projection, dimensions variable.

cinematic interest. Nothing, incidentally, could be in starker contrast to the above than the import of the radically different kind of extreme slow motion to be seen in Bill Viola's *The Passions* [2003], a *ne plus ultra* of technologized theatricality.[9])

Returning to *Déjà vu*, one recurrent type of scene that underscores the sense of absorption in movie acting just evoked involves telephone conversations.[10] The DVD includes one such scene, the conversation with Paula after Frank has learned that he has only a short time to live in the course of which she offhandedly mentions Philips's death and he impatiently demands to know the location of Philips's office. No one at all familiar with movies and especially with noirs needs to be told that telephone conversations are a standard device, and if we were watching *D.O.A.* itself and not *Déjà vu* it would not consciously occur to us when we see Frank talking or shouting into the phone that there is in fact no one at the other end of the line (ditto for Paula back in Banning). Yet because of what I have called *Déjà vu*'s "opaquing" of *D.O.A.*, it is all but impossible, so I want to claim, not to be struck by the contrast between Frank's various tones of voice during the conversation – his initial irritation that Paula has called at just that moment, his distracted attempts to make amends, his shift of tone when he learns of Philips's death, and then his explosion of irritation and urgency when Paula fails to give him immediately the address of Philips's office – and the basic fact that he, or

112 Douglas Gordon, still from *Déjà vu*, 2000. Triple video projection, dimensions variable.

rather Edmund O'Brien, is doing all this on his own, with a dummy phone in his hand (so at least we are entitled to assume). In this connection, too, it would be instructive to analyze the scenes in the doctors' offices, where Frank learns his fate and reacts with a mixture of panic, outrage, and denial, as well as the protracted scene in the nightclub, with special emphasis on the musicians, who collectively put the structure I have just analyzed under pressure for the simple reason that to the extent that one sees them as absorbed in the making of the music on the soundtrack, they appear to one as they would in the movie itself. In fact at those moments in *Déjà vu* when musicians appear on three or even two of the "screens," the collective impression is of some sort of creative jazz documentary. (The musicians prove difficult to "opaque," in other words, even as a certain mugging for the camera is likely to strike the viewer as conventionally theatrical in its own right.) At the same time, the nightclub scene also contains – it was designed to provide – a crucial narrative development, the substitution of the drinks by a sinister figure we see mainly from behind and the succeeding moment when Frank, trying to pick up the wealthy "jive crazy chick" at the bar, fatally drinks the poison – twice, as a matter of fact (a neat touch). Yet because of the interplay among the projections the distracted viewer is capable of missing the fleeting instant of the substitution, something that the movie itself is at pains to make impossible.

113 Douglas Gordon, still from *Déjà vu*, 2000. Triple video projection, dimensions variable.

Simply put, then, Gordon in *Déjà vu* takes a representative Hollywood movie and "opaques" it by systematically denying the viewer access to the sort of near-total involvement in which the classic movie experience has always been recognized to consist. (The viewer is denied all but the most tentative and unsatisfactory access to the world of the movie.) Precisely by doing this, though, Gordon makes available to be seen, indeed he almost forcibly directs the viewer's attention to the for the most part persuasive-seeming absorption of the actors – especially O'Brien and Britton – in their exacting and unforgiving professional tasks (in the world of the performance, one might say). I think of that "opaquing" as a kind of theatricalizing of the movie itself, a theatricalizing that is then unexpectedly and ingeniously defeated or overcome – to use the language of "Art and Objecthood" – by the reorientation of the viewer's attention that I have just described. This is not quite to conclude that Gordon's operations make *Déjà vu* a modernist work of art, but if the account of it I have just given is essentially correct that at least means that certain artistic issues that first came to the fore around the middle of the eighteenth century in France and that received a further, explicitly ontological inflection in the encounter between high modernism and Minimalism/Literalism in the mid-1960s are at or near the top of one more important and admired contemporary artist's agenda. It also goes to show that

there is no telling beforehand exactly how those issues will play out in a new situation. Take for example Gordon's well known statement, "Cinema is dead, going nowhere. Nobody can break out of the narrative structures demanded by mainstream audiences, except avant-garde film makers, whose films nobody wants to watch anyway. It could be fun to raise the dead. I'm looking for something that might replace cinema, not film. Some way of getting back that enjoyment."[11] Who could have imagined that that something, that way, would involve a re-engagement with a centuries-old attempt to defeat theater?[12]

feature film, through a looking glass, and b-movie

In fact let me start to bring this essay to a close by laying down the claim that Gordon, especially in works involving film, is consistently an antitheatrical artist, a fact that his many commentators have equally consistently missed (with one notable exception: Russell Ferguson[13]). I shall glance briefly at three more works, *Feature Film* (1999), *Through a Looking Glass* (1999), and *B-Movie* (1995).

114 and 115 Douglas Gordon, stills from *Feature Film*, 1999. Video installation, dimensions variable.

First *Feature Film*. In it Gordon made use of another Hitchcock film, *Vertigo* (1958), specifically of its musical soundtrack composed by Bernard Herrmann. What *Feature Film* films is the American conductor James Conlon, then in his late forties, leading an unseen orchestra – the ensemble of the Paris Opera – in a full-length performance of the score (the performance lasts two hours and two minutes, exactly as long as the movie). The filming was done with three cameras, two static and one mobile. There are three different versions of the piece; the one I saw in Edinburgh in 2006 (which seemed to me unimprovable) comprised two simultaneously running mirror-reversed projections on facing walls in a dark gallery, with the music issuing from speakers on the two walls, and I will treat it as definitive of Gordon's aims. The point of the projections, as I understand them, is to focus in isolation from everything else – for all we know there is no orchestra and Conlon is conducting to recorded music – on Conlon's shapely, well-groomed, hypnotically interweaving hands (the last phrase comes from Raymond Bellour;[14] Conlon wears a sweater with the sleeves pulled up) and his handsome, soulful, continually expressive face, in other words on precisely those personal attributes which, in the act of conducting, are most liable to appear theatrical in the usual sense of the word. (There may be a different sort of personal compo-

116 and 117 Douglas Gordon, stills from *Feature Film*, 1999. Video installation, dimensions variable.

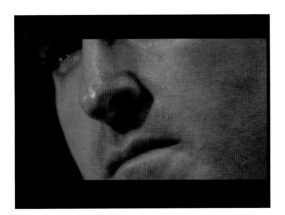
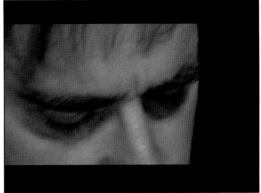

nent to the present interpretation: at concerts I often find myself wishing that performers were screened from view so as not to put me off by their demonstrations of feeling.) Not that Conlon seems particularly to have overdone either his gestures or his expressions. Nevertheless the exclusive focus on these for the entire duration of the score has the effect of bringing out every nuance of theatricality they might be taken to imply, while at the same time – this is the crux of the piece – the sheer brilliance and assertiveness of the cinematography and editing (the latter by Gordon himself) go in another direction entirely.

More precisely, the image-stream flows by in bright color and strong chiaroscuro, at extremely close range, in short discontinuous segments, with abrupt, arbitrary-seeming cuts from one angle of attack to another, invariably cropping Conlon's features (sometimes losing sight of his face and hands entirely) and with a conspicuous blurring of his hands and arms at their fastest-moving – all of this, crucially, with not the slightest indication on his part that he is conscious of the camera even when it zeros in on his eyes. (Sometimes he seems to be gazing down, as at a score, sometimes to be looking up, presumably at the orchestra. Throughout, he appears to be "in" the piece, though the overall sense of theatricality is such as to make this seem possibly an intended effect rather than a certainty.

118 and 119 Douglas Gordon, stills from *Feature Film*, 1999. Video installation, dimensions variable.

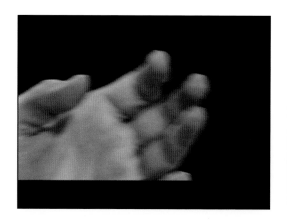 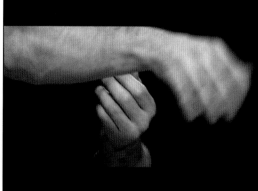

There is in this regard at once an affinity and a difference between *Feature Film* and Sala's *Long Sorrow*.) There are also, it should be noted, longish intervals when the music falls silent, as happens at exactly those points in the movie, and both screens go dark, the mobile camera, out of focus, panning the empty hall with its red seats. At first I found it hard to know what to make of all this, but after a while the awareness dawned – to my surprise – that the theatricality which on the one hand is highlighted and indeed milked for all it is worth ("Conlon is acting more than he is conducting," Philip Monk has written [p. 163]; this is too simple but it is nevertheless significant) is on the other continuously redeemed or "transcended" by the film itself. More precisely, one comes increasingly to feel that instead of interfering with one's pleasure in the music – the usual outcome in an actual concert – that theatricality comes to function as the very element that motivates the moment-to-moment development of the work as a whole, the music and indeed the implied background presence of *Vertigo* itself being in this account subordinated to Conlon's conducting, or rather to the athletic if not hyperactive presentation of the latter on the facing screens. (The subordination is abetted by the fact that we are not dealing with a piece of music by Bach, Mozart, Beethoven, Schubert, or some other master, that is, a composition with

120 and 121 Douglas Gordon, stills from *Feature Film*, 1999. Video installation, dimensions variable.

an autonomous structure and profound expressive claims of its own. In some of the writing about *Feature Film*, the critics' enthusiasm for Herrmann's score leads them to deny this simple fact.) Put slightly differently, instead of being features of the performance from which the viewer wants instinctively to look away – my initial reaction – Conlon's expressions and gestures, repeatedly thrust on us by the virtuoso filming and editing, turn out not only to hold our attention but as it were to contend for it from one screen to the other. That the two projections are mirror-reversed – at once the same and different – contributes to the outcome. As do, counterintuitively, the dark and silent intervals: these too exert an undeniable magnetism as one waits somewhat impatiently for image and music to resume. Two last facts: Gordon auditioned several conductors before choosing Conlon, who was ideal for his purposes; also, after the initial performance with a real orchestra Conlon insisted on doing another take based only on a recording of the sound. *Feature Film* makes use of portions of both takes, which is to say that the orchestra that one never sees is both present and absent.[15]

The second work I want to consider, *Through a Looking Glass* (1999), uses a brief segment of film from Martin Scorsese's *Taxi Driver* (1976), specifically the scene in which the increasingly disturbed protagonist, Travis Bickle (played by Robert de Niro), practices his draw in front of the mirror in his apartment (his most famous line: "You talkin' to me?"). In Katrina M. Brown's description:

122 and 123 (*facing page*) Douglas Gordon, stills from *Through a Looking Glass*, 1999. Double video installation with sound, dimensions variable.

Extracting the crucial seventy seconds, [Gordon] duplicates the footage and projects the two pieces of film onto facing walls in a darkened room with one sequence flipped left-to-right to mirror the other [as in the Edinburgh version of *Feature Film*]. They are not synchronized, one running slightly after the other, the differential increasing with each progressive screening [from one frame to two then 4, 8, 12, 16, 32, 64, etc. up to 512, when it reverses and slowly returns to parity; the whole process takes about an hour], so that what at first appears to be a slight glitch develops into a time lapse that allows Bickle to be in dialogue with his reflection, with the viewer placed between the two, caught in the crossfire.[16]

A less detailed description of the piece by George Baker goes further as regards the fate of the viewer:

Projected simultaneously on the two opposite walls of the gallery, Gordon [sic] at first seemed to place the viewer in a position of being directly and aggressively addressed by the installation. And yet the opposite effect ultimately took over, as the two looped appropriations gradually fell out of synch with each other, producing a cacophonous "disassociation," one in line with the narrative plot of Gordon's cinematic source. The work derealized the exhibition space and seemed in a parallel manner to utterly negate the viewer by recourse to a pathological space of the virtual, of the virtual as a space of pathology.[17]

To my mind, Baker's account veers off-course with his invocation of pathology and the virtual; the crucial point is precisely the negation of the viewer and "derealization" of the exhibition space, an antitheatrical feat if there ever was one. (What antitheatricality means in Gordon's art differs sharply from piece to piece.)

Finally, I want to return briefly to my earlier suggestion that a work like *Play Dead; Real Time* lays bare – all but forces on one's attention – the empathic-projective mechanism that lies at the heart of one's response to often minimally demonstrative absorptive motifs. So for example in the (extreme but nevertheless characteristic) case of Chardin's *Young Student Drawing*, glanced at and briefly discussed in the Introduction, the draftsman is seated on the ground in such a way that we see nothing of his face and indeed glimpse only the tip of his chalk-holder, not even the hand that wields it (not even the fingers). Yet we are spontaneously convinced as to the young man's entire absorption in the act of drawing – how can this be? No doubt his bodily attitude is exactly "right;" but in view of how little there is to go on in ascribing a state of mind to Chardin's figure, and not just ascribing it but so to speak empathizing with it, it is hard not to conclude that we have been led to "project" such a state into an only minimally expressive representation. (I am tempted to say, into or onto what is in the end simply inanimate matter, a piece of stretched canvas covered with dried chemicals, but that would be a Minimalist/Literalist way of putting things; the representation trumps its material basis.) In other words, the deep inwardness that is the hallmark of such paintings comes largely from the viewer. In *Play Dead; Real Time* we are dealing not with a painted image but with a (technologically) projected one based on the filming of a real animal, the elephant Minnie, and in this case my suggestion – supported by others whose responses I trust – is that the viewer is made acutely aware of his or her own irrepressible impulse to respond empathically to the appearance, movements, and doings of that alien yet also seemingly intimately familiar creature. (The impulse all but figures concretely in the piece itself.)

In closing then: Gordon's *B-Movie* (1995), a tiny video of a struggling fly lying on its back and kicking its legs, is perhaps his most focused if not his most extreme

124

work in this vein; it could, one feels, have been made as an illustration of paragraph 284 in part 1 of Ludwig Wittgenstein's *Philosophical Investigations* where the philosopher writes:

> Look at a stone and imagine it having sensations. – One says to oneself: How could one so much as get the idea of ascribing a *sensation* to a *thing?* One might as well ascribe it to a number! – And now look at a wriggling fly and at once these difficulties vanish and pain seems able to get a foothold here, where before everything was, so to speak, too smooth for it.[18]

It is as if Gordon's video not only shows us such a fly but also makes us palpably, disturbingly aware of our own empathically projective role in the process by which something like pain gets the foothold ("here" – but where *is* "here," exactly?) to which Wittgenstein alludes.

124 Douglas Gordon, still from *B-Movie*, 1995.
Video installation, dimensions variable.

in place of a conclusion

In a sense, this book does not call for a conclusion. My intention from the first was simply to write four essays (originally four lectures) about contemporary artists whose work I had come to regard as remarkable. Four exemplary individuals, in other words – and perhaps that is the larger point of such a project, that at this moment in American and European cultural history, with the art world in near-total disarray intellectually, institutionally, and financially, at once subject to the overwhelming pressures of globalization and beguiled by notions of resistance or "criticality" which virtually by definition have only the most tenuous purchase on reality, with auction prices for modern "classics" reaching insane heights ($71.7 million and $63.3 million for two Warhols! $17.2 million for Damien Hirst's shark! $4.5 million for Felix Gonzalez-Torres's nearly 200 pounds of individually wrapped blue cellophane candies with the word "Passion" on them!) and yet with no collective faith in the very idea, however qualified, of an autonomous

work of art, much less in the possibility, however qualified in turn, of making something lastingly valuable, the most that an unapologetically modernist critic like myself could reasonably hope for is that a handful of serious artists, working independently of each other and for the most part in different arts or mediums, might somehow find their separate ways to genuine achievement.[1]

Indeed the fact that the artists treated in this book have no significant relationship to each other beyond that established by their work was part of my motivation in dealing with them between the same set of covers. As I explain in the Introduction, all four essays take a certain impetus from my recent book *Why Photography Matters as Art as Never Before* in which I try to show how the work of no less than sixteen art photographers, as well as two sometime movie-makers, may be understood as engaging in diverse ways with problems and issues that go back in the first instance to the opposition between high modernism and Minimalism/Literalism as analyzed in "Art and Objecthood" and other essays of 1966–7, and beyond that to the emergence of modern (that is, pre-modernist) painting in France starting in the mid-1750s. Critical reaction to that book has been mixed, as I expected it would be, but there is no need to go into that here. The important point is that I have a theory about the issues at stake in a central tradition of modern art, one that I do not regard as having been effectively refuted, and also that my belief in the rightness of that theory has been reinforced by my finding new works of art, such as those analyzed in this book, that seem to me to instantiate and, what is more, to develop it in terms I could not possibly have imagined before encountering the works in question.

So for example Sala's evocation of presentness via duration in *Long Sorrow*, *Three Minutes*, and *After Three Minutes* goes far beyond anything even remotely envisioned in "Art and Objecthood," in which duration as such is understood as on the side of theatricality, while at the same time making it clearer than ever before that no direct presentation of presentness is conceivable, much less realizable (in the end, Moondoc biting down on the reed of his saxophone is fully as "metaphorical" a treatment of the theme as Louis's *Alpha-Pi*). Ray's preoccupation with what he calls embedment may be understood as a dialectical response

both to Minimalism/Literalism's theatrical staging of indeterminately structured "situations" involving the self-aware viewer *and* to Caro's abstract sculptures, which as no comparably ambitious works before them had done necessitated being placed on the ground or, in the case of pieces in which abstract smallness is at issue, on tables of one sort or another, a dual approach of the greatest interest to Ray but perhaps not quite what his exacting concept has in view. Marioni's monochromes circumvent or, better, transcend the demands with respect to shape and objecthood put forward in "Shape as Form" and "Art and Objecthood" even as they ravishingly confirm the larger stakes of those essays in ways not previously imagined by their author. And Gordon's *Déjà vu*, *24 Hour Psycho*, and *Through the Looking Glass* achieve their antitheatrical ends by intervening in movies, a medium explicitly exempted from modernist concerns in "Art and Objecthood." In all three works, moreover, as in *Play Dead; Real Time* and *Feature Film*, the element of installation plays a much more conspicuous role than in any art admired by me in the time of high modernism. The same goes for Sala's presentation of his work in galleries and museums. My claim, of course, is that none of this translates into indeterminacy; in no case does the viewer's awareness of the circumstances of viewing – including, in *Play Dead; Real Time*, the time one spends actually looking at the screens and monitor – stand in for the work. More broadly, three of the four artists discussed in this book, Ray, Marioni, and Gordon, explore modes of art-making that at first glance can appear to belong to avant-gardism in Greenberg's definition of the term. Yet, as has been seen, all turn out in different ways to pursue aims that are closer by far to the values of high modernism, which in effect have been dialecticized in their work. A similar dialecticization comes to the fore in *Why Photography Matters*, with respect to what I there call to-be-seenness as well as to the revisionist treatment of absorptive themes and effects in Wall's "near documentary" photographs, Struth's family portraits, and related works by Dijkstra, Fischer, Streuli, and diCorcia; to the thematizing of intentionality in Demand's photographs (as in Ray's *Hinoki* and other reproductive works, and, differently inflected, in *Long Sorrow*), hardly an approach within the parameters of high modernism; to the pursuit of "good"

versus "bad" objecthood in the Bechers' Typologies, a distinction with no meaning outside photography; and to a range of other strategies without precedent in the art and criticism of the 1960s.

Finally, although this book singles out artists whose work seems to me to prove the current vitality of high modernist themes and issues, it also demonstrates that that vitality is not tied to a specific medium, or to put this more strongly, that the question of medium-specificity, while not exactly irrelevant to the artists I discuss – Ray's commitment to sculpture and Marioni's to painting are definitive for both of them, while Sala's pursuit of presentness finds a perfect home in video – no longer plays the kind of role that it did at an earlier moment in the history of modernism. That is, I would no longer wish to argue that for a work of contemporary art to matter deeply it has in all cases to be understood as doing so as an instance of a particular art or medium. My conviction as to Sala's accomplishment is in no way dependent on an appreciation of a standing canon of previous video art; and in the case of Gordon, it is not at all clear how the concept of a medium bears on my analyses of *Play Dead; Real Time* or *Déjà vu*. In other words, for all my allegiance both to the art of high modernism and to my own earlier writing, I have not been standing pat.[2]

I do not know what else to say. There is a line in one of Dylan's songs – "To live outside the law you must be honest" (*Absolutely Sweet Marie*; I have eliminated a "But" and a comma) – which for a long time I planned to take as an epigraph for this book, but then I thought I would save it for the very end, which is what I have done. Well, each of my four artists lives outside the law in that he has found his own unsanctioned path to highly original achievement, and each is honest in that he has done so in part by refusing to succumb to a cultural consensus that has lost almost all sense of artistic quality, philosophical seriousness, and, it sometimes seems, hope for the future.

There remain two postscripts, the first on the laying bare of empathic projection, and the second on a recent lecture by Jeff Wall.

postscript one: the laying bare
of empathic projection

The topic of empathic projection came up twice in my essay on Gordon, first in connection with *Play Dead; Real Time* and second, at the end, with reference to the enigmatic *B-Movie*. My suggestion was that in both those works the viewer's tendency to project empathically – to project his or her own inevitably anthropomorphizing feelings – onto or into the moving image of the elephant Minnie (or simply the elephant Minnie: this too is unclear) and then, much less intensely but nevertheless unmistakably, that of a struggling fly – is in effect forced into the viewer's consciousness by the works themselves. My further claim is that both works therefore may be seen as laying bare a psychic "mechanism" that goes back to an absolutely formative moment in western painting, the moment of Caravaggio (and certain contemporaries) in the 1590s and early 1600s when the

125 Michelangelo Merisi da Caravaggio, *Penitent Magdalen*, 1596–7. Oil on canvas. 122.5 × 98.5 cm. Galleria Doria Pamphilj, Rome.

representation of figures deeply absorbed in their actions, feelings, thoughts, and states of soul first emerged as a major artistic resource. An early instance of this is Caravaggio's *Penitent Magdalen* (1596–7), which depicts a young woman with long, partly loosened hair and ordinary clothing sitting on a low chair with her hands not quite crossed or clasping each other in her lap. Her head has fallen forward and to the left, her eyes are shut or all but shut, and a single tear glistens on the side of her nose. On the floor beside her are a broken string of pearls and a flask of wine or conceivably ointment, both plausible accessories for

a Magdalen. The point, or my point, is that whereas the previous norm for paintings of the Magdalen had been to show the protagonist in a state of somewhat histrionic remorse – Titian's canvas in the Pitti, all naked breasts, flowing hair, and copious tears, being perhaps the most spectacular instance of this – the young woman in Caravaggio's canvas appears all but expressionless. Indeed seventeenth-century critics such as Giovanni Bellori criticized Caravaggio's picture on precisely those grounds – in Bellori's view the artist had simply chosen a young woman who pleased him, sat her in a room in an inexpressive pose, painted her naturalistically, all the while "pretend[ing] that she is the Magdalen." He conceded that the painting was well executed, but the implication of his remarks is that nothing about the work suggests the depth of feeling that the subject requires. Subsequently, of course, Caravaggio's *Magdalen* came to be seen in an altogether opposite light, as a *tour de force* of emotional veracity. For Helen Langdon, a recent biographer, Caravaggio's originality consisted in showing

> an individual and melancholy young girl in a room, at the very moment when she sees that the pleasures of this world are a temptation. He puts the religious scene back into a real context, into the context of the everyday, renewing its immediacy, re-creating its meaning. . . . This ability to rethink religious imagery and to endow the intensely real with profound resonance remained characteristic of Caravaggio's religious art.[1]

In a chapter called "The Invention of Absorption" in my book *The Moment of Caravaggio* I comment that Langdon's remarks are largely accurate but that what is important to recognize is that the artist

> sought to accomplish this not simply by posing a young woman in contemporary costume in an almost featureless room and then depicting her with unexampled realism, but also, crucially, by inviting the viewer to see the woman in his painting as wholly absorbed in painful thoughts and feelings – thoughts and feelings that, the painting suggests, lie too deep for expression in any more openly demonstrative form.[2]

I note specifically the minimalism of bodily and gestural clues as well as the seeming implication that the young woman's absorptive state is one that by its very nature has persisted for some time and, probably, will go on doing so (no painting could be less momentary in feeling, I say in response to Langdon's rhetoric of "the very moment"); and then write:

> I have used the phrase "the invention of absorption" but there is also a sense in which Caravaggio's *Penitent Magdalen* is the scene of a momentous discovery: the discovery that a powerful mode of emotional communication can be actuated by absolutely minimal physiognomic and gestural means. Put slightly differently, the discovery concerns what viewers, confronted with certain sorts of outwardly almost wholly inexpressive figures – figures who are outwardly inexpressive in certain distinctive ways – spontaneously do, at least in the western tradition (but doesn't this also hold for native viewers of countless sculptures of Buddha and Buddhist sages?): namely, read that lack of outward expression as an unmistakable sign of intense inwardness and sheer depth of feeling, as if in the presence of certain extremely slight but nevertheless telling visual hints or cues the illusion of absorption, which is to say the endowing of the figures in question with an imagined inner life comparable, if not superior, in intensity to the viewer's own, proves irresistible. The discovery, in other words, is of the basic truth that human beings tend strongly to project – that by and large they cannot *not* project – a conviction of inwardness onto, or rather into, painted or sculpted figures who elicit that act of projection in various barely specifiable ways, which is why the magic of absorption continues more or less unabated to the present day. (p. 76–7)

The remainder of the chapter enlarges on this point through detailed discussion of a series of major paintings by Caravaggio (the *Death of the Virgin, Incredulity of Thomas,* and the Vienna *Crowning with Thorns*), while the following chapter takes up a complementary theme, the sense in which Caravaggio's resort to absorption has for its other face an unprecedented mode of address, or to put this slightly differently, in which absorption, with its implication that the absorbed

figure or figures are unaware of the beholder, and address, with its strong suggestion that the beholder is imagined as being on the spot as never before, form a single "system" organized around the imagined presence of the beholder before the painting.

In the art of Caravaggio and his followers the thematization of absorption, despite what I have just described as its implication that the figure or figures in the painting are unaware of being seen, is not contrasted with theatricality in the pejorative sense of the term. That only comes to pass – the depiction of figures wholly absorbed in what they are doing, feeling, and thinking and therefore oblivious to all else, specifically including the beholder standing before the painting, is only imagined as a project *that can fail* – in another country, France, roughly 150 years later, that is, shortly after the middle of the eighteenth century; and it is precisely when that takes place – this is the argument of my trilogy, *Absorption and Theatricality*, *Courbet's Realism*, and *Manet's Modernism* – that painting embarks on the dialectical path that eventually leads it, in Manet's revolutionary canvases of the early 1860s, to pictorial modernism. (Chardin's absorptive pictures of the 1730s, such as the *Young Student Drawing*, either belong to the moment immediately prior to the start of that development or, once the development gets under way, can be seen as having belonged to it all along.) Furthermore, it will be recalled from the Introduction to the present book that the depiction of absorption plays a crucial role in Jeff Wall's lightbox photograph *Adrian Walker*, even as the thematization of what I call to-be-seenness means that the subject of that photograph is not depicted in the "throes" of absorption and indeed can be understood by the viewer as cooperating with Wall to produce jointly the photograph in question (in other words, he can be understood as posing, which in the Diderotian system would be fatal to the illusion of absorption). In *Why Photography Matters as Art as Never Before* I go on to discuss Wall's exploitation of absorptive themes and motifs in a range of other images, as well as absorptive aspects of the work of photographers such as Thomas Struth, Rineke Dijkstra, Luc Delahaye, Patrick Faigenbaum, Roland Fischer, Beat Streuli, and Philip-Lorca diCorcia. In all those cases, however, as in *Adrian Walker* and other works by

Wall, absorption coexists with a newly explicit acknowledgment of the role of the photographer (and often the subject) in the production of the photograph, which is also one way of describing the internal dynamic of Sala's *Long Sorrow* – Moondoc's instant-to-instant absorption in his playing being at once threatened and motivated by his extreme situation, and requiring in addition all Sala's ingenuity as director and editor of both image and sound to persuade the viewer of the film's truthfulness in that regard. (Gordon's use of movie acting as an "ontological object" at once circumvents and brilliantly solves the problem of needing to invent new strategies and *dispositifs* for the persuasive depiction of absorption.)

Against this background, the laying bare of empathic projection in Gordon's two videos takes on possibly epochal significance, all the more so in that they are not unique in this both within his oeuvre – I am thinking, for example, of his *10ms^{-1}* (1994), a video loop made from a fragment of a medical film from the First World War in which a psychologically damaged man, dressed only in underpants, struggles and fails to stand up and walk – and outside it – a powerful video by Sala, *Time after Time* (2003), being a particularly vivid case in point. Of *10ms^{-1}* Gordon has said, "There's a real problem here, about how one is supposed to look at these images. . . . [Y]ou can see that what is happening on the screen might be quite painful – both physically and psychologically – but it has a seductive surface. What do you do – switch off or face the possibility that a certain sadistic mechanism may be at work?"[3] Empathic projection in this case is at once solicited and challenged by the oddness of the damaged man's behavior and the slow-motion jerkiness of the image-flow; the "sadistic mechanism" is Gordon's name for the basis of the fascination that nevertheless holds the viewer before the work, troubled conscience and all, and his statement suggests that consciousness of that "mechanism" is thrust on the viewer under those circumstances. (Note once more that the emphasis falls on the structurally imposed recognition of the "mechanism," not on the nuances of a particular subject's personal experience of it.)

Similarly, in Sala's *Time after Time*, shot in Tirana at night, an emaciated horse stands by the side of a road as cars and trucks roar past (just a few, but the sense

126 Douglas Gordon, still from *10 ms⁻¹*, 1994. Video installation.

of danger is continuous); the video, which lasts not quite five and a half minutes, all but defies the viewer not to empathize in full consciousness of doing so with the frightened horse and indeed to speculate fiercely – again, fully consciously – as to the propriety of Sala's having filmed so forlorn an animal in such a situation.[4] (For reasons that are perhaps self-evident, it is no accident that "human-related" animals such as Gordon's elephant and Sala's horse have come to play a crucial role in connection with the dynamic I am describing. Robert Bresson's extraordinary film, *Au hasard Balthasar* [1966], which almost unbearably chronicles the ups and downs in the life of a donkey in the French countryside, marks an earlier stage in this development.) Sala's control of the situation is further manifested in the way in which the image, initially sharp, goes out of focus and then sharpens again in time to capture the cars rushing past; indeed

127–30 (*above and facing page*) Anri Sala, stills from *Time after Time*, 2003. Video, stereo sound. 5 min., 23 sec.

131 Anri Sala, *Time after Time*, 2003. Still from "pocket."

with the loss of focus two light sources in the middle distance become large and blurred, as if seen through tears, and then as the focus sharpens contract to their original dimensions. Further, at one fleeting moment, lasting half a second, late in the video as two trucks bear down on the horse the screen is filled by a shot of the horse's eye against the night sky – not long enough for the viewer to take it in for what it is but, especially on repeated viewings, the insertion of those dozen frames (Sala calls them a "pocket") gives another, more nearly "cinematic" sort of visual expression to a sense of panic that at once intensifies and preempts the viewer's empathic responsiveness. (There will be more to say about *Time after Time* on a future occasion.)

None of this, of course, implies that absorption's day is over – it still is, and is likely to remain, much too useful and resilient an artistic resource for that to be the case. Yet Gordon's and Sala's videos suggest that we may well be in the neighborhood of a further turning-point in its history, whereby increasingly a recourse to absorptive themes and effects both in photography and, especially, in film and video will find it necessary to come to terms with a new awareness of what from the outset has been the central role of the empathically projecting viewer in making the "magic" of absorption come off.

postscript two: on jeff wall's "depiction, object, event"

In a 2006 lecture entitled "Depiction, Object, Event" that has only recently come to my attention, Jeff Wall draws a fundamental distinction between what he calls the "depictive arts," which include abstraction, and all other kinds of art, importantly including arts of movement. Wall writes:

> The forms of the depictive arts are drawing, painting, sculpture, the graphic arts, and photography. These of course are what were called the "fine arts" to distinguish them from the "applied arts." I will call these the "canonical forms."
>
> The depictive arts do not admit movement. Movement in them has always been suggested, not presented directly. The quality and nature of that suggestion has been one of the main criteria of judgment of quality in those arts.

We judge the depictive arts on how they suggest movement while actually excluding it.

Movement is the province of other arts – theater, dance, music, and cinema. Each of these arts has its own avant-garde, its own modernism, its own demands for the fusion of art and life, and its own high and low forms. But in the 1950s those who took up and radicalized the pre-war avant-garde conviction that art could evolve only by breaking out of the canonical forms, turned precisely to the movement arts. I am thinking here of Allan Kaprow, John Cage, or George Maciunas. They sensed that the depictive arts could not be displaced by any more upheavals from within, any more radical versions of depiction or anti-depiction. They came to recognize that there was something about the depictive arts that would not permit another art form or art dimension to evolve out of them. The new challenge to western art would be advanced in terms of movement and the arts of movement.[1]

Wall remarks that Greenberg was opposed to the first stirrings of such developments, but he goes on to focus on my essay "Art and Objecthood," in which

[Fried] introduced the term "theatricality" to explain the condition brought about by the rise of the new forms. The term made explicit the fact that the radical breach with the canonical forms is not effected by some unheralded new type of art but comes with brutal directness from theater, music, dance, and film. Fried's argument may have had its greatest effect on his opponents rather than his supporters, for it revealed to them with an unprecedented intensity and sophistication both the stakes in play and the means by which to play for them. The development of the new forms exploded and accelerated just at this moment, amidst the clamor of criticism of "Art and Objecthood." (p. 14) [I say something of the sort in the Introduction to this book.]

Wall proceeds to discuss two transitional moments between the depictive arts and the new forms – the Readymade and conceptual art (or as Wall also calls the latter, the "conceptual reduction"), about both of which he has brilliant things to say –

but his main point concerns the division he now sees as having opened up between the depictive arts (or canonical forms) and their post-conceptual competitors:

> The proliferation of new forms in the post-conceptual situation is unregulated by any sense of craft or métier. On the contrary, it develops by plunging into the newest zones of the division of labor. Anything and everything is possible, and this is what was and remains so attractive about it.
>
> By the middle of the 1970s the new forms and the notion of the expanded field had become almost as canonical as the older forms had been. Video, performance, site-specific interventions, sound works, music pieces, and variants of all these evolved with increasing rapidity and were rightly enough considered to be serious innovations. The innovations appeared not as music or theater properly speaking but as "an instance of a specificity within the context of art." They were "not music," "not cinema," "not dance."
>
> The other arts make what I will call a "second appearance" then, not as what they have been previously, but as "instances of (contemporary) art." It appears that in making this second appearance they lose their previous identity and assume or gain a second, more complex, or more universal identity. They gain this more universal identity by becoming "instances," that is, exemplars of the consequences of the conceptual reduction. For, if any object (or, by obvious extension, any process or situation) can be defined, named, considered, judged, and valued as art by means of being able to designate itself as a sheer instance of art [the conceptual reduction], then any other art form can also be so defined. In making its "second appearance," or gaining a second identity, the art form in question transcends itself and becomes more significant than it would be if it remained theater or cinema or dance. (p. 21)

Again, Wall has much to say about various implications of these developments, but his essay closes with several pages keyed to the traditional notion of the autonomy of art. He writes:

The critique of the depictive arts has always concentrated on the question of the autonomy of art, and the corollary of autonomy – artistic quality. Autonomous art has been mocked as something "outside of life" and indifferent to it. The avant-gardes' critique cannot be reduced to this mockery – but in demanding the breaching of the boundedness of the canonical forms, the avant-gardes have failed – or refused – to recognize that autonomy is a relation to that same world outside of art. It is a social relationship, one mediated, it is true, by our experience of a thing, a work of art, but no less social therefore than a get-together at a community hall. Defenders of autonomous art – "high art" – claim that when works of art attain a certain level of quality, their practical human utility expands exponentially and becomes incalculable, unpredictable, and undefinable. They argue that it is not that autonomous art has no purpose, but that it has no purpose that can be known for certain in advance. . . . The autonomy of art is grounded on the quality it has of serving unanticipated, undeclared, and unadmitted purposes, and of serving them differently at different times. (p. 26)

Any critique of the depictive arts from within the boundaries of those arts – on political grounds, say – soon discovered that it was impossible to get round the principle of artistic quality. In Wall's formulation: "The canonical forms of the depictive arts are too strong for the critiques that have been brought to bear on them. As long as the attempts to subvert them are made from within, they cannot be disturbed. As soon as the artist in question makes the slightest concession to the criteria of quality, the criteria as such are reasserted in a new, possibly even radical way" (p. 27). But none of this is true of "the second appearance of the movement arts, the movement arts recontextualized within contemporary art as if they were Readymades" (*ibid.*). Wall continues:

In this recontextualization, the aesthetic criteria of all the métiers and forms could be suspended – those of both the movement arts and the depictive arts. The criteria of the movement arts are suspended because those arts are present

as second appearance; those of the depictive arts, because they could never be applied to the movement arts in any case.

So "performance art" did not have to be "good theater"; video or film projections did not have to be "good filmmaking," and could even be better if they were not, like Warhol's or Nauman's around 1967. There was, and is, something exhilarating about that. The proliferation of new forms is limitless since it is stimulated by the neutralization of criteria. The new event-forms might be the definitive confusion – or fusion – of the arts. An event is inherently a synthesis, a hybrid. So the term "confusion of the arts" seems inadequate, even obsolete. Now art develops by leaving behind the established criteria. The previous avant-gardes challenged those criteria, but now they do not need to be challenged; they are simply suspended, set aside. This development may be welcomed, or lamented, or opposed, but it is happening, is going to continue to happen; it is the form of the New. This is what artistic innovation is going to continue to be, this is what artists want, or need, it to be. (p. 28)

In other words (concluding his argument):

Contemporary art, then, has bifurcated into two distinct versions. One is based in principle on the suspension of aesthetic criteria, the other is absolutely subject to them. One is likewise utterly subject to the principle of the autonomy of art, the other is possible only in a situation of pseudo-heteronomy. We can't know yet whether there is to be an end to this interim condition, whether a new authentic heteronomous or post-autonomous art will actually emerge. Judging from the historical record of the past century, it is not likely. It is more likely that artists will continue to respond to the demand to transcend autonomous art with more of their famous hedging actions, inventing even more sophisticated interim solutions. We are probably already in a mannerist phase of that. This suggests that "interim mimetic heteronomy" – as awkard a phrase as I could manage to produce – has some way to go as the form of the New. It may be the form in which we discover what the sacrifice of aesthetic

criteria is really like, not as speculation, but as experience, and as our specific – one could say peculiar – contribution to art. (p. 29)

I hope it is already clear why I have cited Wall's lecture at such length. As usual, I find myself in agreement with many of his observations; after all, does not "Art and Objecthood" claim: "The concepts of quality and value – and to the extent that these are central to art, the concept of art itself – are meaningful, or wholly meaningful, only within the individual arts. What lies *between* the arts is theater" (p. 164). But this time our agreement extends, or may extend, less than all the way. For from the point of view of his lecture, Sala and Gordon exemplify what he calls "the second appearance of the movement arts," which is also to say that their practices escape the rule of aesthetic criteria, of considerations of quality or value as these traditionally have been understood. And there is truth in this, which is why I wrote toward the end of In Place of a Conclusion: "I would no longer wish to argue that for a work of contemporary art to deeply matter it has in all cases to be understood as doing so as an instance of a particular art or medium. My conviction as to Sala's accomplishment is in no way dependent on an appreciation of a standing canon of previous video art; and in the case of Gordon, it is not at all clear how the concept of a medium bears on my analyses of *Play Dead; Real Time* or *Déjà vu*."

But – this is where Wall and I diverge, or possibly diverge – my claim is precisely that the works by Sala and Gordon that I examine in this book do deeply matter, and that they matter on artistic and ontological grounds that I have done my best to articulate. Simply put, those grounds concern the issues that were brought to the fore in "Art and Objecthood," and before that in the larger dialectic of antitheatrical painting and criticism originating around the middle of the eighteenth century in France. Wall in the past has proven intensely sympathetic to these and similar considerations (hence in part the generous remarks about "Art and Objecthood" in "Depiction, Object, Event"), and it remains to be seen whether he will be persuaded by the readings of Sala and Gordon put forward in this book. "We can't know yet," I have quoted him as stating in his last para-

graph, "whether there is to be an end to this interim condition, whether a new authentic heteronomous or post-autonomous art will actually emerge" (p. 28). It would not have occurred to me to frame my overall argument in these terms, but no reader who has come this far can doubt for a moment that I would wish to claim for the works discussed in these pages the authenticity that Wall and I both regard as the sine qua non of serious achievement.*

* Let me close by citing in this connection two works, both short films, by the Algerian artist Philippe Parreno (Gordon's collaborator on *Zidane*), included in his 2010–11 exhibition in London at the Serpentine Gallery, *The Boy from Mars* (2003, but newly edited and with new sound) and *June 8, 1968* (2009). For the second of these, see my essay "*Sonnenuntergang*: On Philippe Parreno's *June 8, 1968*," in *Philippe Parreno Films: 1987–2010*, exh. cat. (London, 2010–11), pp. 133–44. The earlier film bears almost uncannily on the issues raised by Wall's essay, in that it involved the construction on a marshy site in rural Thailand of a flimsy-seeming, semi-translucent pavilion-like structure designed by the French architect François Roche expressly so that it could be made the subject of a film. (The site was owned by Parreno's friend, the artist Rikrit Tiravanija; the structure was left behind for subsequent use once the film was made.) Electricity was generated by unconventional means: a buffalo operated a dynamo, and the electricity thus produced was stored in a series of batteries within the structure itself. In fact, it was that very electricity that powered the making of Parreno's film, which after a static opening tableau proceeds episodically, without commentary of any sort, never explaining how it came to be but issuing in a ten-and-a-half-minute long sequence of haunting and beautiful shots of the structure viewed from a distance and from within, the night sky against which mysterious burning objects (paper lanterns) silently ascend, the marshy setting, the buffalo laboring to raise a heavy weight, a sudden storm, a lightbulb going on. The soundtrack, added recently, contributes powerfully to an overall impression of sensuous immediacy. The sequence concludes with a black screen and a song composed and sung by Devendra Banhart, which has the effect of "extending" the film beyond itself, as if into another space or medium. (Structure to film to song.) Obviously *The Boy from Mars* deserves fuller consideration than I can give it here, but even these brief remarks perhaps suggest that it can be taken as a kind of "real allegory" of autonomy or self-sufficiency under the new "heteronomous" artistic dispensation analyzed by Wall.

132–3 *(facing page)* Philippe Parreno, stills from *The Boy from Mars*, 2003.

notes

INTRODUCTION

1 Robert Morris, quoted in Michael Fried, "Art and Objecthood," in Fried, *Art and Objecthood: Essays and Reviews* (Chicago and London, 1998), p. 154. Further page references will be in parentheses in the text.

2 Walter Benn Michaels, *The Shape of the Signifier: 1967 to the End of History* (Princeton and Oxford, 2004); Jennifer Ashton, *From Modernism to Postmodernism: American Poetry and Theory in the Twentieth Century* (Cambridge and New York, 2005). See also Robert B. Pippin, *Hegel's Practical Philosophy: Rational Agency as Ethical Life* (Cambridge and New York, 2008).

3 Clement Greenberg, "After Abstract Expressionism," in Greenberg, *The Collected Essays and Criticism*, ed. John O'Brian (Chicago and London, 1986, vols. 1 and 2; 1993, vols. 3 and 4), vol. 4, *Modernism with a Vengeance, 1957–69*, pp. 131–2.

4 Donald Judd, "Complaints: Part I," *Complete Writings 1959–1975* (Nova Scotia and New York, 1975), pp. 97–8.

5 See, e.g., Stanley Cavell, "Knowing and Acknowledging," in Cavell, *Must We Mean What We Say? A Book of Essays* (1969; Cambridge and New York, 2002), pp. 238–66.

6 Douglas Crimp, "Pictures," *October*, no. 8 (Spring 1979): 75–88.

7 Michael Fried, *Why Photography Matters as Art as Never Before* (New Haven and London, 2008), p. 38. Further page references will be in parentheses in the text.

8 Stanley Cavell, *The World Viewed: Reflections on the Ontology of Film*, enlarged ed. (Cambridge, Mass., and London, 1979), pp. 22–3.

9 "From Silence to Language and Back Again" (a conversation between Lynne Cooke and Anri Sala), *Parkett*, 73 (2005): 76.

10 "Michael Fried and Charles Ray," in *Charles Ray*, essay by John Kelsey, interview by Michael Fried, texts by Charles Ray, Matthew Marks Gallery (New York, 2010), pp. 45–55.

11 See *Joseph Marioni. Paintings 1970–1998: A Survey*, exh. cat. (Waltham, Mass., 1998), with essays by Carl Belz and Barbara Rose.

ONE: SALA

1 Simone Weil, *La Pesanteur et la grâce* (Paris, 1988, 1991), p. 45. In English (approximately): "Grace is the law of descending movement."

2 "Hans Ulrich Obrist in Conversation with Anri Sala," in Mark Godfrey, Hans Ulrich Obrist, and Liam Gillick, *Anri Sala*, Contemporary Artists (London and New York, 1996), p. 17. Further on in the conversation Sala explains his choice of the site of the video: "One day I was visiting a neighborhood in Berlin called Märkisches Viertel, and I came across a very long building nicknamed 'langer Jammer' or 'long sorrow.' What attracted me was the way the inhabitants called it 'long sorrow' instead of 'big' or, say, 'deep,' as one would usually refer to sorrow. The expression kept the notion of 'long' as a space rather than as a time feature. It was a long sorrow because it was situated in a long building, not a long sorrow because it started a long time ago or will go on for a long time. There is something there that defies the habits of the language. I enjoyed the idea that a free jazz improvisation in that place could become a continuation of the architecture of the building, so that the building would become an even longer sorrow" (p. 19).

3 Moondoc, quoted in *ibid.*, p. 27.

4 Fried, "Art and Objecthood," in Fried, *Art and Objecthood: Essays and Reviews* (Chicago and London, 1998), p. 167.

5 Jennifer Ashton, *From Modernism to Postmodernism: American Poetry and Theory in the Twentieth Century* (Cambridge and New York, 2005), p. 175.

6 Roland Barthes, *Camera Lucida: Reflections on the Ontology of Film*, trans. Richard Howard (1980; New York, 1981), p. 78.

7 So, e.g., in Sala's 2008–9 exhibition at the Museum of Contemporary Art in Miami all the works on view were synchronized in such a way that one ended as another began; the viewer who entered the largely darkened and newly partitioned gallery

space was forced to make his or her way to a video that was playing, and then when it was done to discover which new projection was now under way. In effect a serious viewer was compelled to spend some considerable time in the exhibition, generally learning where to go at which moments in order to see particular pieces from start to finish. Again, this was not at all a Minimalist/Literalist exercise in "experience" taking the place of the works in question; but it was an arrangement that would have been unthinkable in the days of high modernism, one that testified to the viability of a certain notion of installation in the present context. See *Anri Sala: Purchase Not by Moonlight*, curated by Raphaela Platow, exh. cat. (North Miami and Cincinnati, 2008–9), with essays by Svetlana Boym, Michael Fried, and a conversation between Anri Sala and Raphaela Platow.

8 Michael Fried, "Morris Louis," in Fried, *Art and Objecthood*, p. 121.

<div align="right">TWO: RAY</div>

1 Robert Storr, "Anxious Spaces," interview with Charles Ray, *Art in America* 86 (Nov. 1998): 101. Further page references will be in parentheses in the text.

2 Paul Schimmel, "Beside One's Self," in *Charles Ray*, organized by Paul Schimmel, exh. cat. (New York, Los Angeles, Chicago, 1998–9), with essays by Schimmel and Lisa Phillips, p. 61. Further page references will be in parentheses in the text. On Ray's admiration for Caro's art see also the interview with Michael Fried, "Early One Morning . . . ," *Tate etc.*, issue 3 (spring 2005): 50–53, and "Michael Fried and Charles Ray," in *Charles Ray*, essay by John Kelsey, interview by Michael Fried, texts by Charles Ray, Matthew Marks Gallery (New York, 2010). Further page references to the last will be in parentheses in the text.

3 Michael Fried, "Anthony Caro" (1963), in Fried, *Art and Objecthood: Essays and Reviews* (Chicago and London, 1998), pp. 274–5.

4 Lane Relyea, "Charles Ray: In the No," *Artforum* 31 (Sept. 1992): 66.

5 For more on this, see Fried, "Anthony Caro's Table Sculptures," in *Art and Objecthood*, pp. 202–9.

6 Clement Greenberg, "Contemporary Sculpture: Anthony Caro," in Greenberg, *The Collected Essays and Criticism*, ed. John O'Brian (Chicago and London, 1986, vols. 1 and 2; 1993, vols. 3 and 4), vol. 4: *Modernism with a Vengeance*, p. 206.

7 There are acute remarks on Ray and scale in James Meyer, "No More Scale: The Experience of Size in Contemporary Sculpture," *Artforum* 42 (Summer 2004): 220–28. Briefly, Meyer sees Ray as resisting the widespread tendency toward mere size in favor of "a sculptural scale tied to the body" (228). He understands this as part of the lesson of Caro, and also notes, "Scale, in [Ray's] practice, entails a constant adjustment to particular sculptural ideas" (*ibid.*).

8 Charles Ray, "1,000 Words: Charles Ray Talks about Hinoki," *Artforum* 46 (Sept. 2007): 439.

9 See in this connection the interview with Yuboku Mukoyoshi in *documenta 12 magazine* (2007), available at: http://magazines.documenta.de/frontend/article.php?Id Language=1&NrArticle=1243. One excerpt from Yuboku's remarks: "Well, normally when I'm carving or putting the finishing touches on a wood surface, I wear gloves so that no oil from my hands gets on it. So, although it would be absolutely out of the question for pieces I've done the conventional way, and this is really an exceptional case, while making this piece our faces would brush up against it, and we'd go inside the tree, and sit still and listen to the sound of the tree, or enjoy the aroma of it, things like that. While working inside it, I really felt glad that, through working with hinoki and making Buddhist sculpture, I could have this kind of opportunity. [Ray] made the work go so smoothly, to an extent that would be almost impossible with a Japanese person. It's said that the Japanese are a people who are fairly considerate to others, but he was way beyond that. He read what I was thinking and let me do the work in my way, and he put all his energy into it, one hundred percent and more, and I learned a lot from that."

10 Ray, "1,000 Words."

11 Alternatively, embedment might at the limit be thought of as concerned with space as such, as distinct from merely local instances of it, along the lines laid down by Kant in the first *Critique*. In his words: "Space is not a discursive or, as is said, general concept of relations of things in general, but a pure intuition. For, first, one can only represent a single space, and if one speaks of many spaces, one understands by that only parts of one and the same unique space. And these parts cannot as it were precede the single all-encompassing space as its components . . . but rather are only thought in it. It is essentially single; the manifold in it, thus also the general concept of spaces in general, rests merely on limitations. From this it follows that in respect to it an a priori intuition (which is not empirical) grounds all concepts of them" (Immanuel Kant, *Critique of Pure Reason*, trans. Paul Guyer and Allen W. Wood [Cambridge and New York, 1999], pp. 158–9).

12 Ray, "1,000 Words."

13 From a communication from Ray: "The power of the piece has a lot to do with the space within the bottle. If the figure is just a bit bigger, it is birthing out. If the figure is just a bit smaller, it is in an environment. Both qualities make bottle totally understandable and non-sculptural. . . . Wine bottles are made of cheap flint glass. Optically there is a distortion that keeps the figure from being seen as a collectible in a bell jar. I feel that the fact that the figure is me is part of the puzzle of the work, so to speak. I don't see this as bottled me or the idea of a possessor as having me in a bottle but more as a mental/physical condition of the maker of the sculpture." He adds that the sculpture is painted wood, "22 parts, I think."

14 Tom Morton, "The Shape of Things," *Frieze*, III (Nov.–Dec. 2007): 127.

15 John Kelsey, "Field and Factory," in *Charles Ray*, p. 58.

<div align="right">THREE: MARIONI</div>

1 Michael Fried, *Why Photography Matters as Art as Never Before* (New Haven and London, 2008), pp. 14–15, 143–6.

2 Fried, "Art and Objecthood," in Fried, *Art and Objecthood: Essays and Reviews* (Chicago and London, 1998), pp. 149–50.

3 Clement Greenberg, "After Abstract Expressionism," in Greenberg, *The Collected Essays and Criticism*, ed. John O'Brian (Chicago and London, 1986, vols. 1 and 2; 1993, vols. 3 and 4), vol. 4, *Modernism with a Vengeance*, p. 132.

4 Jeff Wall, "Frames of Reference," in Wall, *Selected Essays and Interviews* (New York, 2007), p. 178. Further page references will be in parentheses in the text.

5 Compare Buchloh: "For Richter . . . painting still accomplishes the task of memory and of the labor of mourning over its lost capacities. Yet at the same time it is not the disappearance of painting as a privileged form of knowledge and as a highly specialized convention of representation that Richter mourns; it is the destruction of those forms of knowledge and experience once provided by painting for its spectators that Richter considers a loss, and it is a loss that in turn engenders the elegiac conditions of painting. This conservative revision of the functions of painting, of its purpose as an always already lost model of visual differentiation and sublimation, as much as the allegorical recapitulation of its lost epistemes, its outmoded categories, its vanished enlightenment ambitions, and its promises of sensual gratification – all of these operate as a resource of resistance against the factual and final incorporation of these experiences into spectacle culture." Benjamin H. D. Buchloh, "The Allegories of Painting," in *Gerhard Richter. Documenta IX, 1992; Marian Goodman Gallery, 1993* (New York, 1993), p. 14.

 See also the following more recent exchange between Buchloh and Richter:

 BB: In earlier conversations, you have always denied that painting could come to any definite end. How do you judge this situation now, after the experience of your big and tremendously successful show at the Museum of Modern Art in New York?.

 GR: Maybe all those people came in order to see the end of painting, a last flare-up, before it's over.

 BB: Why do you think that there is no painting anymore?

 GR: Because I never see it anymore. Films, however, which in contrast to so-called painting have something to say, something to offer. It is kind of astonishing

that painting is even still exhibited, and when you see on top of that how much effort the art critics put into poetizing meaning around these paintings, then the laughable role of painting today really becomes clear.

BB: So you see painting as an already dying culture – is that with sadness, or with satisfaction?

GR: With sadness. There were times when this culture came to life. For example, after the war, first in France, or then in America. There you had wide swaths of the Western world believing that a Barnett Newman was something wonderful and exciting. There's really not much of that left anymore.

BB: Yes, and now wide swaths of the Western world and the American world see that the painting of Gerhard Richter is something totally unique. Your exhibition in New York spawned an almost cultlike following, endless queues at New York's Museum of Modern Art, such that we were all asking ourselves how it is even possible that so many people want to see it. What do they see in it? And why do they want to see it?

GR: I can't say I know why. Probably, as I said, these people wanted to see the last flicker of painting.

BB: And is that what you represent?

GR: Yes, I represent that. After that, though, is the end. (Benjamin H. D. Buchloh, "An Interview with Gerhard Richter [2004]," trans. Sara Ogger, in Benjamin H. D. Buchloh, ed., *Gerhard Richter, October* Files 8 [Cambridge, Mass., and London, 2009], p. 181.)

6 With respect to the issue of intention, see the exchange with Buchloh on the subject of Richter's gray monochromes. Buchloh insists that they could only have been paraphrases of the then current convention for monochrome. Richter disagrees, and Buchloh asks: "Why are your monochrome paintings any different? Because you painted them?" Richter: "Yes, because I intended something different, because the similarity is merely superficial." Buchloh: "Because you regarded it as a linguistic tradition and not as an intention of your own?" Richter: "But it is an intention of my own: the intention to convey a different content" ("Interview with Benjamin H. D. Buchloh, 1986," in Gerhard Richter, *The Daily Practice of Painting: Writings 1962–1993*, ed. Hans Ulrich Obrist, trans. David Britt [1993; Cambridge, Mass., and London, 1995], p. 154). A further point would be that Richter's intention so described remains *essentially* his own, i.e., private, as if by design leaving the viewer in the dark. I will only add that Richter is also, to my mind at his most arresting, an absorptive painter; this is a topic for another occasion.

7 Michael Fried, "Joseph Marioni, Rose Art Museum, Brandeis University," *Artforum* 37 (Sept. 1998): 149; *idem*, "Joseph Marioni, Peter Blum, Chelsea," *Artforum* 45 (Sept. 2006): 372.

8 Yve-Alain Bois, "Surprise and Equanimity," in *Robert Ryman*, exh. cat. (New York, 1990), n.p. See also Bois, "Ryman's Tact" in Bois, *Painting as Model* (Cambridge, Mass., and London, 1990), pp. 215–26.

9 *Color Chart: Reinventing Color, 1950 to Today*, exh. cat. (New York, 2008). Texts by Briony Fer, Melissa Ho, Nora Lawrence, and Ann Temkin.

10 Stéphane Mallarmé quoted in Michael Fried, "Morris Louis," in Fried, *Art and Objecthood*, p. 126. Further page references will be in parentheses in the text.

11 The McNay Museum exhibition, for which there was no catalogue, was called "Joseph Marioni: Liquid Light" and was curated by René Paul Barilleaux.

12 Michael Fried, "Shape as Form: Frank Stella's Irregular Polygons" (1966), in Fried, *Art and Objecthood*, pp. 77–8. Further page references will be in parentheses in the text.

13 In the original text, the painting analyzed is Stella's *Moultonboro III*. But the latter's whereabouts are unknown, and no adequate illustration of it exists, so *Moultonboro II* has been substituted for it in these pages.

14 Michael Fried, "Jules Olitski," in Fried, *Art and Objecthood*, pp. 143–4.

15 "Interview with James Faure Walker," in Clement Greenberg, *Late Writings*, ed. Robert C. Morgan (Minneapolis and London, 2003), p. 164.

16 See, however, Walter Benn Michael's observations about the role of shape in James Welling's photographs in his *The Shape of the Signifier: 1967 to the End of History* (Princeton and Oxford, 2004), pp. 100–05.

17 Joseph Marioni and Günter Umberg, *Outside the Cartouche: The Question of the Viewer in Radical Painting*, trans. Nikolaus Hoffman and Rolf Taschen (Munich, 1986), text in German and English, p. 18. Further page references will be in parentheses in the text.

18 Jochen Poetter, "'An Unapproachable Beauty': Painting between Attraction and Repulsion," in *Günter Umberg mit Bildern auf Kölner Sammlungen, Body of Painting*, exh. cat. (Cologne, 2000), p. 104. Further page references will be in parentheses in the text.

19 James Elkins, "Painting," in Elkins, *Six Stories from the End of Representation: Images in Painting, Philosophy, Astronomy, Microscopy, Particle Physics, and Quantum Mechanics* (Stanford, Cal., 2008), p. 47.

20 Joseph Marioni, "Footnote #6: Michael Fried Siting the Plane," unpublished essay.

21 Rex Butler, "The Touch Between the Optical and the Material," in *Joseph Marioni: Four Paintings*, exh. cat. (Brisbane, 2000), p. 27.

22 Joseph Marioni quoted in Stephen Addiss, "Joseph Marioni and the Articulation of Color," in *Joseph Marioni: Iro*, exh. cat. (Amarillo, Tex., 2003), p. 42.

1 Michael Fried, *Absorption and Theatricality: Painting and Beholder in the Age of Diderot* (1980; Chicago and London, 1986), pp. 92–105. Further page references will be in parentheses in the text.

2 Jeff Wall, "Frames of Reference," in Wall, *Selected Essays and Interviews* (New York, 2007), p. 179.

3 Stanley Cavell, *The Claim of Reason: Wittgenstein, Skepticism, Morality, and Tragedy* (New York and Oxford, 1979), pp. 421–5. I use this concept in the course of discussing "the invention of absorption" in *The Moment of Caravaggio* (Princeton and London, 2010), ch. 3, pp. 69–97. See Postscript 1, below.

4 Fried, "Art and Objecthood," in Fried, *Art and Objecthood: Essays and Reviews* (Chicago and London, 1998), p. 164.

5 D. K. Holm, "Nocturnal Admissions: Book Review – *Close-up 2*," at http://www.asitecalledfred.com/2007/08/24/nocturnal-admissions-book-reviews-close-up-2/

6 V. F. Perkins, *Film as Film: Understanding and Judging Movies* (1972; New York, 1993), p. 138. Further page references will be given in parentheses in the text. See also a more recent essay by Perkins, "Where is the World? The Horizon of Events in Movie Fiction," in John Gibbs and Douglas Pye, eds., *Style and Meaning: Studies in the Detailed Analysis of Film* (Manchester and New York, 2005), pp. 16–41.

7 Stanley Cavell, *The World Viewed: Reflections on the Ontology of Film*, enlarged ed. (Cambridge, Mass., and London, 1979), pp. 24–5.

8 "If, then, grace is a characteristic we expect from intentional movements, and if, on the other hand, everything intentional must be banned from grace itself, then we will have to look for grace in what happens unintentionally when intentional movements are carried out, and also corresponds to a moral cause" (Friedrich Schiller, "On Grace and Dignity," in Jane V. Curran and Christophe Fricker, eds., *Schiller's "On Grace and Dignity" in Its Cultural Context: Essays and a New Translation* [Rochester, N.Y., 2005], p. 140). The Curran and Fricker volume includes the original German text along with a translation by Curran. Other passages too bear on this issue. My thanks to Ralph Ubl for pointing me toward Schiller's fascinating treatise.

9 It is only fitting, therefore, that admirers of Viola's work tend to draw a sharp distinction between it – e.g., the 20 individual pieces that comprise *The Passions* (2003) – and *24 Hour Psycho*, which they view as positively conservative with respect to "the system of *perceptual* illusion that is cinema" (Mark Hansen, "The Time of Affect, or Bearing Witness to Life," *Critical Inquiry* 30 [Spring 2004]: 594, emphasis in original). They are perfectly correct to claim that *The Passions* (and related works) and *24 Hour Psycho* are fundamentally different in this regard, but of course they fail to see that artistically the difference is all in Gordon's favor.

10 The importance of telephone conversations in *D.O.A.* is noted by Philip Monk in his chapter on *Déjà vu* in *Double-Cross: The Hollywood Films of Douglas Gordon* (Toronto, 2003), pp. 199–201. Further page references will be in parentheses in the text.

11 Douglas Gordon quoted by Holger Broeker, "Cinema is Dead! Long Live Film! The Language of Images in the Video Works of Douglas Gordon," in *Douglas Gordon: Superhumanatural*, exh. cat. (Edinburgh, 2006), with texts by Ian Rankin, Keith Hartley, Holger Broeker, Michael Fried, and Jaroslav Andel, p. 79.

12 Here it is worth mentioning a recent multiscreen work by the South African artist Candice Breitz, *Him + Her* (2008), which presents extremely brief excerpts from films starring Jack Nicholson and Meryl Streep, in effect isolating and decontextualizing short bits of their performances, which are, therefore, rendered intensely not to say unbearably theatrical. Yet no effort is made to counter this theatricalization; rather the whole point is to thrust it in the viewer's face, which is to say that Breitz's piece deliberately leaves the world (not just the art world) in somewhat worse shape than she found it.

13 Russell Ferguson, "Trust Me," in *Douglas Gordon*, organized by Russell Ferguson, exh. cat. (Los Angeles and Washington, D.C., 2003), with essays by Michael Darling, Ferguson, Francis McKee, and Nancy Spector and an interview by David Sylvester, pp. 15–55. Ferguson writes: "In 'Art and Objecthood,' Michael Fried refers to 'the utter pervasiveness – the virtual universality – of the sensibility or mode of being that I have characterized as corrupted or perverted by theater.' Despite the fact that much of Gordon's work unfolds over time and is thus 'theatrical' in a quite literal sense, the distortions and extensions of normal time that are pervasive in it also contribute to a profoundly anti-theatrical experience" (p. 16). Ferguson goes on to discuss *24 Hour Psycho*, leading to the remark: "In the end, viewers are led away from the temptations of narrative into a constantly renewing now, as if unwillingly confirming Fried's famous conclusion: 'Presentness is grace' (*ibid.*)."

14 Raymond Bellour, "The Body of Fiction," in a brochure included in *Feature Film: The Book* (London, 2000), p. 4. The book includes a CD containing a performance of Bernard Herrmann's score; the other essay in the brochure is Royal S. Brown, "The Music of Vertigo."

15 A revealing comparison with *Feature Film* is provided by Sam Taylor-Wood's *Sigh* (2008), an idiotic multiscreen installation featuring the BBC Concert Orchestra "playing" a specially commissioned score by Anne Dudley but without their instruments. They should be ashamed.

16 Katrina M. Brown, *Douglas Gordon* (London, 2004), p. 98. See also Nancy Spector, "a.k.a.," in *Douglas Gordon* (2003), pp. 134–9; and Monk, *Double-Cross*, pp. 134–5.

17 George Baker in "Round Table: The Projected Image in Contemporary Art," *October*, 104 (Spring 2003): 77. The others taking part in the round table were Malcolm Turvey,

Hal Foster, Chrissie Iles, Matthew Buckingham, and Anthony McCall. Gordon's work comes up frequently as the discussion proceeds, in my view to little avail.

18 Ludwig Wittgenstein, *Philosophical Investigations*, trans. G. E. M. Anscombe, 3rd ed. (1953; Oxford and Malden, Mass., 2001), p. 83e.

<center>IN PLACE OF A CONCLUSION</center>

1 Apropos of the foregoing, it is striking that Hal Foster, in a short text summing up the art of the first decade of the 21st century that has remained "most vivid" for him, singles out work that exploits "negations . . . wrested from relativities and contradictions" – the terms are T. J. Clark's – but not, as Clark maintained was true of modernism, "as a making over of formlessness into form. On the contrary," Foster specifies, "it is concerned with letting this formlessness be, as it were, so that it might evoke, as directly as possible, both the 'confusion' of ruling elites and the 'violence' of global capital. As might be expected, this mimesis of the precarious is often staged in performative installations" ("Precarious," *Artforum* 48 [Dec. 2009]: 208). Foster goes on to cite six for the most part evanescent projects by Robert Gober, Jon Kessler, Mark Wallinger, Isa Genzken, Paul Chan, and Thomas Hirschhorn. (The reference to Clark is to his "Clement Greenberg's Theory of Art," *Critical Inquiry* 9 [Sept. 1982]: 139–56.) In a note, Foster cites approvingly a response to a questionnaire by the curator Kelly Baum, who writes, "What if art's heterogeneity signals possibility instead of dysfunction? What if, in its very heterogeneity, art were to productively engage current sociopolitical conditions. . . . I think what we are seeing today is art miming its context. I think we are witnessing art performing 'agonism,' 'disaggregation,' and 'particularization.' Heterogeneity isn't just contemporary art's condition, in other words; it is its subject as well" (*October*, 130 [Fall 2009]: 91–6; 91, 93). My point is not that Foster and Baum are mistaken in their claims about some art of our time; it is rather that their formulations obviously do not apply to the work of the artists discussed in this book.

In the same issue of *Artforum*, however, Scott Rothkopf describes Charles Ray's sculpture *Boy with Frog* (2008) as "an eight-foot-tall alabaster hallucination of a child staring intently at

135 Charles Ray, *Boy with Frog*, 2009. Painted steel. Punta della Dogana, Venice.

the amphibian he dangles by its hind leg." He then writes: "That the animal is more minutely rendered than its captor suggests the intensity of the child's absorption in his prize and his obvious obliviousness to his own lack of clothing" ("Best of 2009," *Artforum* 48 [Dec. 2009]: 182). To be perfectly clear, I do not in the least feel that Rothkopf ought to have cited me in this connection; on the contrary, I welcome his willingness to deploy those terms exactly as he does – they are meant to be used.

2 That is not to endorse the notion of "post-medium condition" first introduced and then repudiated by Rosalind E. Krauss. (See most recently her *Perpetual Inventory* [Cambridge, Mass., and London, 2010], esp. the essays in part II, "Medium," pp. 19–88.) This is not the place for a detailed discussion of Krauss's views, but to my mind her recent attempts to re-theorize a viable notion of medium-specificity via the concept of "technical support" leave all the crucial questions unanswered, indeed unasked. For example, one might wish to suggest that according to my account of *Déjà vu*, what I refer to more than once as movie acting constitutes the work's technical support. (Ditto for *24 Hour Psycho*.) Yet such a suggestion tells us nothing of importance; what we want to know is what Gordon's interventions with respect to movie acting are in the service of, artistically and ontologically speaking: and to get at that, I want to claim, requires coming to grips with the issues concerning theatricality explored in this book.

POSTSCRIPT ONE

1 Helen Langdon, *Caravaggio: A Life* (1998; New York, 1999), pp. 148–9.

2 Michael Fried, *The Moment of Caravaggio* (Princeton and London, 2010), p. 76. Further page references are given in parentheses in the text.

3 Douglas Gordon quoted in Katrina M. Brown, *Douglas Gordon* (London, 2004), p. 43.

4 Daniel Birnbaum, "Anri Sala: Musée d'art moderne de la ville de Paris," *Artforum*, 42, (Summer 2004), refers to "an old, pathetic horse that stands alone on the side of a Tirana motorway . . . its body illuminated only by the headlights of passing cars. Again, it's very difficult to discern what exactly is going on: There is no explanation as to how the pitiful creature ended up in this predicament. Perhaps it was left behind, perhaps it escaped the slaughter house, who knows? It just stands there, repeatedly lifting its hind leg in a heartbreaking gesture of self-defense" (p. 241). In an unpublished conversation with Hans Ulrich Obrist, Sala explains that in certain venues (he mentions Nantes) viewers refused to come to the museum because of the way they felt he had treated the horse. However, Sala notes, no one hesitates to kill mosquitoes. "So it's interesting," he adds, "to see where the borderline is between the animals that we feel sorry about and those we don't."

1 Jeff Wall, "Depiction, Object, Event," Hermes Lecture, s'Hertogenbosch, The Netherlands, 2006, pp. 12–13. Further page references will be in parentheses in the text. Reprinted with minor changes in *Afterall*, no. 16 (Autumn/Winter, 2007): 5–17.

index

on Caro's sculptures 6–7
on cinema's escape from theater 181–3, 203
criticisms of 8, 11, 219
Diderotian sensibility 13–14
on "experience" as standing in for the work of art 6
Ferguson on Gordon's antitheatricality 234*n*.13
and presence and presentness 46, 48, 61–2, 202
on theatricality at war with art 9–10, 11, 70–71, 223
Wall on 125, 219, 223
art photography 121–6
and absorption 116, 170, 209–10
and antitheatricality 18–22, 122, 170–71
see also Why Photography Matters
Artforum (journal) 3
Ashton, Jennifer 7, 47–8
Au hasard Balthasar (film) 211
Austin, J. L. 9
autonomy of art principle 220–21, 222
avant-gardism 73–4, 203

Baker, George 197–8
Barthes, Roland 60–61, 66, 183
Baum, Kelly 235*n*.1
Becher, Bernd and Hiller 21, 170, 203–4
beholder
and art photography 170–71, 209
Diderot's antitheatricality 12–15, 169
Manet's modernism 16–17, 170
Bellori, Giovanni 207
Bellour, Raymond 193
Belz, Carl 26
Birnbaum, Daniel 236*n*.4
body: emphasis on 71
Bois, Yve-Alain 130–31

Breitz, Candice: *Him + Her* 233–4*n*.12
Brener, Roland 67–8
Table Top Sculpture 85, *85*
Bresson, Robert: *Au hasard Balthasar* 211
Brown, Katrina M. 196–7
Buchloh, Benjamin H. D. 230–31*nn*.5 and 6
Bustamante, Jean-Marc 122
Butler, Rex 159

Cage, John 219
Capa, Robert 59
Caravaggio
and absorption 205–9
Penitent Magdalen 206–8, *206*
Caro, Anthony 3, 10–11, 46, 87, 103, 203
break with past and "bodiliness" in work 71–2
Early One Morning 89, *89*, 91
and meaningfulness 6–7
Midday 2, *3*, 4, 72
Night and Dream 111
Ray's interest in 26, 67–8, 69–70, 72–4, 78–9, 89, 91, 106, 115
Sculpture Seven 72
Sculpture Two 78, *78*, 79
table sculptures 84, 85–6, 120
Cartier-Bresson, Henri 59
Man Jumping a Puddle 60
Cavell, Stanley 9, 24, 175, 182–3, 184
Chamberlain, John 133
Chardin, Jean-Baptiste-Siméon 116
Young Student Drawing 12–13, *13*, 14, 18, 48, 198, 209
Chevrier, Jean-François 121–2
cinema
and absorption 182, 184–5, 188, 189–91
escape from theater 181–4, 192, 203
Gordon's work 178–92

copyright and photograph credits

38: Photo © RMN/Daniel Arnaudet.

39: Image courtesy National Gallery of Art, Washington D.C.

40: © Henri Cartier-Bresson/Magnum Photos.

90: © ARS, NY and DACS, London 2011. Photo: Steven Sloman. © 2011. Photo Art Resource/Scala, Florence.

125: akg-images

12-NOV-11 H+I 36·00 115345